THE POPULAR PHOTOGRAPHY
ANSWER BOOK

THE POPULAR PHOTOGRAPHY
ANSWER BOOK

edited by
HARVEY V. FONDILLER

ZIFF-DAVIS PUBLISHING COMPANY • NEW YORK

Library of Congress Catalogue Number: 80-80280
ISBN: 0-87165-039-8

Printed in the United States of America
Second Printing 1981

Ziff-Davis Publishing Company
One Park Avenue
New York, New York 10016

CONTENTS

PREFACE

Ever since 1937, when *Popular Photography* was founded, readers have asked questions about the equipment, materials and techniques used in picture-taking. In this book, we have selected the most-asked (and, we trust, the most useful) of the innumerable questions submitted. The answers were supplied by experts on the magazine's staff.

The question-and-answer approach to learning is as old as Socrates. In more recent times, it is exemplified by the oft-quoted statement that teaching (or was it learning?) is best accomplished when an instructor sits on one end of a log and a student on the other. The directness of this kind of face-to-face relationship is paralleled, in some measure, when the student of photography can obtain answers that enable him to progress to a higher level of competence.

Some of the questions in this book are basic ones asked by two generations of picture-takers. Others deal with newly developed cameras, films and procedures. Whether the question is old or new, we have provided up-to-date information from specialists and from manufacturers who supplied technical data.

We are indebted to the thousands of *Popular Photography* readers who submitted questions and to Contributing Editors Cora Wright Kennedy and Robert L. McIntyre, who researched the answers.

HARVEY V. FONDILLER

1
CAMERAS/LENSES/SHUTTERS

RANGEFINDER OR REFLEX?

Which type of 35mm camera is better, the single-lens reflex or the rangefinder type?

As always, choice between cameras depends on the pictures you want to take and how you like to work. The single-lens reflex is favored by nature fans and others who like to take close-ups and use a variety of lenses. A rangefinder type of camera is favored by those who shoot available-light pictures at low levels of illumination or follow fast action outdoors.

INSIDE THE EYE-LEVEL FINDER

How does the eye-level prism finder of a single-lens reflex camera work?

It enables you to look straight forward and see a life-size or nearly life-size image on a ground-glass focusing screen. The image you see is erect and correct from left to right, like the view you get in a regular eye-level finder.

MOVABLE MIRROR IN SLR

What is instant mirror return?

When you take a picture with a single-lens reflex, the mirror that reflects the scene you see in the finder must fly up out of the way so light can go straight back to the film at the instant of exposure. Early cameras of this type were designed so the mirror remained up until the shutter was wound for the next exposure, making it impossible to see an image in the finder once the picture had been taken. More recent cameras are designed so that the mirror flies up for an instant, permitting the exposure, and then drops back into place so you can see the subject again. This is called instant mirror return.

STOPPING-DOWN AUTOMATICALLY

How does the automatic diaphragm on a single-lens reflex camera operate?

The automatic diaphragm is set for the aperture the photographer wants to use in making the picture. Pressing the shutter release performs two functions in rapid succession: The lens aperture closes down to the opening for which it was preset, and the shutter is released to take the picture. On some cameras, the lens is reopened as you let up on the shutter release; with others it reopens when you cock a special lever or rewind the shutter.

"BUYPOINTS" OF PRO EQUIPMENT

Why do some amateurs select professional equipment like a view camera?

They need the advantage of larger film size or a camera with more controls, and are willing to get them by carrying heavy equipment and learning to master the techniques of using it. View cameras offer large film sizes, great general flexibility, interchangeable lenses, and the possibility of developing a picture or two without thinking in terms of rolls of film. These are only a few of the points involved.

ANTI-CONVERGENCE ADJUSTMENT

What is the use of the rising front adjustment found on many view cameras?

When you tilt your camera upward to take in a tall building, the sides of the walls will seem to converge toward the top of the picture. This effect can be avoided if you keep the camera level, raising the lens in its standard to take in the top of the building instead of tilting the whole camera. Raising the lens makes the camera take in more at the top of the picture without causing vertical lines to converge.

BACK TO PLATE BACKS

I purchased a camera at an auction and would appreciate information on its use. It has a 135mm f/4.5 lens, uses 4×5-inch film, and came complete with 12 metal filmholders, which take one sheet each. It also has a ground-glass focusing back.

This is one of the many "plate-back" cameras that were popular early in this century. If it is still in good repair (shutter working and bellows light-tight), you can use it for outdoor picture-taking, portraits and close-up work. Many cameras of this type had double-extension bellows, which permit making copies the same size as the original. You are fortunate in the 4×5 size—the majority of these plate-backs took film in odd sizes no longer readily available. Many old-timers in photography learned the basic facts of picture-making while squinting at the ground glass of a camera such as yours.

PRACTICE MAKES PERFECT

How can I keep from being "all thumbs" when I go out with my new camera?

Put it through some "dry runs" without film. Sit down with the instruction book and your camera and go through the full sequence of picture-taking operations, again and again. Line up subjects in the viewfinder and squeeze off imaginary pictures, thereby improving your technique for shooting without moving the camera.

A DUSTY PROBLEM

I have noticed small bits of dust inside the viewfinder of my SLR and have been told they will not affect my pictures. Is this true?

Yes, it is! Such dust, however, can be quite annoying if there is enough of it. The question you have to ask yourself is whether or not it bothers you enough to pay for having it removed by a good camera repairman. If not, simply learn to live with it until it's time to have the camera cleaned by a competent repairman, or your SLR needs to be looked at for some other reason.

SCRATCH-FREE MIRROR CLEANING

How does one clean the mirror in an SLR camera? A friend told me that the mirror is very delicate and extremely susceptible to scratches.

Your friend has the right idea. About the only reasonably safe home treatment is to try and blow dust off the mirror. You could use air from an ear syringe or from a can. (For the record, so-called "canned air" really contains a propellant that pushes the air before it.) At any rate, be gentle

3

here. And try to hold the camera at an angle so the dust you blow goes out of the mechanism, not into it. If this doesn't solve your problem and the dust is too bad for shooting, take the camera to a competent repairman. Just don't try any other home remedies, please.

MIDWAY IN ASA

My camera has an ASA 25–1,600 range with two dots between each number. What do all the dots stand for?

The essential fact to remember is that in terms of film sensitivity and exposure, each number shown is the equivalent of one-third f-stop from the next one. So, ASA 64 film calls for one-third less exposure than ASA 50 film. But any number that is *twice* as big as another indicates the film is *twice* as sensitive to light. For example, ASA 400 film calls for half the exposure needed for ASA 200 film—either by stopping the lens down *one full* stop or by moving to the next fastest shutter speed instead.

OLD AND NEW STOPS

I recently acquired an old Leica rangefinder camera with the following f-stops: 2, 2.2, 3.2, 4.5, 6.3, 9 and 12.5. How do these relate to each other and to modern f-stops?

First, there is a one-third f-stop difference between f/2 (which, of course, is also on modern scales) and f/2.2. Next, there are one-stop differences between f/2.2, 3.2, 4.5, 6.3, 9, and 12.5, respectively. Therefore, each time you move up to the next bigger number in this part of the series, you halve the light that can reach the film.

It will be most convenient for you to use a hand meter that has these different lens-opening numbers. If this is not possible, however, note that all apertures from 3.2 are also one-third f-stop above ones on modern scales. Specifically, the one-third f-stop differences are indicated here by dashes: f/2.8–3.2; f/4–4.5; f/5.6–6.3; f/8–9; f/11–12.5.

PROLONGING STRAP LIFE

I usually carry my cameras without a case, using leather straps that are still relatively new. What is a good way of treating the leather to keep it in good condition so that the straps will last for a long time?

Try treating only the smooth side of the straps every few months with a good leather cleaner and preservative, such as liquid Lexol, that may be available in craft shops or in a quality-shoe store. Simply follow directions on the bottle and be sure to finish off by rubbing the leather briskly with a soft, dry cloth such as old toweling.

If no special leather preservative can be found, try treating the smooth areas of the leather instead with solid, floorwax paste that you allow to dry on the leather. Then buff this thoroughly with a soft cloth. For the record, saddle soap is a cleaner, not a preservative. And neat's-foot oil should be avoided because its residue can stain clothing. Readers who have leather cases should, of course, treat the smooth sides of both case and strap as described above.

GETTING SHARP ON LENSES

What should I look for in selecting a camera lens?

A lens must be considered along with the camera that uses it. The type of photography you want to do plays a part in the selection, too. Here are the main points:

1. Focal length—this determines the image size you will get on the film. Hence it also affects the distances at which you will have to photograph different subjects in order to fill the picture with them. In this way, focal length also determines the perspective that will be displayed in your picture.

2. Maximum aperture—the wider the aperture (the lower its f/number), the greater the amount of light the lens can transmit. This is a distinct advantage when the light is weak.

3. Quality—the more completely a lens is corrected, the sharper the pictures it will yield in black-and-white and color.

4. Mechanical features—these include focusing adjustments, click stops, a depth-of-field scale, available shutters and flash synchronization.

APERTURE SETTINGS—BY THE NUMBERS

What is an f/number?

This is a number used to calibrate the aperture settings of most lenses. It indicates, theoretically, that any two lenses of the same f/number will form equally bright images regardless of focal length. To derive the number, the focal length of the lens is divided by the diameter of the

aperture—a 4-inch lens with 1-inch aperture, for example, would be rated at f/4. The f/numbers on a lens scale are usually arranged so each one transmits twice as much light as the next one does. There are full-stop differences between the following: f/1.4, f/2, f/2.8, f/4, f/5.6, f/8, f/11, f/16, f/22, etc. Lenses often have maximum apertures, however, that fail to fit in with the full stops of the normal scale.

NEITHER WIDE NOR TELEPHOTO

What is the normal focal length for a camera lens?

Its length is usually somewhere around the diagonal of the film size the lens is intended to cover. A lens for a 35mm camera, for example, usually has a 2-inch (50mm) focal length to cover a 1 × 1 ½ film size. But the lens that comes on 35mm cameras may be as short as 44mm or as long as 58mm.

"UNCONFUSING" THE CIRCLE

What is a "circle of confusion"?

Ideally, a lens should form a "true" point-size image of a point, but in practice the image of a point (even when very small) always has a measurable diameter. This diameter of the image of a point, as formed by a given lens, is known as the circle of confusion.

DOWN TO A FINE POINT

What size circle of confusion is considered acceptable?

A circle of confusion with a diameter of 1/100 inch usually is considered acceptable in a print intended for viewing at a normal distance (10 inches). This means that if it is a contact print, the lens with which the negative is made should have a circle of confusion of no more than 1/100 inch. If the print is a ten-times enlargement, then the camera lens should be corrected to provide a circle of confusion of only 1/1000 inch. Many other factors, however, influence the apparent sharpness of a picture.

TEST BEFORE YOU CHOOSE

What is the best test of lens quality?

Comparative picture-taking! Testing on an optical bench can reveal many things—the presence of internal reflections (or flare) at wide apertures, resolving power, etc.—but there is no substitute for an actual performance test.

IT'S GOT TO LOOK SHARP

How can I test my camera lens?

Tack a sheet of newspaper on the wall and photograph it with your camera on a tripod, making sure the camera is level and square with the wall. Focus very accurately. Expose carefully, using a cable release and a short exposure to eliminate all chance of movement. Start shooting at the widest aperture. Develop the film carefully and blow up a few of the negatives to 11×14 inches. With an $f/3.5$ lens, for example, the letters should be sharp and clear at all apertures if there is nothing wrong with your lens. With a good, fast lens used at widest aperture, you cannot expect the edge areas to be as sharp as the central portion of your negative. This over-all sharpness is usually achieved before (or at) $f/2.8$ with an $f/2$ lens and continues through the range of stops. There may, however, be some loss of sharpness as you get to smaller stops, such as $f/16$, but this is not a fault in the lens. It is a normal state of affairs for many of the fast lenses that are used on small cameras.

BASICS OF BETTER LENSES

What are the aberrations found in simple lenses and corrected in better ones?

1. Chromatic aberration, which brings light of different colors to a focus in different planes.

2. Spherical aberration, the failure of the lens to focus central rays at the same plane as marginal ones.

3. Coma, unequal focal length in different concentric zones.

4. Curvature of field, an image of a flat object is formed in a curved plane.

5. Astigmatism, the condition in which a radial line cannot be focused sharply at the same time as another line at right angles to it.

6. Distortion, the pulling in or pushing out of lines toward the outside

7

of the picture area, resulting in either a barrel-shaped or pincushion-shaped image of a square.

CANCELING THE ABERRATIONS

How are lens aberrations corrected in designing the better lenses?

They usually are canceled out. One element of the lens is designed to create equal and opposite aberrations which offset those of another element.

WHAT APERTURE FOR EXTREME SHARPNESS?

At what opening does a lens give the sharpest pictures? A friend swears his works best at f/6.3. I have always thought you should use the smallest aperture a camera has, like f/22 or f/32, for maximum sharpness. Who is right?

You both are right, but you aren't talking about exactly the same thing. When a camera is focused at a given distance, objects within a plane at that distance and at right angles to the lens axis always will be sharp. As you use smaller lens apertures, nearer and farther objects also will be brought into sharp focus. This is the depth-of-field principle which backs up the use of very small apertures. Now, let us consider only the plane upon which the camera is focused. Objects within that plane will always be sharp, but they will be rendered sharpest at some one particular aperture. This is what is called the critical aperture for the lens being used. It usually is somewhere around one or two stops smaller than the maximum aperture, and may be f/6.3 for a given lens. The difference in sharpness between pictures taken at the critical aperture of a lens and some other aperture, considering only the plane which is in focus, is not likely to be great. It is nowhere near as important as the difference in sharpness of near and far objects when different apertures are used.

SHARP TO THE EDGE

Are super-speed lenses sharp at normal apertures?

Recently designed lenses of extra-wide aperture are as sharp as the lenses regarded as standards of quality a few years ago—at their commonly used apertures. At the widest aperture, edge areas may be somewhat less sharp than the central portion of the picture, but this clears up

8

as you stop down slightly. The wide apertures are a plus, gained by modern lens design and the use of new optical glass. The critical apertures of ultra-speed lenses, however, are likely to be nearer their maximum apertures than were those of lenses made years ago.

THE LONG AND SHORT OF IT

What are the important differences between lenses of short and long focal length?

There are two main differences which affect the size of the image and the depth of field. The greater the focal length of a lens, the larger the image it will form of a given object at a given distance—and the less area it will take in. The shorter its focal length, the smaller the image of a given object—and the larger the area it will cover. Lenses of shorter focal length have greater depth of field than longer ones when set at the same f/number and focused at the same distance.

NEW IS ALSO BETTER

How do today's lenses compare with the fine old lenses we hear about?

Lenses today are better than ever—they are capable of giving sharper images and better contrast at wider apertures. However, some fine old lenses are still around and do a good job.

COVERAGE AND CUTOFF

Why do my color slides come out dark at the corners when I use my telephoto lens?

If your slides are all right when you shoot with a normal lens, there are at least two possibilities: The telephoto may not quite cover your film size properly, or your lens shade may be too small and may shadow the corners of your pictures. Make a few test shots without it to check this possibility.

THE RANGE OF DEPTH OF FIELD

Why is it that some pictures show everything sharp, from near objects to far ones, while others show everything out of focus except the subject itself?

Two variables affect the depth of field, or range from near to far objects that appear sharp in pictures taken with a given lens. They are the aperture that is used and the distance at which the camera is focused. Smaller apertures such as f/8 generally give greater depth of field—or sharpness over a wider range of distances—than wider apertures like f/4.5. The greater the distance at which the lens is focused, the greater its depth of field. Thus a lens focused at 20 feet may show everything sharp from 10 feet to infinity, while the same lens focused at 4½ feet may show only objects at distances between 3½ and 6 feet satisfactorily sharp.

GETTING IT ALL IN FOCUS

Where should I focus my camera to get maximum depth within a scene?

Depth-of-field scales are invaluable here. Using your rangefinder or ground glass, or estimating, determine the distances of near and far points which should be sharp in the picture. If scene depth is from 6 to 20 feet from the camera, for example, and you are shooting with a 50mm lens, the depth-of-field scale shows that a setting slightly under 10 feet at f/16 will solve the problem. As your lens is stopped down, depth of field will be gained on both the near and far sides of the plane on which you focus—but the gain in feet is greater in the direction behind your plane of focus.

USING THE HYPERFOCAL DISTANCE

How do you set a camera to get maximum depth in outdoor scenes that include far-off objects?

You set the lens at its hyperfocal distance—which isn't as complicated as it sounds. The hyperfocal distance for a given lens opening is the shortest focusing distance at which everything from half that distance to infinity will be sharp.

BY TABLE OR SCALE

How can I determine the hyperfocal distance for my lens at different apertures?

Most lens manufacturers will supply you with hyperfocal distance tables that provide this information. If your camera has a depth-of-field scale, you can use it to achieve the same result. Adjust the focusing

mechanism to bring the aperture you want to use opposite the infinity mark on the scale. When this has been done, the lens is focused at its hyperfocal distance for that aperture.

MIRROR-SHARP IMAGES

What's the best way to focus your camera for sharp mirror pictures?

The focusing formula for reflection pictures is to set your camera for the distance from camera-to-mirror plus mirror-to-subject. If your camera has a rangefinder or ground-glass focusing, simply use it to focus on the reflection in the mirror. Either of these methods will make the reflected image come out sharp. To get both the reflected image and the mirror frame in sharp focus, it is best to measure the distances of each (using your camera) and then consult your depth-of-field scale. Use a small aperture for depth of field.

KEEP IT CLEAN!

Why is it important to keep a lens clean?

There are two reasons. First of all, a clean lens takes sharper pictures with better contrast. Dirt and smudges make the image cloudy. Second, a lens can become permanently damaged by grit which scratches it or fingermarks which can etch their way into its surface.

LENS-CLEANING PROCEDURE

How should a lens be cleaned?

First, remove surface dust with a fine sable brush. If that's all the cleaning it needs, stop right there. If the lens surface is cloudy or smudged, after brushing off the dust, wipe the lens lightly with special lens tissue or a well-laundered handkerchief. If it is greasy, use lens cleaning fluid, but apply it sparingly.

GO EASY WITH FLUID

Can lens cleaning fluid damage my lens?

It won't hurt the glass surfaces, but it could cause trouble if it were applied so liberally that it ran in around the lens mount and between the lens elements.

USE CAUTION WITH SILICONE

Is silicone-treated cloth or paper helpful in cleaning lenses and keeping them clean?

Treated material of this type is effective on uncoated lenses, like those of spectacles, but it should never be used on photographic lenses with coated surfaces. The surface coating of a lens is porous and will take up silicone from the cloth or paper. This will change the optical properties of the coating, making it less effective.

REPAIRABLE WHEN SCRATCHED?

Can a scratched lens be repaired?

It is possible to regrind and repolish the front element of a scratched lens, but whether it is advisable depends on the size and depth of the scratch, the design of the lens and its replacement cost.

FOCAL-PLANE AND BETWEEN-THE-LENS

What are the basic types of shutters used in cameras today?

Two are very familiar to us: the focal-plane shutter and the between-the-lens shutter. In the former, the shutter usually consists of a cloth curtain with a slit which travels across the image plane in the camera to expose the film. Many 35mm cameras such as the Nikon and Leica use this type, and the position of the shutter permits easy interchangeability of lenses. The between-the-lens system places the shutter between front and rear elements of the lens. When the shutter release button is pressed, metal leaves open and shut to allow light to pass through for a specified period of time and take the picture.

THOSE OVAL WHEELS

I've seen old pictures of racing cars in which they seem to lean forward and their wheels are stretched out diagonally instead of being round. What causes this phenomenon?

This is a fairly common result of shooting fast-moving objects with a focal-plane shutter. This type of shutter doesn't expose the whole picture at once. Instead, it exposes a narrow strip of it at a time as the shutter slit moves across the face of the film. If the slit is ¼ -inch wide and moves across the narrow dimension of 4×5 film, for example, it will take 16 times the exposure time to traverse across the negative. With each segment getting 1/500-second exposure, the elapsed time from beginning to end of the exposure will be 16/500 second or about 1/30 second. A car can move quite a distance in this period. If the slit moves from the top to the bottom of the camera, it actually moves from the bottom to the top of the picture since the image in the camera is inverted. Hence the bottom is recorded first, and higher portions of the picture are recorded later as the car moves forward. This accounts for its forward-leaning appearance.

LEANING IMAGES

Are other types of distortion sometimes introduced by the focal-plane shutter in pictures of moving objects?

Yes. When the slit moves in the same direction as the moving image on the film, the subject will appear elongated. When the slit moves in the opposite direction, the subject will seem shortened. When the slit moves from the top to the bottom of the image, the subject will seem to lean backward. Remember that the image is inverted by the camera lens, or you will find just the opposite of the effect you expect.

ACCURACY OF VIEWFINDERS

Why do my pictures always show the subject too small with a lot of waste space around all four sides?

Some viewfinders take in less than the negative records. This serves as sort of a "safety factor" to avoid leaving out important subject matter near the edge of the picture, but it results in pictures that are quite loosely composed. If your viewfinder is like this, learn to move in closer to your subject and allow for the extra space you know you will get on the film.

With the eye-level type viewfinder, make sure you are holding the camera with your eye close to the finder opening. If you hold the camera too far from your eye, you will see only the center portion of the picture area. If it's worthwhile to you, set your camera up on a tripod and make a test shot. Aim at the side of a house or some other target where it is easy to check the area covered by the finder. Note the cut-off points for all four corners of the finder. Then take a picture, and check the print against the original subject to see how negative area compares with what the finder in the camera indicated.

CHECKING FLASH SYNCH

Can I check the flash synchronization of a camera with a focal-plane shutter without taking and developing pictures?

Yes. Place the flash off the camera, in a position where it will shine into the front of the camera as you look into it with the lens removed. At this point you can see the focal-plane shutter. Keep looking at it as you trip the shutter. When the flash fires, the curtain will be illuminated by the bright light—if it is still closed. But if synchronization is correct the curtain will be out of the way, and you will see the full width of the camera's pressure plate instead.

ON MATCH-NEEDLE SLRS

What is meant by "preset" or "automatic" lenses that are available for my match-needle SLR 35?

One thing common to each is that you preselect the aperture you wish to use. With automatic diaphragm lenses, however, when you shoot, the mechanism automatically closes the lens down to the preselected f-stop, then after exposure opens the lens wide again. And whether metering is a wide-open or stopped-down operation, it is done by turning the f-stop ring after a suitable shutter speed has been set.

With a typical preset lens, you must stop down or open up the lens manually. And when metering (which is always done in stopped-down fashion), the fastest way to operate is to turn both the presetting ring and a second ring (not found in automatic lenses) together. However, the second ring only is turned to open up the lens for viewing or focusing, or to close it down again afterwards to the preselected aperture. Conven-

iently, this ring stops at the preselected opening, so you don't have to lift your eye from the finder.

CLOSE-UPS WITH AN SLR 35

What are the advantages of close-up lenses with an SLR 35?

The most obvious one is that there may be no other camera choice since non-focal-plane-shutter 35s can't use bellows and extension tubes. Otherwise, people often prefer the small size of close-up lenses and the fact that no exposure compensation is required. They also find they can cover quite a range with just a few attachments. For instance, one can go all the way to a film image that is about three-quarters life size by using a +10 with a 50mm ("normal") lens. For less magnification, photographers often use a +2 or +3—each of which covers a wider specific range with your lens. However, note that it's necessary to stop down the lens as far as possible, not just for maximum depth of field, but for best image quality.

DEPTH OF FIELD AND CLOSE-UPS

I'm having trouble getting enough depth of field in close-ups made with an SLR, a 55mm lens and extension tubes. Is it true that depth remains pretty much the same for various lenses provided the f-stop and the size of the image on the film are identical?

Unfortunately, yes. And depth of field is, at best, extremely shallow with ultra close-ups. You might try, however, to increase depth very slightly by switching to another lens set-up that lets you get similar size images, but stop down further, say to f/22 or even to f/32, if the lens permits.

Another option is to move back for somewhat more depth, so image size on film will not be so great. Whenever possible, many photographers plan their close-ups so that important areas are all pretty much in the same plane, parallel to the film plane in the camera. The idea then is to make the in-focus and out-of-focus imagery work together for the best possible visual effect.

15

A FOCUSING PROBLEM

I have an SLR 35 camera with a split-image rangefinder spot. But when I focus on a subject about 5 feet away, this area of the picture comes out blurred, while things about a foot or so behind the subject are clear and sharp. What are the reasons for this, and what can I do about it? It is most apparent at wider lens openings.

Unless you have faulty eyesight, this seems to be a mechanical problem. Get your camera checked out by a competent repairman for "back focusing." Here, by definition, when you focus on an object, the camera really places the focus farther back. Naturally, if the lens is closed way down, the resulting depth of field usually conceals the problem. But at wider apertures, it is very likely to show up. The same basic ideas hold for the opposite problem of "front focusing," where your focus actually falls, unfortunately, in front of the point focused on rather than directly on it.

NOT THE LENS BUT IMAGE SIZE

Is it true that depth of field will remain the same for a number of lenses regardless of focal length if image size on film is the same?

This is true for conventional lenses, provided the same f/stop is used in each case. Then, only the camera-to-subject distance will vary according to the focal length of each lens.

IT'S MAINLY ON THE PLANE

When subject distances are given for a lens, such as 2 and 3 feet, to what point of lens or camera is the distance figured?

All marked distances on lenses are usually given for the subject-to-film-plane point. And the plane of the film may be indicated by a line on top of the camera body. The same measuring point is also implied in other references to subject distances. However, on rare occasions (sometimes in the close-up field), manufacturers may talk about the distance from subject to either the end of the prime lens or to the end of an auxiliary lens placed over it.

MIRROR PROBLEMS

I find it hard to believe that depth of field must be so great when I make a mirror shot and want the reflections of distant objects and the frame of the mirror all to be sharp. Is there some way to get around this?

Unfortunately the sticking point is that your needed depth of field (or zone of sharpness) has two basic limits. True, the near figure is just the distance from your camera to the reflecting surface. But the far one is actually the distance from the camera to the mirror, *plus* the distance from that surface to the reflecting object or objects. So a lot of depth is often required. And you may not be able to obtain it even at a small aperture such as f/16.

One possible compromise, of course, is to back off to a greater shooting distance from the mirror, and see if the depth of field covers then. Another idea is to keep the reflection sharp, but settle for the mirror frame being out of focus. At any rate, use the depth-of-field scale to explore the possibilities, using this mode of operation. First focus on the farthest and nearest objects you want to be sharp. Then, if you are shooting at f/16, set the far distance so it falls opposite f/16 on the depth-of-field scale. And see if the near distance is at or within the f/16 mark on the other side of the scale. If it is and you enlarge most of the image to 8×10 or 11×14, both your near and far objects should be sharp.

KEEPING YOURSELF IN FOCUS

I want to make some self-portraits at 3–4 foot distances with a normal lens and using my SLR 35's self-timer. About how far should I stop down the lens so that it is not a hassle getting myself in the proper area for sharp images?

Many photographers go for the most depth of field they can get at such close distances, by stopping the lens down as far as they can. Then they use this depth together with some reference point, such as the depth of the chair seat.

For example, if you focus at three ft. with a 50mm lens and stop down to f/16, total depth is about 11½ inches, which is less than the depth of a typical chair seat. What's more, only about 4⅞ inches of that depth is in front of the point of focus, while a little over 6½ inches is behind the same focus point. Life is easier if you use the same lens at f/16 and focus at four feet. Then total depth is 22 inches, with about 8½ inches in front of the point of focus and 13½ inches behind.

17

MORE ON DEPTH OF FIELD

I see photos where there is great depth, say from a subject at four feet to objects at infinity. How is it possible to get such depth? I've tried the smallest aperture with my normal lens, but that wasn't the answer.

It certainly isn't. Try changing to a shorter focal-length lens, where maximum depth indicated on the depth-of-field scale will be greater. Just place the infinity marker opposite the smallest aperture on the depth-of-field scale. Then look at the same aperture mark on the other side of the scale to see what the closest sharp area will be. If this is sufficient, shoot with the lens set this way.

For example, with a 35mm lens, maximum depth is indicated as a bit less than 4 feet to infinity for f/16. But with a shorter focal length lens, maximum depth on its scale will be greater for f/16. Such scales work well if all or nearly all of the negative area is enlarged to 8×10 or 11×14, and each print is viewed at a suitable distance.

D-S CONVERSION

A friend gave me an old 135mm Goerz lens with the following numbers for lens openings: 4.6, 6, 12, 24, 48, 96, 192 and 384. Can you please convert these numbers to conventional f-stops?

What you have there are old Dallmeyer-Stolze numbers placed on some lenses made during a period before 1902. Here are their equivalents in f-stops: 4.6=f/6.8, 6=f/7.7, 12=f/11, 24=f/16, 48=f/22, 96=f/32, 192=f/45, and lastly, 384=f/64.

WHY B FOR TIME?

I know that you can make time exposures on the "B" camera setting by holding the shutter button down to keep the shutter open. Then you let go when you want the exposure to end. But exactly how did B for Bulb get its name?

This term originated a long time ago, in the days of the early air-shutter release. There actually was a bulb that the photographer squeezed. And this sent a column of air down a tube to open the shutter. As long as the photographer kept the bulb in squeezed condition, the shutter stayed open. But when he let go and the air returned to the bulb, the shutter naturally closed.

WHEN Z EQUALS T

What does the "Z" setting stand for on my old folding camera?

This stands for the German word "Zeit," meaning Time, and is used for making time exposures. In use, you'd probably first push the shutter release to open the shutter and push it again to end the exposure. In a few instances with nonfolding cameras, however, the Z setting is used somewhat differently.

RED SPOT ON LENS MOUNT

What's the small red mark next to the focusing mark on my lens?

This is a special focusing mark to use with infrared film, as infrared rays do not come to exactly the same focus as do light rays. So, proceed as follows: First, focus as usual, noting the footage setting at the conventional mark (1). Then shift that footage setting slightly so it falls opposite the infrared focusing mark (2). This works well, usually, if you also shoot at a small aperture (such as f/8 or smaller), allowing depth of field to give you a safety factor.

A MATTER OF SHAKE AND BLUR

What is the slowest shutter speed at which a 200mm lens can be safely hand-held with a 35mm SLR?

There is no hard and fast rule, as people's ability to hold a camera and lens steady varies widely. Also, the balance of lens plus camera can make a significant difference. And some combos seem to settle steadily in your hands, while others are wobbly. So run a few long-lens tests with detailed subject matter at a distance of, say, 30 feet or more, and determine your own no-shake level with the combination you have at present. Try running the shutter-speed gamut from 1/125 second on up. If you are an ultrasteady type, start at 1/60. If you are typical, however, when 8×10 prints have been made or slides projected, chances are that 1/125 or 1/250 second may be the slowest speed that is generally safe for you.

CONTOURABLE LENS SUPPORT

I've heard that a bean bag can be helpful for steadying a longer lens, such as a 200mm or 300mm, on a railing, ledge, or chair back. About how big should one be? And how do I make it?

The only guidelines here are that the bag should be big enough to form a reasonable-sized horizontal cradle for the lens barrel, but not too heavy to carry. For the kind of lens you mention, a bean bag made out of two pounds of dried beans (pinto, navy, Great Northern, etc.) or dried black-eye peas should do.

One good, simple, non-sewing approach is just to put such dried legumes in a heavy-duty sock. Gently compact the contents down enough, then tie a firm knot in the sock end itself. Be sure, of course, that the weave is tight enough and that there are no holes. Otherwise, the beans will dribble out while you are using the bag, or you may have beans in your gadget bag.

MEASURING THE EYE

What is the focal length and f-stop range of the average human eye?

Eastman Kodak Co. tells us their best approximation of the eye's focal length is between 23mm and 25mm, with an f-stop range of $f/2.8$ to $f/22$.

LARGER, YET SMALLER

What are some of the smaller lens apertures after f/16?

Some of these are: $f/22$, $f/32$, $f/45$, $f/64$ and $f/90$. Each represents a full-stop change, that is, moving to the next higher number given cuts the amount of light that can reach the film in half.

ABOVE AND BELOW

Where do lens openings like f/3.5 and f/4.5 fit on the full f-stop scale?

These two apertures are, respectively, just one-third f-stop below and one-third f-stop above $f/4$. Some other f-stop markings that are between the usual full-stop changes are seen on some lenses. Again, all are just one-third f-stop above or below a usual aperture.

USING TWO LENS EXTENDERS

How do you figure the right exposure increase when using a pair of 2X lens extenders together?

The easiest method is to divide the normal film rating by 16, then set the result on your meter, reading the compensated exposure directly. If you prefer not dividing, remember the two extenders together call for a *four-stop* exposure increase. In either case, bracket exposures initially until you are sure you're zeroed in for your equipment and film. Stop down to f/11 or f/16.

WHAT GAIN IN SPEED?

When I use a gunstock or chest tripod with a long lens, such as 200mm, how much gain can I expect in terms of using slower shutter speeds? I still want sharp pictures.

We can't make any definite pronouncements here, because the gain varies from person to person, the specific equipment and personal steadiness. However, a lot of people find that an accessory like a chestpod or gunstock lets them use the next slower shutter speed below their minimum without the accessory. So, if your ordinary limit with such a lens is 1/125 second, the accessory might permit you to get sharp pictures at 1/60 instead. There are, of course, exceptions either way. Furthermore, if you brace your body against a wall, pillar or other firm object as well, you may be able to go even further down the shutter speed scale. Run a few tests and find out about this with all of the lenses you intend to use in this manner.

ZOOM LENSES

Recently I used a zoom lens on my SLR 35 and obtained excellent pictures most of the time. However, at the longest and shortest focal-length settings, vertical objects such as poles were curved, instead of remaining straight. Does this distortion occur with all zoom lenses?

Not by any means. Both barrel and pin-cushion distortion show up more with some zooms than others. Yet in a number of zoom lenses, distortion, if present, is so slight that it cannot be noticed on 11×14 prints. When these faults are evident, however, they have more effect on vertical or horizontal straight lines near the edges of the frame and tend to occur at the extremes of the focal-length range. (For instance, if pin-

21

cushioning shows up at the longest focal length, you're likely to find barreling at the other extreme.) You can reduce or eliminate the distortion problem in a few basic ways: shift away from the extreme focal-length setting; move the camera so straight lines are closer to the center of the picture; or combine both approaches if necessary.

REFOCUSING A ZOOM LENS

If true zooms are defined as lenses that remain in focus throughout the focal-length range, why do I get advice to refocus the zoom at times, especially at shorter settings?

This is often suggested when you focus (as advised) at the longest setting and zoom to the shortest setting. There can be a slight focus shift with some lenses that is significant because it is not covered by depth of field. Using a tripod, check your lens out as described. After shifting to the shortest setting, refocus in some cases, not in others, and keep track of what you do. Then it should be easy to determine matters for your zoom lens.

SPECIAL-EFFECT ZOOMING

How does one zoom from one focal length to the other during a single exposure? I've seen pictures with this effect, and I would like to make my own.

This only takes a little practice and some suitable subject matter. Go through some dry runs first, with the camera on a tripod you take along or on a firm substitute support found on the spot. Practice zooming smoothly from the longest focal length to the shortest, or vice versa, with the camera set at a suitable slow speed, perhaps 1 second. Because a long-enough time is needed to do the zooming, such shots are often taken at night or in low-enough light.

2
FILMS

COMPACT, BUT WHAT'S INSIDE?

I like to save space by removing each roll of Kodak 35mm film from its cardboard box but not from the film can. This way film takes up less room in my bag but is still protected. What's the best way to mark the plastic cans for fast identification of what's inside?

People do this in different personalized ways. Some simply write on the can, if this is possible, often using an indelible marker or pen. And this works well on the gray, slightly rough tops of some Kodak cans. But if you write on other surfaces, check to see that the writing can't smudge. Other photographers often use pressure-sensitive labels that will adhere firmly to the top and sides of each can. These can be small colored dots that match film cartridge colors—such as green for Tri-X or magenta for Plus-X. However, if film cartridges have the same identifying color (as red for Kodachromes or blue for Ektachromes), and you use more than one having the same color, you need to identify further. One choice is to use white self-sticking labels and write on these, giving film name and speed. Or you could select a color-coded label and add the necessary written matter. Pick a system that suits you best.

KEEPING IT COOL

I've been told it is a good idea to put unused black-and-white film in the freezer to keep it for several months before it is used for general-purpose shooting. Is this really true?

Not by any means. It is most commonplace for photographers to use room storage for black-and-white film in our more temperate climes. However, refrigerator storage is advisable for extremely long keeping or for adverse storage conditions, such as high temperature, to retard normal deterioration or change. In such cases you might store factory-sealed black-and-white films on a lower refrigerator shelf where temperature is under 50°F for storage periods up to 12 months. It is not necessary to resort to the freezer and 0°F unless you plan to store film for several years.

But some photographers who want minimum change for scientific purposes do this even though film is used much sooner. Either way, since film is also affected by high humidity, leave the package unopened so the film will remain surrounded by the low-humidity air packed with it. Also allow enough warm-up time, such as an hour (for a 35mm cartridge standing alone), for each 25°F rise in temperature.

A MATTER OF CONTRAST

How do black-and-white films differ in contrast?

Some have a higher inherent contrast than others. In general, high-speed panchromatic films have somewhat lower contrast while slower films have higher contrast. However, these differences are not as great as they used to be. General-purpose films fall between these extremes. It is important to remember that exposure, development, and the relationship between them also are important factors in determining the contrast of a negative.

FAST FILM FOR EVERYTHING?

Why not standardize on the fastest black-and-white film available? Then you become accustomed to working with it, and you always have its high speed at hand for occasions when you need it.

If all or nearly all your pictures are taken by available light under very difficult circumstances, standardizing on a high-speed film probably is desirable. Slower films offer advantages, however, which make them desirable when you don't require high speed. They may provide finer grain, wider exposure latitude, greater sharpness, more contrast, or other qualities which are of use to you.

FOR SHARPER IMAGES . . .

What makes one film capable of producing sharper pictures than another?

Several factors. Grain structure is one. Thickness of emulsion is another. The film base is a third. An emulsion of even the finest grain will produce sharper pictures if it is coated in a very thin layer because there is less opportunity for light to become diffused by bouncing between the

silver particles in printing. Likewise, a thin base diffuses the light less than a thick one.

GRAIN, CONTRAST, SHARPNESS

For sharp pictures, should I always use an extremely fine-grain film?

Not necessarily. The thing we call sharpness is only partly dependent upon grain. It also is affected very much by contrast. Fine detail may fail to stand out in a negative, however fine its grain may be, and yet may be brought out in a negative of coarser grain that has sufficient contrast.

AGAINST THE GRAIN

Why do some photographers worry so much about grain in their pictures?

What we call grain is the visual evaluation of the grouping of silver particles on a print. The nature of this depends mainly on the physical granularity of the negative and its density. Some films produce a negative with an inherently finer grain structure than others. Grain affects the sharpness of a picture and the amount of detail it is capable of rendering. Like contrast, it is affected by exposure and development as well as the nature of the emulsion itself.

ACCURACY IN EXPOSURE

If I know the manufacturer's rating for my film and use an exposure meter, will this guarantee perfect exposure?

Generally you will get good results with color if your camera and meter are in good working order. Exposure ratings for black and white are best used as a starting place for making your own tests to determine the film rating that will give the results you want when taking pictures with your own particular equipment and techniques. With either color or black and white, good pictures also depend on correct use of the exposure meter and exposing for the most important picture areas.

THE SKY TURNED BLACK

What film is used to take unusual black-and-white pictures that make the sky appear almost black, and green foliage almost white?

This is the effect you get with infrared film, which is sensitive to the infrared rays that lie outside the visible portion of the spectrum. It is also sensitive to blue light. For general shooting outdoors, use a medium-red filter like the Wratten 25(A); a deep-red filter is recommended for the maximum infrared effect. Both cut out the blue and allow infrared rays (and sometimes extreme red ones) to make the picture.

USING INFRARED FILM

What are the uses of infrared film? And is any special equipment needed?

The amateur most often is intrigued with the striking pictorial effects it produces. Other uses are in scientific and medical photography, and in aerial photography for the penetration of haze and detection of camoufl-age. Generally you need only a camera that is opaque to infrared rays, infrared film, and a filter that absorbs light in the ultraviolet, violet and blue end of the spectrum.

IR FOCUSING

What special precautions does infrared require?

The camera must be impervious to infrared radiation, and in critical work focus must be adjusted for infrared if there is no special infrared focusing mark. Try extending the lens about one-quarter of 1 percent of its focal length beyond the setting at which it is correctly focused for ordinary photography by white light. Even if an infrared focusing mark is employed, always stop down as much as possible.

WHEN TREES APPEAR LIGHT

Why do some trees appear extremely light in infrared photographs?

Chlorophyll reflects infrared radiation quite freely while it absorbs white light. Thus green leaves appear lighter in infrared pictures than they do in ordinary photographs. There are differences between species

of trees, too. The flatter leaves of deciduous trees appear much lighter than the needles of conifers. These differences make it possible for an expert to identify the trees that make up a stand of timber by means of infrared aerial photographs.

THE INVISIBLE MADE VISIBLE

Is infrared film sensitive to ordinary heat?

It is. You can use the "light" of an electric iron or other source of heat to take pictures without any visible radiation. Exposures must be quite long unless you are interested only in photographing the heat sources themselves.

GETTING INTO IR

My main interest is in practical infrared photography, both color and black and white. Is there any good printed matter on the subject?

One very interesting publication on the subject is Kodak's *Applied Infrared Photography* (pub. no. M-28, soft cover), which provides a broad range of information. Subjects covered include equipment and materials, indoor and outdoor shooting, lighting, copying, photography of scientific specimens, photographing in darkness, law applications, photomacrography, photomicrography, and photographing infrared luminescence.

RATING TRI-X AT 200

Is it really a good idea to expose Tri-X Pan film at a rating of EI 200 rather than the usual ASA 400?

This certainly can be a wise thing to do if the entire roll of film is to be exposed in rather contrasty light, and you wish to reduce contrast. Try exposing at 200 (which is the equivalent of opening up one stop from the normal ASA 400). Then reduce development time about 30 percent for the EI 200 exposed roll. This way you compress the tonal scale more, so the resulting images will be a lot easier to print.

CLEANING BULK-LOAD CASSETTES

I've heard that cassettes used for bulk loading of 35mm film often get dirty. How do you clean the lips to make sure no particles of dirt get embedded there? Or should you throw the cassettes away instead, after a few uses, rather than fool around with them?

Lots of photographers have different answers here. Some vacuum the plush lips with a small vacuum tool to draw out dirt or grit. Others blow compressed air at the lips to get rid of particles that might be damaging to film. Still a third alternative is to use one of the cleaning approaches mentioned, but to discard the cassettes after a specific number of uses. Conservative souls often get rid of cassettes after using them only four or five times. And when jobs are very important, do as many professionals do—don't take any chances. Buy freshly packaged film.

DELAYED DEVELOPING

Is there danger in putting your camera away for several months with a partly exposed roll of film in it?

With ordinary black-and-white films, this is not likely to result in noticeable damage unless the camera is stored where it becomes excessively hot. The undeveloped image in color film is much more susceptible to deterioration, particularly when temperature and humidity are high. Hence it is safest, particularly in summer, to have color films developed as soon as is convenient after exposing them. If this is impossible, store film on the bottom shelf of the refrigerator. Make sure film is protected from moisture by a plastic bag or some other container. Some photographers include dried-out silica gel to absorb moisture and keep the film dry.

SENSITIVITY TO RADIATION

Will anything except light itself produce an image on film?

Films are sensitive to different types of radiation as well as visible light. Among them are ultraviolet and atomic radiation. They also are affected by X-rays, by certain chemicals in the air or in processing solutions, by physical abrasion, and by pressure from sharp edges such as a fingernail.

APPEARANCE OF COLOR NEGATIVES

Why do color negatives look so unusual?

Their light and dark tones are reversed in relation to the original subject matter, as is the case with any black-and-white negative. In addition, the colors are reversed. Each hue is represented in the negative by its complementary color. Thus black appears white, and red appears cyan or blue-green. On top of this, Kodacolor negatives have a pronounced overall orange color. This is because of two color-corrective "masks," one reddish and one yellow, incorporated in the film itself. These colors only appear during development.

JUDGING COLOR IN NEGATIVES

Can I tell how a picture will print by inspecting it as a color negative?

Not very well. You can tell how sharp it is and whether detail is visible in the shadows, and with experience you can learn to recognize serious color distortions. It is impossible to tell by inspection, however, whether minor color irregularities exist.

ELIMINATE THE VARIABLES

How can I get more uniform color pictures? I keep careful track of lighting and exposures, but I keep noticing slight variations I can't explain from time to time.

The secret of uniform quality is elimination of as many variables as possible from the entire photographic process. If you have already got your exposures pretty well under control, you can score a gain by standardizing operations for a particular batch of film. If you're really critical, you can notice the difference if you buy a quantity of film of a specific emulsion number, make a series of tests with it, and then use it consistently.

A HOT PROBLEM

I use mailers for sending in my Kodak color-slide films for processing. What is a good procedure in the summer months to avoid unwanted film changes that can, I understand, result from having the film sit around in the heat too long?

One good step is first to put the film back in the can with air that is reasonably dry, such as air from an air-conditioned room. In fact, careful workers let the film sit in such a place for about an hour before putting it in the can and affixing the lid firmly. Then if it is hot and film must be kept for a day or so, those cans are stored in a refrigerator, often on a lower shelf. When you do mail the film, be sure to avoid having it sit and bake in a hot street mailbox. Instead, it is a very wise idea to take the mailer directly to your post office.

OVERALL COLOR CAST

Why do all the slides on some rolls of color film have a strong greenish cast?

It sounds like a problem of poor film storage, under conditions of too much heat or humidity or both. This is a common problem in warm climates, even if you buy fresh film that has been kept cool. So keep unused film in the refrigerator on one of the lower shelves. It's not necessary to use the freezer. But be sure to get the film to the processor quickly. Otherwise, during the interim, keep it cool and dry in the refrigerator after exposure. For this purpose, just enclose the film in its can in dry air (like that from an air conditioner) before placing the can on one of the refrigerator shelves. If you mail film in for processing, do this so the film won't fry in a sunbaked mailbox: mail at night or take it directly *into* your local post office.

JUST TOO MUCH CURL!

I prefer to mount my own Kodachrome slides, so I order "unmounted" strips from the Kodak processing lab. But these rolls have a pronounced curl, and that makes mounting somewhat difficult. Can you suggest how to remove the curl?

Considerable help can be obtained by winding the film emulsion (or duller) side out. Handle it carefully, of course, and only by the edges. Wrap some clean, plain protective paper around it, about the width of the film, then put a flat rubber band around this. It's best to leave the film this way for several days. After this time, mounting should be a lot easier. Remember, too, that transparencies tend to flatten a bit after mounting.

OF FRAMES AND BULK LOADING

How much regular film can a bulk-loaded 35mm cassette hold safely? I want to achieve extended shooting capacity without moving to half-frame 35s.

We advise not going much beyond 40 full-frame exposures with any general-purpose film (Tri-X, Plus-X, etc.) that has a tri-acetate base. If there is too much film on the spool, it will not travel easily, and you will get cinch marks. Also, processing reels are made generally to accommodate up to 36 full-frame exposure; so even with 40 or 41 shots, there will be a loose end to wind around the reel. If you need many more shots in a real hurry, try working with two full-frame bodies loaded with the same type of film.

HOW THE NUMBERS GET THERE

Are the frame numbers on the edges of 35mm film included in the film as latent images during manufacturing, or are they registered on the film when it is exposed in the camera?

You're right the first time around. The numbers (as well as the film name) are exposed on the film by the manufacturer. And these latent images are made visible when you process the film.

3
EXPOSURE

SOME METER ABC'S FOR BEGINNERS

What is the difference between incident- and reflected-light metering?

The idea of reflected-light metering is no hang-up for most people. It is clear that such readings are made of light actually reflected by the subject. And a light-colored subject will reflect back more light than a dark one. On the other hand, incident-light readings measure the light *falling on* the subject. And the reading is the same regardless of the subject's reflectivity. Only a few meters are designed primarily for making incident readings and feature a white hemispherical light collector. But a great many reflected-light meters permit making incident readings via a white converter that you slide over the regular cell.

Some basic rules of incident-light metering are as follows: First, if light on the subject and at camera position are the same, simply hold the meter out in front of you, with the cell aimed back at where the camera will be. Second, if light on the subject and camera position are different, you need to go up to your subject to make your incident-light reading, with the cell aimed back at where the camera will be. Third, with strong, bright sidelight, many photographers aim the cell halfway between the sidelight (sun or other) and camera position. Note also that with top or side light, some of the incident-light converters found on reflected-light meters are more efficient than others.

WHEN COMPROMISE EXPOSURES ARE INEFFECTIVE

Is it possible, even when taking careful reflected-light readings of different subject matter, to find a situation where a compromise exposure won't work?

The wedding photographer faces this problem often, when he shoots a picture of the bride in white cutting a white wedding cake with the bridegroom beside her attired in black. Working under studio conditions, the photographer can put more light where he needs it and hold illumination back in other areas. Taking candid flash pictures, however, leaves little room for control, and usually the black suit suffers.

32

READ THE METER RIGHT

Recently I took some close-ups, holding my reflected-light meter close to the subject matter to make sure of reading only the important part of the picture. They were overexposed. What could have happened?

One danger in holding the meter close to the subject is that the meter's shadow or the shadow of your arm and hand may influence the reading you get. Perhaps that happened here.

EXPOSURE FOR BACKLIGHTED SCENES

How can I take a reflected-light meter reading of a backlighted scene I want to shoot? When I point the meter at the scene, its pointer goes all the way to the end of the scale—but I know that can't be right.

Aim the meter as you would at any scene, but shield its cell from the direct rays of the sun just as you would shield your camera lens in taking a backlighted picture. This will give you a reading for the subject matter you want. Generally an incident reading is preferred for backlighted subjects when you want full exposure in the shaded areas.

READING AT THE PROPER ANGLE

Should a reflected-light reading always be taken from the camera position?

Not at all. If only a small part of a scene is of vital importance to you —like the dress worn by a model in a fashion picture—you probably will want to walk toward the subject and take your reading from that detail itself. Be sure to aim the meter at the subject from the same angle that the camera sees it.

GET UP CLOSE WITH YOUR METER

How should an incident-light meter be held?

You take the meter into the scene itself and make your reading with the meter held at the subject position and the light receptor aimed toward the camera.

DECIDE WHAT'S IMPORTANT

Is it necessary to sacrifice objects at one end of a scene's brightness range in order to get satisfactory exposure at the other extreme?

Often it is desirable to favor the highlights at the expense of the shadows or the other way around. This is particularly true in color, where the brightness range of a scene often exceeds the latitude of the film. For best results, compute the exposure for the parts of the scene that are important to you.

ON OVERALL METER READINGS

Some photographers take many meter readings of objects in a scene before they take a picture. Why not just take one overall reading?

They are checking to see that important parts of the scene fall within range of the film's latitude and to determine what exposure will be best for details that are important.

MINIMUM OR MAXIMUM EXPOSURE?

Where a scene can be exposed satisfactorily in black and white over quite a range of exposures, is it better to lean toward overexposure or underexposure, or to compromise between these two extremes?

Photographers who work with 35mm film usually prefer to keep their exposures near the minimum required for printable negatives, since this technique is likely to give better quality. Those who use larger film sizes, particularly sheet films, are more likely to work toward the middle of the tolerance. They don't need the extra ounce of sharpness and fine grain gained with minimum exposure, and they enjoy the safety factor that average exposures provide.

BRILLIANCE AND CONTRAST

How can correctly exposed pictures of the same scene look so different when taken in bright sunlight and on an overcast day? Doesn't adjusting the exposure compensate for the difference in light?

Exposure adjustments can compensate for differences in the quantity of light, but not in its quality. The brilliance of sunlight is inherently more pleasing than the dullness of a cloudy day. Increasing your exposure will enable you to get a printable picture when the sky is dark, but it won't put in the bright highlights and contrasting shadows you would get on a sunny day.

GETTING THE RIGHT COMBINATION

Why would anyone want to use different lens and shutter combinations to achieve the same exposure?

To stop movement in action pictures or to get great depth of field. For one situation the meter reading may show different lens-opening and shutter-speed combinations:

1/250	1/125	1/60	1/30	1/15	1/8
f/2.8	f/4	f/5.6	f/8	f/11	f/16

All will admit the same amount of light. But, if the photographer wants to arrest movement in fast action, he will choose an exposure at the end of the scale near 1/250 second at f/2.8. If he is more concerned about getting great depth of field, he will prefer an exposure near 1/8 second at f/16, provided his camera is on a tripod. Under average conditions, with no particular problems, he might select an equivalent combination about midway between these two extremes—perhaps 1/60 second at f/5.6.

COMPROMISING ON EXPOSURE COMBINATIONS

What can I do when a picture requires both a high shutter speed to stop action and a small lens aperture for great depth of field?

This is where we have to compromise, selecting the combination most likely to produce satisfactory results. It may be necessary to shift to a different viewpoint from which the scene requires less depth or to shoot at a time when less speed is required to stop the action. Working with faster films makes a wider range of selections possible, and sometimes depth and speed factors dictate the use of these films even though the light is ample for proper exposures with much slower emulsions.

LOST IN THE FOG

How do you set a camera to take pictures in fog?

When the fog is dark and solid, use about three stops more exposure than normal. If it is very light, with sun shining through and some clear sky in sight, use one-half stop less exposure than for normal sunlight.

SHOOTING WHEN AIRBORNE

Are special precautions required to get good exposures from the air?

At altitudes below 1,000 feet you can use the same exposure you would for taking pictures on the ground. At higher altitudes, decrease exposure until you have closed down the lens one full stop at 4,000 feet. Because of the plane's speed and vibration it is desirable to use a very fast shutter speed for pictures at landing and takeoff, and this, of course, calls for a correspondingly wide aperture.

UNDEREXPOSURE SYMPTOMS

What makes black-and-white negatives come out very thin, so that prints made from them appear dark and lack detail in middle tones and highlights?

This is the result of underexposure. If the detail you want can be seen in the negative, even though it is too weak to print, a better print can be made after intensifying the negative. Best results, however, can be obtained only by taking the picture over again with proper exposure.

HARD-TO-PRINT NEGATIVE

What makes a negative come out very dense and flat, so that it takes a long time to print through it?

This is overexposure. Such a negative can be chemically reduced, by removing a portion of the silver from the image to make it easier to print.

REDUCING EFFECTIVE EXPOSURE

I got caught outdoors on a brilliant day, my camera loaded with extremely high-speed film. All my pictures were overexposed, even when I used my smallest lens opening and fastest shutter speed. What can you do in a case like this?

Using any filter you happen to have will cut down the exposure. A medium-yellow filter with a 2X factor, for example, will have the effect of reducing your black-and-white film speed to one-half its rated number. Other colored filters will produce their own pictorial effects in black and white, which you may find desirable aside from the advantage of exposure reduction. With color film, use neutral density filters which are designed to hold back light of all colors equally so pictorial effect is unchanged. They can also be used with black and white.

BALANCING LIGHT RELATIONSHIPS

How is an exposure meter used for lighting in the studio?

Sometimes a photographer wants to maintain a specific relationship between highlights and shadows. In a color photo he may want to keep them within a very close highlight-shadow ratio like 2:1 or 4:1. He first sets up his main light for the basic exposure he wants to use. Then he moves additional fill-in lights nearer the subject or farther away, while taking meter readings, until he gets the lighting balance desired.

FILL-IN FLASH WITH SUNLIGHT

What exposure is required when you use flash as a fill-in for pictures primarily lighted by sunlight?

Base your exposure on the sunlight. Then place the flash at a sufficient distance from the subject so it will require one or two stops more exposure than the sunlight (but doesn't get it). This sometimes requires removing the flash from the camera to get it far enough away or shifting to smaller bulbs or placing a handkerchief over the reflector to cut down the flash intensity. The flash should never be allowed to be so strong or so close to the subject that it will overpower the daylight.

CATCH A RAINBOW

What is a good exposure to use for photographing a rainbow in the sky?

Use the same exposure you would for the scene in normal sunlight. Slight underexposure of about one-third stop will make the colors of the rainbow appear more saturated.

WHEN THE SUN IS SETTING . . .

How do you expose to capture colorful sunsets?

Base your exposure on the sky and clouds, taking a reflected-light reading with the meter tilted up toward them. This will make objects on the ground appear in silhouette.

TOO LITTLE VS TOO MUCH EXPOSURE

In taking color pictures, is it best to have any error you make fall on the side of overexposure or underexposure?

This is a matter of taste. Many photographers prefer results that others call slightly underexposed—with shadows appearing deep and most hues somewhat more intense than in the original scene. Overexposure has the opposite effect, making colors appear lighter than in the original scene. If you have a brilliant projector and a good screen, slides made with slightly less than normal exposure probably will appeal to you.

SCENE WITH SPLIT ILLUMINATION

How can I expose correctly for a scene which is half in bright sunlight and half in shade?

Sometimes you can't! If you expose for the shadow area, objects in sunlight will be overexposed, while if you expose for the sunlight, things in the shade will be lost in dark shadows. Sometimes you can compute a compromise exposure, halfway between the requirements of the two areas, which will work if the brightness differences are small enough to fit within the exposure latitude of your film. Otherwise, it is best to expose for the most important area, such as skin tone, and let the rest go.

You can also move subjects out into the sun, wait for the sun to change position or even wait for an overcast day when the contrast of the scene is lowered. Sometimes you can use flash to lighten the shadow portion of such a scene, if the area isn't too big for the flash to cover.

CONSISTENCY IN OUTDOOR SHOOTING

I have exposed three rolls of color film with my new camera, and I find that I get much better pictures indoors than out. Why should this happen?

There's a simple explanation. When you shoot indoors, you are probably using a flash unit that delivers a measured quantity of light. This quantity is always the same. As long as you set the camera correctly for that unit, the film you are using and the distance from lamp to subject, you will get well exposed pictures every time. However, the intensity of daylight varies from hour to hour, and you may have to compensate for these changes to get consistent results outdoors, even with an automatic-exposure camera.

AUGMENTING OUTDOOR CONTRAST

How can I get more contrast in black-and-white pictures taken on an overcast day?

Use exposure and development for contrast control. In this case, underexpose your film by one stop when you take the picture, and then overdevelop by extending the developing time by one third. The resulting picture will have more snap.

EXPOSURE PROBLEM IN BRILLIANT SUNLIGHT

How can I reduce the contrast of extremely wide range scenes? I take black-and-white pictures on the desert, where a subject like a truck comes out black if I expose for the sand and sky, while the rest of the picture is burned out and grainy if I expose for the truck. I send my film to a custom processing firm.

First, keep the lighting itself as flat as you can. Select an angle that shows the sunny side of the truck, for example. Take advantage of locations where reflections from the sand help illuminate the shadows. Determine a compromise exposure by measuring both highlights and shadows with your meter. Then deliberately open your lens two stops to take the

39

picture. This overexposure will call for cutting development time by somewhat more than one third—the exact amount will depend on the characteristics of your black-and-white film and the developer employed. Tell your custom photofinisher how much you have overexposed the film and the result you want, and he will know how much to modify his processing procedure.

DEFINING FILM ABBREVIATIONS

What difference, if any, is there between the terms ASA film speed and EI (Exposure Index)?

Sometimes there is no difference, but sometimes there is a lot. To begin with, the published ASA is the film rating as determined by the manufacturer according to the standard tests set forth by ANSI (American National Standards Institute Inc., formerly American Standards Association). Next, the exposure index (EI) may work out to be the same. But it can be different in various circumstances. Here are two common situations, although there are others. One is when actual shooting shows that a personalized (slightly higher or lower) rating may be best for you and your equipment. Another is when you use a special developer that will permit a considerably higher exposure index than the published ASA, or if you develop for a somewhat longer time with some suitable standard film developers.

ASA, BY ANY OTHER NAME . . .

What does the term "DIN" stand for? It's a special scale on my camera.

This is the German system of rating the sensitivity of film to light; the letters stand for "Deutsche Industrie Norm" (German Industry Standard). Here's a simple way to remember equivalents: Bear in mind that DIN 21 equals ASA 100; then remember that adding 3 in the DIN system doubles the rating, while subtracting 3 halves it. The accompanying chart of useful equivalents makes this clear. Note the figures in bold type. Half DIN 21 (ASA 100) is DIN 18 (or ASA 50), while twice DIN 21 is DIN 24 (or ASA 200), etc.

DIN	ASA	DIN	ASA
10	8	22	125
11	10	23	160
12	12	24	200
13	16	25	250
14	20	26	320
15	25	27	400
16	32	28	500
17	40	29	650
18	50	30	800
19	64	31	1,000
20	80	32	1,200
21	100	33	1,600

CHECKING CAMERA/METER ACCURACY

Can you suggest some home tests to determine if the dual metering system in my 35-mm camera is functioning properly? I see little difference in either spot or overall average readings in many cases.

You can do several things here. The most obvious step is to check your meter against another of the same type known to be accurate, testing overall average against overall average, etc. Use an evenly lighted white wall to negate angle differences. If possible, check at low, medium, and high intensities.

Another way to check differences is by putting up a circular, suitably large piece of very dark gray paper on a white wall. Then stand back and aim your camera so the marked area for your spot reading falls well within the dark gray area. Obviously, this spot reading should give you a noticeably fuller exposure than the overall average reading that includes a lot of white wall alongside the gray area. This setup also lets you check the cutoff of your spot system. Move the camera so the marked spot in your finder approaches the margin of gray and white. When the line is just within the gray, your spot reading should be unchanged if cutoff is good. But as you move off and into the white area, the needle should go up. Good cutoff is important, especially for a dark subject against a white or light background.

OVERRIDING THE METER

When I photograph back-lighted landscapes or marinescapes and want some detail in shadow areas, how do I know how much to increase the exposure indicated by the camera's built-in metering system?

Metering systems vary, so there is no pat formula. The effect desired will depend, of course, on what the individual photographer really has in mind with a particular scene. For these reasons you have to take a lot of extra shots, varying the degree of increased exposure, until you gain enough experience.

One approach is to try a meter exposure first. Then note the difference as you make about three or four more shots where you double the amount of exposure each time. (For each of these, either open the lens one f-stop, or move to the next slower shutter speed.) After a little while, you'll soon get the hang of things and be able to home in more quickly.

AN OLD NOTION RECALLED

What is the old-timers' rule of thumb for bright, sunny days that relates the film speed to the exposure?

It's just that the basic exposure for bright sun and average subject matter is 1/ASA at f/16. So at f/16 under these conditions with ASA 125 film your shutter speed would be 1/125 second, while for ASA 400 film it should be 1/400; but you use 1/500 which is close enough. In other words, round off figures to match shutter speeds, using 1/60 with ASA 64 film, 1/30 for ASA 25 film, etc.

Remember also to use equivalent exposures if these are suitable. And halve the basic bright-sun exposure when you photograph very light subjects such as beach and snow scenes.

FOOLING THE AUTOMATION

I've heard that it is possible to take a close-up reading with an automatic camera, then hold that reading, move back, and then depress the release all the way to make the exposure. How can I tell if my camera permits this? I don't have a camera manual.

Try pressing the shutter button gently part way down, and keeping it there while you view the subject through the viewfinder. Then note where the needle (that is usually present) falls. If it stays in the same

place, even though you aim the camera at a much brighter or dimmer area, you are holding the initial reading. This is an extremely useful technique in a variety of cases. You may, for instance, want to hold the reading for a shaded face while you back off into bright sunlight to shoot. Or you may want to take a close-up reading for a light face, but back off and hold the reading so a dark surround won't cause you to overexpose the subject's features. Just be gentle in your holding, and press the release button all the way down to take the pictures after you return to shooting position.

EXPOSURE TERM DEFINED

What does the term "EV" mean?

The term stands for exposure value and is a simple way of talking about a specific amount of exposure and, therefore, about a specific amount of light required. The numbers may range, for example, from as far as -8 on the low end to 24 on the high side. But in each case a higher number indicates half the exposure, while going to the next lower number indicates twice the exposure. Obviously, this is a far more convenient way of expressing matters than giving all of the equivalent exposures for a given situation.

For example, EV 12 stands for exposures such as 1/30 at f/11, 1/60 at f/8, 1/125 at f/5.6, etc. But as we move up to EV 13, the group includes 1/30 at f/16, 1/60 at f/11, 1/125 at f/8, etc. And these EV 13 exposures allow half the amount of light to reach the film compared to the ones used for EV 12.

FLASH AND FOCAL LENGTHS

If the guide number for an electronic flash is 60 with my normal (55mm) lens, what would it be for a 135? Would it also apply to zoom lenses?

By definition, a guide number (GN) is just the product of multiplying the f-stop (used) times the distance (from flash to subject). And it is designed for "typical" subject matter in rooms of "average" size with an "average" amount of light-reflecting surfaces. Theoretically, a good GN for your normal lens should be the same for other lenses, like long ones. Most likely, you'll be farther away from the subject with a long lens, and hence would use a wider aperture, derived by dividing the footage into the same GN. However, if transmission loss with your longer lens is

43

noticeably greater than with your normal one, you need to adjust the GN or, simpler still, change the lens opening. Sometimes this is necessary with zoom lenses, where loss of transmitted light can be a factor because of the large number of lens elements. You'd probably be aware of this from ordinary daylight shooting.

FINDING THE GUIDE NUMBER

While in Japan, I bought a small electronic flash unit. I've lost the instructions and list of guide numbers. Can you tell me how to find the right one for ASA 25 film?

A simple procedure will see you through. Just take a series of shots of the same "typical" human subject 10 feet away, in an "average-sized" room with a "normal" ratio between furniture and white or light walls. Vary your aperture only; specifically, change the lens opening half a stop at a time for each shot. Start near your widest setting, and close down by half-stops to f/5.6 (or smaller, if you suspect the unit is fairly powerful). After processing, select the best slide visually. Then multiply the aperture used in this shot by the footage (we used 10 feet for convenience), to get your guide number. If the best shot was made at f/2.8, then 2.8 × 10 provides a guide number of about 28. Put an identifying card in each shot, or keep track of the lens openings used. The approximate half-stop changes are *1.4*, 1.7, *2*, 2.4, *2.8*, 3.4, *4*, 4.8, *5.6*, 6.7, *8*, etc. Apertures in italics are familiar marked values on most lenses.

BASIC FLASH TERM DEFINED

Will you please come to my aid and explain what a guide number means?

Simply stated, a flash guide number is just the f-stop you use multiplied by the flash-to-subject distance. This lets you figure your exposure. For instance: if you have a guide number (GN) of 110, and the flash is 10 feet from the subject, you divide 10 into 110 to get the right f-stop, here f/11. Or you could divide a chosen aperture into the GN to get the right flash-to-subject distance to use. Generally, a built-in dial on the flashgun simplifies the arithmetic. Just set the camera as indicated, between f-stops if necessary. But remember, this system was devised for average rooms with an average amount of white reflective surfaces. For smaller, white-walled rooms, such as bathrooms, close down about one f-stop. Open up one stop for many larger rooms. And for gymnasiums or other nonreflec-

tive areas, you may need to open up much more, say three or four stops. Note also: for flashbulbs, the guide number varies with the shutter speed used. With electronic flash, however, because the flash duration is usually shorter than even the fastest camera shutter speed used, the same GN applies at any suitable shutter speed.

EXPOSING WITH FILTERS

I am using a separate exposure meter. In determining exposure for black-and-white film with filters can I simply divide the ASA by the filter factor, reset the meter to the smaller film rating and read the compensated exposure directly?

Yes, you can. Suppose your filter factor is 2X, which stands for an exposure increase of one f-stop. If you don't want to make this adjustment manually, by opening up one stop or moving to the next slower shutter speed, go the dividing route instead. In this case, you would simply divide two into your film rating—say 400 for Tri-X Pan. Then reset the meter to the resulting 200 and read your compensated exposure directly.

This approach is especially convenient if you are using the same filter for quite a lot of shots one after the other, or if you don't know what the factor stands for. For example, if you don't know that a needed 6X factor means to increase exposure two-and-two-thirds stops (or the equivalent), simply divide 6 into your film rating. With Tri-X, 6 into 400 gives you 66, so you would set the meter to the nearest ASA scale figure, which is 64, and read directly.

Users of through-the-lens-metering cameras please note, however. The above is for separate meters. Just the same it pays to know what filter factors mean so you can check if the through-the-lens-metering system is coping properly. For your guidance then, a 4X factor indicates the need for a two-stop exposure increase while 8X indicates a three-stop increase (or the equivalent in each case). So you might take readings with and without the filter in place, and see if the reading through the filter is somewhere in the right ballpark.

CHANGING FLASH EXPOSURE

Once you know the right flash guide number for "average" conditions, how do you change the exposure for smaller or larger rooms?

It's best to run a few tests. But try closing down the lens from a half to one f-stop more for smaller rooms with light walls. With "average-

45

sized" rooms that have darker walls, or less than an average amount of light-colored reflecting surfaces, try increasing the aperture an equivalent amount.

FILL-IN FLASH INDOORS

How does one use electronic flash merely to supplement contrasty ambient light indoors, rather than replace it? I'm interested in this for home portraiture.

Just forget all about basing the exposures on guide numbers. Instead, set your camera to the right exposure for important highlight areas of the subject's face. Then, provide a fill light that is substantially weaker than facial highlight areas by bouncing light from your flash high off a white wall behind you. To weaken the flash sufficiently (and to reduce shadows moderately), try covering the flash head with numerous layers of white handkerchief or white cleansing tissue, so that the light will really be subdued.

For example *only:* a Tri-X exposure for the lighted right side of a face might be 1/30 at f/4 in a medium-sized living room with the subject about 5 feet from the camera. Then if there is a white wall or corner about 10–15 feet behind you, try to bounce the light from a small electronic flash high up in that direction, using six to eight covering layers of handkerchief or tissue. This will fill the shadow side somewhat but let the existing light dominate. You will soon get the hang of this with a little experimentation and learn just how much fill-in is needed in each case. Use more covering layers in a smaller room and, naturally, less in a larger room.

ON TO BOUNCE FLASH

What's the rule-of-thumb for getting the right exposure with bounce flash? Do I merely open up two stops more than for direct flash?

Not by any means! That two-stop myth fails badly at many commonly used shooting distances.

The only valid rule is as follows: Find the footage from camera to ceiling bounce-point and back down to the subject. Then divide this total into your flash guide number (the one used for direct flash), and open up one f-stop more than the amount indicated to take care of light absorbed by a white ceiling.

USING FILL-FLASH WITH DAYLIGHT

I want to use electronic flash for fill-in light in bright daylight. Can you tell me how to go about it when I am restricted to 1/60 second or slower for synchronization? Is there any convenient way this can be reconciled with the requirements of normal daylight exposure?

Part of the answer is to shift to a slow film such as one in the ASA 25–32 range. Then typical bright sun exposures might to 1/60 at f/11 or f/16 (or their equivalent). These are quite workable for fill-in flash—then use the flash gun at the right distance for fill purposes. If you prefer not to shift from a faster film, you can reduce its effective speed by covering the lens with a neutral density filter. Cut the normal film rating in half with an ND 0.3 filter, divide it by 4 with an ND 0.6, and divide it by 8 if an ND 0.9 filter is used.

In either method, figure flash-to-subject distance by dividing the f-stop of your daylight exposure into the guide number of your flash for the slower film or reduced film rating. This sort of fill will be quite full. To cut its strength in half, cover the reflector with one layer of a clean, white, man's handkerchief; to quarter the effect, use two layers.

HANDKERCHIEF OVER FLASH

How much light reduction will I get if I cover my flash with a layer of white handkerchief or with a sheet of white cleansing tissue?

One layer of a clean, typical, man's handkerchief tends to reduce light from a flash by the equivalent of about one f-stop. In other words, it cuts the light about in half. You will get approximately the same amount of light reduction with some brands of white facial tissue (such as Kleenex), using one typical double-ply layer.

EXPOSURE FOR SILHOUETTES

I've been told to expose just for the light background to make a full silhouette of a subject that is lighted either from the rear or side rear. But how much do I open up from this reading to get a partial silhouette?

That depends on the effect you wish, the type of subject, and the lighting. First make your reading of a light area like a white wall or the sky outdoors. But avoid aiming the meter system at bright lights or at the sun. Then try various exposures where you open up the equivalent of

one, two, and three f-stops respectively. Such partial silhouettes are often most effective if there is some part of the front side of the subject that has highlights. It is also wise to use a lens hood for the exposures.

FLASH OUTDOORS

How is exposure calculated when using electronic flash for fill lighting outdoors?

In a simple way. First determine the right outdoor exposure for the subject, then divide the chosen f-stop into the guide number for your film and gun. The result is the distance at which the direct flash should be placed for a 2:1 (sun-to-flash) ratio. This is very pleasing with color. And you'll have no difficulty with a leaf-shutter camera that lets you synch electronic flash at all speeds. Focal-plane-shutter cameras, however, pose obvious problems, since the highest electronic flash synch often is 1/30, 1/60 or in a few cases 1/125, depending on the camera. It may be necessary to turn to a slower film or use a neutral density filter over the lens. These techniques let you set the right exposure on a bright day or permit shifting to a wider aperture, so the direct flash can be placed at a more suitable distance.

TRICKY SNOW EXPOSURE

How can I get good exposures of kids playing in the snow at a moderate distance? When I stand in shooting position and use the camera's match-needle reading system, too much snow area is included. And the resulting figures in my black-and-white negatives are considerably underexposed. Usually it isn't feasible to move in for good metering without disturbing the children's play.

Simply resort to the old substitute reading approach. A good, easy choice would be just to take a reading off of a similar subject, if one is nearby, in the same kind of light. But another solution that seems to work well is to take a reading off the palm of your hand when it is lighted the same as the kids' faces. Then open up one f-stop or move to the next slower shutter speed.

Getting this hand reading isn't difficult with match-needle metering systems. But it does call on you to hold your palm some 4–6 inches from the lens. Then if needles don't match, bring your hand back to adjust the camera. Next hold your palm out again and check. And so it goes until the reading is correct.

SPECIAL EXPOSURE CASE

What are the best ways to photograph lightning?

To photograph lighting at night, use a fast black-and-white or color film, and place the camera on a tripod or other firm support. Then close down one or two stops from maximum aperture for improved definition, set the camera on Time or Bulb and leave the shutter open for the duration of the lightning flash.

If you want to record several flashes occurring in rapid succession, just leave the shutter open the entire time. When intervals are longer, try covering the lens with a black card between flashes.

FOR FASTER SHOOTING

What is the approximate difference between an exposure for a bright, sunny day with blue skies and one in the shade of a building? It would help to know this so I could shoot faster when moving from bright sun on one side of the street to an area shaded by a building, perhaps on the other side of the street.

That depends, of course, on the depth of the shade. And you should train your eye to see these differences ahead of time. Often the shade exposure is four f-stops (or the equivalent) greater than the bright sun exposure. But in some cases, it is less, like only three f-stops more.

So when you are not actually taking pictures, practice taking meter readings until your eye begins to discern the differences in lighting. This will facilitate making "grab" shots.

DETERMINING GUIDE NUMBER

How can the guide number for a given electronic-flash unit and color film be determined by test?

Make a series of about eight or nine direct-flash exposures with the film, using a typical subject at a distance of about 10 feet. Choose an average-size room with a typical amount of furnishings and white wall space. Start at f/2 or f/2.8 (with wall units), then close down one-half f-stop for each subsequent exposure. After film has been processed (preferably by the manufacturer), pick the shot with the best exposure. Finally, to get your personalized guide number, multiply the f-stop used for that picture by 10 (feet). Approximate round-ed-off half-stop numbers (in case you need them) are between the con-

ventional f-stops in this series: 2, *2.4*, 2.8, *3.5*, 4, *5*, 5.6, *7*, 8, *10*, 11, *13.9*, 16.

Use the determined guide number when shooting with the same film in similar rooms. But note: You may need to stop down ½–1 f-stop more for small rooms with light walls. Or you may need to increase exposures suitably (by opening up the lens) in very large rooms or those with dark walls.

CHANGING GUIDE NUMBERS

Is there a simple mathematical way to increase or decrease flash guide numbers by the equivalent of various changes in f-stops?

This chart should be of help. Just *increase* guide numbers (GN) if pictures are consistently overexposed and *decrease* guide numbers if you get consistent underexposure.

To increase GN equivalent of	½ stop	1 stop	1 ½ stops	2 stops
Multiply GN by	1.2	1.4	1.7	2
To decrease GN equivalent of	½ stop	1 stop	1 ½ stops	2 stops
Multiply GN by	.8	.7	.6	.5

DECEIVING THE ELECTRIC EYE

How can I fool the meter of my rangefinder 35 camera when using a medium-yellow filter to darken blue skies moderately with black-and-white film or a medium-red filter to darken these skies more? Is there a way of adjusting the ASA setting? I need to know because the light sensor of my camera is not in the lens mount; therefore it is not covered by the filter.

Try the same approach used by some owners of hand-held meters, who want to get a compensated reading directly. Simply divide the filter factor into the normal ASA rating for the film, then set the metering system to that new number. For instance, with a medium-yellow filter where the usual factor is 2X and you are shooting with Tri-X, you'd divide ASA 400 by 2 and reset your meter to 200. Similarly, if your medium-red filter has the usual 8X factor, you'd divide 8 into ASA 400 and get a new setting of 50 to use for the same film. Just remember to divide the factor given

for your specific filter. There is some variation here. Also, use factors just as guides.

Naturally, owners of rangefinder 35s where the cell is covered by the filter often don't have to do any dividing at all. This is because such systems tend to take care of the exposure increase with the lighter-colored filters. They may not do the job sufficiently, however, with some darker filters (like the medium-red or others). Then it is helpful to know about factors so you can see if the system is compensating enough. If not, make adjustments as indicated. For instance, if your camera changes the reading by two stops for an 8X factor medium-red filter, simply get that extra stop worth of exposure by dividing the ASA number in half.

LOW-LIGHT EXPOSURE PROBLEM

I've heard about a way out in low-light situations if you can't get a definitive meter reading. It is to take a reading off a clean white card, and then adjust the reading suitably. Exactly how is this extra adjustment made?

This technique works fairly well in some low-light photography, letting you extend your metering range to some extent. And you can choose to adjust the reading in two different ways. One is just to divide the normal ASA rating by 5, then make your white card reading with the card held in the same lighting as your subject. (With ASA 400 film, therefore you would set the meter rating to 80 for the white-card metering.) The other is to leave the meter set at the normal rating (as 400 for Tri-X), and open up the equivalent of two-and-a-third stops from the exposure obtained by the white-card reading. Take your choice, based on convenience.

For the actual white-card reading, you can use a pure white card or heavy sheet of pure white paper (say at least 8×10) or the white side of one of the cards in the Kodak Neutral Test Card packet.

TO RUN OR TROT?

I like to include myself in some outdoor shots, often at a fair distance from my SLR 35 camera. However, on occasion I need more time to get into the picture area and get set than allowed by my camera's self-timer. What inexpensive alternatives do I have, except being faster?

If your camera features a self-timer that is set off by the shutter button, one simple alternative is to get and use a small accessory self-timer such

as the one shown. This can be attached just by screwing the Prontor-type tip (with its adjustable plunger) directly into the cable-release threads found in the center of the shutter release.

The lure of this setup is that you get two delays in succession. And this should work with most 35s having a shutter-button-release self-timer. The first delay (of perhaps 14–15 seconds) starts when the accessory self-timer is set off. When this time elapses, the unit automatically continues your delay time by setting off the camera's self-timer (that you previously set at-the-ready) to provide perhaps 10 or more seconds' delay. Then the exposure is made. And if plunger travel length is not too great, you will be able to advance film without removing the accessory.

Naturally, this basic approach is not suitable if your self-timer is independent of the shutter button. But then you might ignore the timer and explore the possibilities of a long (20–30 foot) air-type release, with a bulb for you to squeeze with your hand or other part of your body. Just learn to be ingenious about keeping the accessory out of picture sight. It also comes with a Prontor-type tip. But some cameras call for screwing an adapter over the shutter button, then screwing the Prontor-type tip into this.

SPLITTING ASA HAIRS

I often take a meter reading and shoot at the exposure given, then make extra shots one f-stop over and under. When I do this with Tri-X Pan film, am I actually changing the ASA from 400? If so, what ASA do I have in each case?

First, what you are actually doing is bracketing your exposures and leaving the meter set at 400. Next, it isn't generally considered that you are changing the ASA. However, when you give one stop more exposure than the reading indicates at 400, the exposure is the same as if you had set the ASA to 200.

Conversely, if you give one stop less exposure than the ASA 400 reading shows, you are really using an exposure that could have been obtained directly with the ASA set at 800. It may be helpful to understand this. But it's simplest not to change your ASA; just bracket when the situation requires it.

CONSERVING METER POWER

I have a through-the-lens metering SLR 35 camera that does not have an on/off meter switch. Is there any way to keep the battery current from flowing when it is not in use except to put the camera in its case or keep the lens cap on?

These two techniques still are good bets between shooting sessions. But the photographer who wants to shoot fast knows there are other practical ways of preventing light from reaching the cell or cells so the battery won't be drained. This is mostly a real problem in brighter light, such as outdoor daylight. But once the weather is cooler, you could just sling the camera strap over your shoulder and carry it under a loose-fitting coat for reasonable protection against light when not in use (if the coat is opaque). Simply swing the camera out front when it is needed. Such protection is also good for keeping the camera warm.

However, if you want to keep the camera outside in much more free-wheeling style, try these two techniques. One is to keep a covered arm over the lens. There is some possibility of light leakage with this method if you aren't careful. A somewhat better alternative is to face the lens firmly enough into your midriff between shots, and keep it that way with one of your hands. Just be sure you pick a soft area, free from buttons or zipper parts that could scratch the lens surface.

CDS METERS IN COLD WEATHER

I intend to take photos in very cold climates, well below zero. Is a special technique needed for light measurement with a cadmium-sulfide meter?

If your CdS meter is powered by a Mallory PX-13 mercury cell, change to Mallory's PX-625 (with a white gasket) since this gives far better cold-weather performance. Then use common sense. Despite the battery change, cold can affect other meter parts before it affects the mercury cell. Keep the meter warm by carrying it close to your body between shirt and jacket, for example. The same technique holds for the camera. Both meter and camera should be brought out for use only briefly.

FOCUS, SHAKE, OR . . .?

When my prints and slides aren't sharp, how can I determine if the cause is poor focus, camera shake or whatever?

You need to play detective and make some deductions. First see if *anything* is sharp. If nothing is, the odds are that you moved the camera

53

during exposure unless, of course, the focus was wildly off. Next, see what *is* sharp. For example, if you focused in front of the subject, you might be able to see how sharpness decreases along a sleeve or shoulder as you move visually toward the face. On the other hand, if the body and shoulders of a seated or standing person are sharp but the head is not, chances are the person moved his head during an exposure that was on the slow side.

BRACE YOURSELF!

I know it's important to keep one's elbows in closer to one's body (if possible) for holding the camera steady. But is one position of the feet better than another for steadiness?

There's no one specific stance that is better than another for everyone. So experiment with a free-standing position that feels best for you, remembering that general recommendations are to keep the feet and legs comfortably apart. Note also that it is often helpful for better balance to have one of the separated feet slightly further forward than the other.

FOR GREATER STEADINESS

Is it really true that fastening a length of light rope to the camera, then holding it firmly under my foot and pulling up so that the rope is really taut, will steady a 35mm camera when shooting? And what should I use for the fastening job? I like the idea because light rope is so portable.

It is true, but the extra steadiness tends to be moderate. However, this gain might be significant at times. So make yourself a unit in which enough light rope (woven nylon in this case) is well fastened to a short ¼-20-threaded eye bolt (that has a securing nut). Your hardware dealer can cut the bolt down for you. And the threading fits American tripod sockets. As you attach the unit, just be sure to stop turning as soon as you feel a slight resistance. Then tighten the nut. You're ready at this point to run tests and determine the benefits.

Although the idea seems most useful for horizontal shooting, you may find it moderately helpful for vertical formats as well.

4
FILTERS

FILTER VARIATIONS

What are the basic differences between skylight (1A) and clear "haze" filters?

We assume you're talking about a typical clear haze filter that holds back some of the ultraviolet rays and blue light. The skylight (1A) absorbs in these areas, too, but in addition holds back a trifle of the green light as well. For this reason the skylight filter is very slightly pink in color and has a very slightly stronger warming effect, which is particularly useful for faces.

USING A CLEAR FILTER

I have heard conflicting statements over the use of a clear (or nearly clear) filter over my camera lens for protection. What do you suggest?

There is no doubt that there are times when it is wise to protect your lens in such a fashion while shooting outdoors. Consider, for example, the damage that might occur to your lens due to direct exposure to rain or snow, or flying sand or salt spray at the beach. So use some common sense. And protect the lens not only in this manner when necessary, but by adding a lens shade. Also, if necessary, put a protective plastic bag around the camera and lens, just leaving an opening to shoot through. Photographers often use a rubber band around the end of the lens barrel to secure the plastic.

However, indoors or out, when there is no reason to use a filter and no potential danger in the air, why use a filter at all, as it is unnecessary. Then the best you can expect from such filter use is that it won't harm your sharpness and contrast. In some cases, however, it might. Keep in mind that you can give the lens a lot of protection when not shooting simply by covering it with a tightly fitting lens cap, preferably of the screw-in type.

EXPOSURE CHANGES WITH FILTERS

How much extra exposure must I give when I use filters for color and black and white?

Check the instruction leaflet that comes with the film and is too often tossed away unread. It's full of essential information, including exposure data for shooting with basic filters. Black-and-white increases are given as filter factors to use. In color, exposure relates to: a new exposure index to use with the filter; guide numbers for shooting by flash with the indicated filter; the amount to open up or close down the lens. Remember that any exposure increase recommendation is merely a starting point. Differences in camera efficiency, meter operation or the picture effect desired all are good reasons for deviating from printed recommendations.

SHOOTING RED AGAINST GREEN

Suppose I want to photograph a girl in a red dress, in a garden setting, against a background of green foliage. My film renders the red dress in about the same tone of gray as the green leaves. What can I do?

If you recognize a problem like this before you shoot, your eye is well trained for working with black and white. Most of us find the red and green color contrast so striking in color, we are most surprised to discover that the two hues may come out the same in black and white. There are two ways to get separation. A red filter will make the dress seem lighter, while darkening the foliage behind it. However, it will lighten red lips considerably for highly unpleasing results. A green filter will work the other way, lightening the foliage while darkening the dress. Skin tone will be darkened but results are far more satisfactory than with the red filter.

GETTING SKIES TO DARKEN

It seems as though I never get the effects I should when using filters for black and white. Skies don't darken as I expect them to. What am I doing wrong?

First of all, you may be overexposing your pictures. If you give a filtered shot too much exposure, it usually cancels out the filter effect. Try a pair of comparative pictures, one with normal exposure for the filter as you have been using it and a second with two stops less exposure. The second may come closer to giving the effect you want. Secondly, you may

be using sky-darkening filters on gray, overcast days. If there is no blue in the sky, there will be no sky-darkening effect.

AVOIDING LOSS OF SHARPNESS

How do filters affect the sharpness of pictures?

That depends on the film size and degree of magnification in printing or projecting. A single, thin gelatin filter or a glass one with surfaces that are flat and parallel will not cause noticeable sharpness losses under most conditions (up to 8×10 or 11×14 prints from 35mm or $2 \frac{1}{4} \times 2 \frac{1}{4}$ negatives). Once you consider the filter effect, important gain in apparent sharpness is possible with black and white. Filters usually are selected to increase contrast, and this gives a greater appearance of sharpness. When you consider using a filter, remember that the added contrast effect often cancels out the slight sharpness loss which using it may entail. Loss in sharpness may be noticeable in some cases, however, as when you use two or three filters in combination.

DARK SKIES IN COLOR

Is there any way I can darken the sky in a color picture? I want to get the effect you would achieve by using a medium-yellow filter with black-and-white.

Sky brightness can be controlled by using a polarizing filter. It works on the principle that light from the sky is at least partially polarized and hence can be controlled by means of a filter whose axis of polarization is at right angles to the major axis of polarization of the light. In practice it's easier than that—you view the sky through the filter while rotating it to determine the proper angle as you see the sky darken. Then you place it on the camera lens at that angle. Adjustment is facilitated by some polarizers which come in mounts that can be rotated on the camera lens, and units with attached viewing filters so you can observe the effect while turning the filter on the lens itself.

OH, THAT GREASY GUNK

I've used a thin layer of petroleum jelly on a lens filter to achieve diffusion effects while shooting. It worked fine. But I don't know how to remove the stuff from my screw-in glass filter without damaging it. What do you suggest?

57

We know it's no fun to remove the gunk from your filter. So next time try using a washable (or disposable) support, such as clear acetate, held with the grease-side out away from your lens. Meanwhile, try this fairly easy method of grease removal from your glass filter.

First, wipe off as much of the gunk as you can with a soft, lint-free cloth, and do it gently. When residual grease is at a minimum, apply some lens cleaner to a fresh piece of similar cloth and wipe the glass. The cloth should be damp, not dripping, so that the liquid doesn't run down the sides to where the filter is cemented to the rim. Keep on doing this. After four or five applications, the filter should be clean. Lacking a bottle of lens cleaner, we've also succeeded in the same fashion with an antistatic film cleaner.

A FACE FLUSHER

What filter should I use when the skylight filter doesn't give me warm enough faces with color transparency film? This happens sometimes with rather pale faces in very cool shade areas outdoors.

Try one of the yellowish 81 series light-balancing filters. The 81A will give you just a bit more warmth. Or you can go on to some slightly stronger ones, such as 81B and 81C, respectively. Each calls for only a one-third stop increase in exposure that will be compensated for automatically if you are using a through-the-lens metering type of camera.

A PROBLEM WITH FILTER FACTORS

How do I find the filter factor when I use two filters together?

The simple act of multiplying the two known filter factors will give you a good approximation. For instance, a factor of 4 multiplied by a factor of 2 equals a factor of 8—which calls for increasing exposure the equivalent of three stops. Then to be on the safe side, bracket exposures a half stop either way the first time you use two particular filters together. This caution is included because adding extra glass surfaces can cause some loss of light or loss of filter effectiveness.

5
OUTDOOR PICTURE-TAKING

THE EVENING SUN GOING DOWN

What is the best exposure for sunsets? How should it be done?

It depends on a number of factors, from the type of sunset to the effect desired. Some photographers feel that a good starting point is to aim the meter at the sunset sky, but not to include the sun, especially if it is a ball of fire. Make several exposures: one as the meter indicates and others bracketed. Doubling the exposure will give you more foreground detail and a somewhat lighter sky. Halving the meter reading will provide a darker sunset with more saturation of colors. For a really dark result, with just that ball of fire well exposed, aim your meter briefly at the sun and expose as indicated.

STARLIGHT PHOTOGRAPHY

I want to photograph star trails this summer. How do I go about it?

This is best done on a clear, moonless night away from artificial lights. Using tripod and cable release, set the lens at infinity (stopping down far enough so you can use long exposures for interesting star trails without fogging or overexposing the film), and set the shutter on T or B. One starting point is to aim the camera at the North Star for circumpolar shots. For striking star trails, you may need really long exposures, such as one to four hours. A normal lens can be used, but a longer lens may be preferable.

NORTHERN LIGHTS

What exposure should I use for shots of the Northern Lights with fast color film?

With ASA 160–200 color transparency films exposure tends to fall between 1 second and 1 minute at f/4, for "medium bright" displays. However, if Northern Lights are "ultra-bright," times may be as short

as ½, ¼ or ⅛ second at f/4. Take extra pictures at well-spaced exposure times until you gain experience.

AFTER THE STORM

What sort of lighting should I choose for the most dramatic mountain pictures?

Views taken after a storm or when clouds are gathering are likely to be more exciting than shots taken on sunny days. Mist adds its own aerial perspective to distant views. Every sort of weather brings out particular qualities of its own in mountain pictures.

FRAME THOSE MOUNTAIN VIEWS

My distant views of mountains make them look flat and uninteresting. What is wrong?

Far-off views of mountains are likely to be disappointing. To make the most of them, select a viewpoint that provides strong foreground framing, shooting between a pair of trees or a fence gate to add depth to your picture. Darkening blue sky with a yellow or orange filter for black and white, or a polarizer usable with either color or black and white, helps immeasurably.

HIGH-ALTITUDE PROBLEM

On my last vacation I took a series of mountain views that came out with shadows almost black. Ordinarily I get much more shadow detail. The day was perfect—clear and cloudless. Was there something wrong with my film or the processing?

Probably not. Light at high altitudes is likely to be extremely contrasty, particularly when skies are clear and blue. There just isn't dust or moisture enough in the air to reflect light into the shadows. Under these circumstances, particularly with color film, it is best to shoot with the sun near your back so you do not take in large shadow areas. You'll get more detail on days when the air is less clear and when there are white clouds in the sky to reflect light into the shadows.

SHOOTING FROM A BLIND

How do nature photographers get close-ups of wild life subjects?

There are several approaches. One is to set up a blind in a likely location, hide in it, and then actually shoot close-ups (preferably with a telephoto lens) when your quarry passes by. Another is to set up the camera in a blind and watch the area it covers through binoculars, tripping the shutter by remote control when the game is in view. A third is to let the subject take its own picture, but this is more complicated. It is done by arranging a trap that will trip the shutter when the quarry triggers the mechanism. This might consist of a thread, a concealed treadle switch, a beam of light or some other tripping device.

GETTING AWAY FROM THE SUBJECT

Are there special remote-control outfits designed for nature photography?

There are—for nature work and for other applications that require taking pictures automatically or semi-automatically. One such unit advances its own film after each exposure and can be tripped by closing an electrical circuit with a pushbutton on a long cord or at a greater distance, without wires, by means of a radio-actuated tripper.

LOOK BEYOND THE FOREGROUND

What makes a good background for photographing flowers? My backyard pictures show the flowers well, but things in the background often spoil the effect.

Plain sheets of cardboard are useful for this purpose. With tall flowers it sometimes is possible to shoot from a low angle and use the most natural background of all—the sky. Light blue cardboard gives a good effect. Avoid backgrounds of intense colors that are likely to detract from the flowers themselves.

LOOK FOR THE HIGHLIGHTS

What do you look for when you focus an image on the ground glass? I have trouble telling when a picture is sharp.

Bright highlights like the reflection in a person's eye or the glint on a bright object are easiest to judge. Eyeglasses and patterns in clothing also

61

make good focusing points. When you focus, shift the adjustment until the image just begins to blur in one direction and then shift it the other way until blurring just starts. Then center the adjustment between these two positions.

SQUEEZE—DON'T JAB!

How can I avoid any movement when the camera is hand-held?

Take a firm stance with feet apart, brace the camera firmly against your cheekbone or forehead if it is of the eye-level type, tuck your elbows in, draw a breath before you shoot and hold it as you trip the shutter. Squeeze off the exposure—don't make it by jabbing at the release.

FIGHTING FLARE

When I shoot toward the sun, even on a clear day, why do some of my pictures have a foggy appearance?

Reflections within the lens and camera often cause lack of contrast in pictures taken toward the sun or any bright light source. This flare can often be reduced or eliminated by using a lens shade.

ECLIPSE THE SUN

How can I avoid flare when the sun is within the picture area I want to show?

Sometimes it is possible to keep the sun from striking the lens by carefully choosing a camera position that places the sun behind a tree, building or other obstruction. Moving just a foot or two may do the trick.

OVER-THE-SHOULDER SHOOTING

Photographic magazines show many striking pictures taken with side lighting or with the camera pointed almost directly toward the sun. This is contrary to the old rule for shooting with the sun shining over your shoulder. How come?

Flat, front lighting, of the type you can get with the sun at your back or shining over your shoulder, is much more likely to give satisfactory results in color or black-and-white shots of average subjects in which you

want to avoid large, dark shadow areas. If faces are important and you want to show maximum detail throughout a picture, this simple lighting is the answer. When the light comes from the side or back of the subject, determining exposure is more difficult. Breaking the rules can give you more striking pictures, if the things you expect to bring out aren't lost in the shadows.

WHEN THE SUN IS ABSENT

How can I get good color pictures of a building that faces north? The sun never seems to strike its front.

This is a problem that makes life miserable for architectural photographers. Sometimes, in the summer, you can choose a day when the sky is somewhat overcast for a soft, overall lighting effect. A skylight filter will remove excess blue from the light and give the picture added warmth. With a light-colored building against a blue sky, you can darken the sky with a polarizing filter. This will increase the contrast between the two areas and emphasize the structure. When all else fails, you may be able to get a dramatic effect by shooting toward nightfall, when the interior building lights have been turned on. Use a time exposure.

FLASH ON A DULL DAY

How do you use flash in place of sunlight as your main source of illumination for brighter shots on a dull day?

Plan the picture, whenever possible, as a close-up without distant background showing. This will help avoid a faked effect, since we know the flash can't reach far into the distance. Determine the exposure for daylight and set the camera for one stop less. To get the flash distance, divide the guide number for your film, shutter speed, and flash combination by the stop you are using. The flash should be placed high to give the light a direction that might be expected of sunlight.

EXPOSURE FOR FILL-IN FLASH

How do you compute the exposure for using fill-in flash outdoors?

First determine the correct exposure for your subject in sunlight, ignoring the flash, and set the camera for this exposure. Then if you want

a 2:1 relationship between the daylight and flash, use the guide number for your film, shutter speed and flash combination and divide it by the stop at which your camera is set to determine the flash-to-subject distance. Often it is desirable to weaken the flash further for a 4:1 ratio. The simplest way of doing this is to drape one thickness of a large, clean, white handkerchief over the reflector to block off about one-half the light. Illumination from the flash is reduced by nearly three-quarters when you use two thicknesses. What if you don't have a suitable man's handkerchief? Just divide the guide number by an aperture one stop wider than the lens setting you are using. This will also give you a 4:1 contrast ratio, which will fill in shadows less than the 2:1 ratio mentioned before.

COMPRESSION WITH EXTREME TELEPHOTO

How do photographers get the effect of extreme crowding you sometimes see in pictures of traffic, taken from a distance?

This striking result is obtained by using a lens of very great focal length to obtain a magnified view from very far away. A 500mm lens on a 35mm camera is an example. When the pictures are enlarged, objects at different distances in street scenes will seem to be compressed. The effect is noticeable in landscapes only if they contain distant objects known to be of the same size, like rows of uniform trees in an orchard or derricks in an oil field.

FLASH REVEALS SNOWFLAKES

How can I bring out snowflakes in a winter scene?

Select a viewpoint that will provide a dark background for the flakes. Use flash on the camera to bring them out without affecting the rest of the scene.

THROUGH A LENS WIDELY

How do you take a series of pictures from the same position when you want to fit them together to make a wide, panoramic view?

The trick is to mount your camera on a tripod and turn it to make overlapping views. The pivot point should be beneath the lens. Panoramic heads, available for some cameras, simplify this. Prints of the

negatives then can be trimmed to match and fitted together. Don't tilt the camera either up or down. If a number of prints are required, they can be made by copying the assembled print.

SEAWATER PROTECTION

Will saltwater spray damage a camera?

It will if it is allowed to remain on it or to penetrate into the camera mechanism. When a camera has been wet with spray, wipe it off as soon as possible. At the first opportunity, wring out a cloth in fresh water and wipe again. Repeat if it shows white salt crystals upon drying. Take the camera to a good repairman as soon as possible.

KEEPING SAND FROM LENS

How can I protect my lens from damage from flying sand and spray at the shore?

One way is to keep a filter on your lens: Some fans use a light-yellow filter in this way for black and white, regardless of whether or not they need it for pictorial effect. The filter generally requires only a two-thirds stop exposure increase with daylight. For color photography, a skylight filter will perform the same function and calls for no increase in exposure.

FIRST AID FOR WET CAMERA

What should I do if my camera is immersed in salt water?

Pour fresh water over it from a bucket or hose, dry it as best you can, and get it to a repair shop as soon as possible. Don't try odd remedies you may have heard of, like dunking the camera in kerosene. Anything except plain, fresh water is likely to cause more trouble than it might prevent.

6
TRAVEL

HOME PASSPORT PICTURES

Can I take my own passport photos?

Certainly. All you have to do is be sure to follow the requirements for size of prints and general quality, as specified on the passport application form. Both prints submitted must be identical—made from the same negative. You can even use color prints, which must fulfill all other requirements for black-and-white prints.

STOCK UP HERE

I will be in Europe for six weeks next summer and want to take many color slides of my trip. Will I have any trouble getting color film there?

You can buy good color films in Europe, but the American brands with which you are familiar may be in short supply or not available at all. We recommend taking along a good supply of the film you like best. You can arrange to send it back to your dealer for processing so your pictures will be ready for showing upon your return.

FAMILIAR EQUIPMENT IS BEST

I am leaving for Europe next week and will be taking a lot of pictures. I'm thinking of buying a new camera. What kind would you recommend?

In spite of the fact that many travelers try to do it, an expensive trip abroad doesn't provide the best opportunities for learning to use new equipment and getting the most out of it. If your present outfit produces the type of picture you want and is in good condition, you will do better to stick with it rather than force yourself to master a new outfit in new surroundings. If you decide to upgrade your equipment with a new camera of better quality, then get it well before you leave and practice taking pictures with it.

STILLS OR MOVIES?

I am going on a long trip and want to take pictures to show my friends when I get back. Which should I shoot, color slides or movies?

The choice depends on what sort of subjects you will be shooting and on how you like to work. Movies should move. They are at their best showing action subjects. They follow a bit of action from its start on through its climax to an end. Movies require more planning than most still pictures. They call for direction, too. Often you must tell people what to do to keep them moving before the camera. Action is not as important in color slides. When you want to show movement, you usually can find one instant that will capture the feeling of action. Stills are most natural for landscapes, city scenes, and portraits of people where movement is not expected. Both movies and stills require editing to put on a good show. The mechanics of assembling a slide show are easy; You weed out the poor shots and rearrange the good ones in an order that tells their story. Movie editing calls for cutting and splicing, rearranging scenes and adjusting them for length. If action is important in your pictures, and if you like to plan your shots and don't mind directing your subjects, chances are that movies are for you. If you like pictures that don't depend on action for their interest and prefer to shoot with a minimum of planning and direction, slides probably are your best bet.

KEEP EVERYTHING COOL

What is the best way to carry film and photo equipment in a car?

Safety from overheating, excessive vibration and theft are the important things to consider. The glove compartment ranks low in desirability because of its excessive heat in summer. The back window ledge is hot, and visibility of equipment there is almost an invitation to theft. Best of all is a spot on the floor in front of the back seat, where the temperature is moderate and equipment can be covered to keep it out of sight. The trunk compartment is fine when temperatures are moderate, but a hot sun may make it too warm for storage of film.

THE FIRST STEP: PLANNING

How do experienced moviemakers happen to be on hand when interesting things are going on—wherever they are?

67

It isn't so much a matter of happenstance as of planning. Arrange your trip so you will arrive in New Orleans for the Mardi Gras or in Munich for the October festival. Try to time your arrival in the farm states at threshing time or in forest country when the leaves take on their autumn hues. If you know you will visit certain towns, write ahead to find when special events are scheduled. Every photographer has natives tell him, "You should have been here last week . . ." But it won't happen as often if you plan your trip to catch important activities at places you visit.

GETTING STRANGERS TO POSE

How can an amateur get people in his pictures? I don't like to go up to strangers and ask them to pose, but there are times when travel scenes would be much better if someone was in them.

One solution is to decide what you want to shoot, set your camera and then wait for someone to walk into your scene. This works well in foreign cities, where you find local people going about their own business in their own dress. It's no good in the desert, though.

GET INTO THE PICTURE

I like to take pictures in the mountains with friends in the foreground. If I go out alone, my scenic shots seem dead. How can I pose in my own pictures?

If your camera has a self-timer, it's easy: All you have to do is release it and take your place in the scene before the shutter clicks. You can also acquire an accessory self-timer which will function with a large number of cameras that do not incorporate this feature.

RECORD FIRST IMPRESSIONS

When should a photographer start shooting pictures of an area he plans on covering in a vacation travelogue?

As soon as possible. If you're on your way to the Grand Canyon and see a roadside sign that says, "Grand Canyon—103 miles," snap a picture of it. Try to record first impressions and general views as you approach a city. Sometimes you can catch a broad view from an airliner or from a roadside vantage point in the hills above the city.

JUST FOR THE RECORD

What can I do when I come upon interesting places where picture-taking is prohibited?

Look around for a souvenir stand. Often, when cameras are barred, it is because the picture-taking concession has been sold to a professional. You are likely to find color slides and picture postcards on display, and you can make a selection from among them to fill out your photo story. If pictures are not available, ask about obtaining permission to take your own. There's always a chance it may be granted, for a fee, if you are interested.

MAKE SOMETHING HAPPEN

How can I take interesting pictures when there's nothing going on?

There are places whose very sleepiness gives them their own particular photographic appeal. Maybe you can make something happen. Perhaps you can't stage a rodeo, but you can seek out the places where young riders practice and get some action shots. Look up other aspects of major activities when important things aren't going on.

THE NONSTOP GUIDED TOUR

How can I get good pictures on a guided tour of a city? They hardly stop at all, and many places are merely described as the bus goes by.

You can't do much picture-taking during such a tour—but don't let that keep you from taking the tour. Often it is a time-saver. It will give you a chance to evaluate many places where there are picture possibilities. Then you can go back and spend time at the ones that have the greatest appeal to you.

TILL THE SUN COMES OUT

How can I get better pictures on dull days? A traveler's schedule seldom permits waiting for sunshine.

The soft lighting of overcast days is fine for color photography, if you can manage to avoid including too much of the flat, gray sky in your

69

pictures. This is good lighting for shooting down from high places and for concentrating on details rather than showing many broad scenes. Take only as many general views as you really need to establish locale. For the rest, select camera angles which limit the distance the camera takes in and which avoid showing too much sky. Often you can gain sparkle by using flash off the camera.

PREPARATION IS THE SECRET

I'm always short of things to say when I get around to preparing the commentary for a travel slide show. What can I do about it?

Gather printed matter along the way. Postcards of most places carry interesting information about them. Tourist bureaus and other travel organizations usually have folders describing events in different areas and main places of interest. Make notes of your impressions and any interesting episodes that occur as you travel. All this material will help when you put the show together.

SHOOTING FROM A PLANE

Can I get sharp pictures through a plane window?

They will be reasonably sharp unless the window is badly scratched or very dirty. For best results hold the camera as close to the window as you can conveniently without touching it.

CLEAR VIEW WANTED

Where are the best seats for taking pictures from an airliner?

Next to the window at about the middle of the ship. From this point you can avoid the wing-tip if you want an unobscured view of the ground, yet you can include the wing if you feel you want it in order to show depth in your pictures.

AVOIDING THE SHAKES

How can I avoid the blurring effect of vibration in taking pictures from an airliner?

Hold the camera in your hands and avoid resting elbows, shoulders, hands or camera on any part of the plane. That way your body will cushion the effect of vibration. A speed of 1/100 second will do for most views, although you'll want 1/200 or faster if you plan on shooting during the takeoff or as the plane touches down.

IDENTIFYING THE PLACE

What are some of the things I can use to get "built-in titles" for my travel slide show?

Watch for road signs and advertising billboards. In town, look for signs at railway stations, airports and bus depots. Don't neglect city limit markers. You'll find bronze tablets or other markers at many spots of historical interest. If you ask directions of a native, a shot of him as he points the way may fit in nicely to fill the screen while you tell how you got from one place to another.

A QUESTION OF WEIGHT

How much equipment should I take along to make movies on a vacation trip?

That depends on your travel plans. If you are going all the way in your own car, you probably can afford luggage space for things that it wouldn't be worthwhile carrying on a more complicated itinerary involving trains, boats, buses and planes with their luggage weight restrictions.

WEIGHT REDUCTION HINT

What are the minimum requirements for shooting good movies while traveling light?

The most important items are the camera, plus filters, a telescoping tripod with pan head, and a gadget bag that will take the camera and

accessories and a day's supply of film. Your major film supply can be packed in other luggage.

GET IN CLOSE!

What type of movie shot is likely to add the most interest to a travel film?

Probably the close-up, because few filmmakers remember to take enough of them unless they are seasoned veterans. In any film, close-ups are especially appealing when they show children, animals or people doing something of interest.

MOVIES FROM A CAR

How can I get smooth movies from a moving car? I tried shooting the city limit signs of towns we visited last summer, but many of the scenes came out too jiggly to use. Our car doesn't seem to ride that roughly!

Let your body absorb the vibration by sitting straight, elbows drawn in, and avoiding contact with doors, armrests or window ledges. If your camera provides adjustable filming speeds, there is a trick that will help: Shoot at 24, 32 or 48 frames per second instead of the usual 16. This has the effect of smoothing out the car's movement. Remember to shorten the filming time and to open your lens aperture to compensate for the exposure shortening at high speeds. At 32 fps, use an aperture one stop wider than you want when shooting at 16 fps and cut your filming time in half.

7
SPORTS AND ACTION

SHUTTER SPEEDS FOR ACTION

What are some guidelines on shutter speeds to use for action subjects?

As a starting point for stopping motion, remember that speeds down to 1/30 second may work well if you shoot at the peak of action—such as at the top of a baseball pitcher's delivery. Slow shutter speeds are also suitable (especially with subjects moving parallel to the film plane) if you "pan" with the action.

DISTANCE VS SPEED

Why is the distance of the moving subject important? It's moving just as fast, regardless of how far away it is.

Distance counts because it controls the size of the image on the film. Closer objects form larger images, and the bigger they are the more they will move across the film during a given interval, hence creating more blur than a smaller image. Longer focal lengths also form larger images. And finally, the degree of enlargement affects apparent sharpness because the amount of image movement may be magnified to the point where motion looks blurred.

DEPENDS ON THE ACTION

How do you decide what speed to use when you shoot action that doesn't all move in the same direction or at the same rate? I can see where it would be possible to calculate the speed necessary to catch a moving train, but what about a pileup on the football field?

That's where experience helps, and even the experts can't always tell how sharp their pictures will be. A shutter speed of 1/200 is the minimum for football shots, and it takes 1/400 or faster to get a good percentage of them really sharp.

DEPENDS ON THE ANGLE

How fast must I shoot to get reasonably sharp still pictures from a moving car?

Use at least 1/100 second when shooting through the windshield and 1/500 through the side windows. Why the difference? It takes much faster speeds to stop motion at right angles to the camera than coming directly toward it.

A TERM DEFINED

Just what is meant by the phrase "peak of action"?

This is a momentary pause that occurs just before the subject's direction of movement starts to reverse itself. For instance, a tennis player reaches the peak of action at the top of a serve. Or a circus trapeze artist reaches the peak of action at the end of a swing, just before he starts swinging back. But look for it in other activities too. Learn to use it to stop motion as much as possible. You may need it when slower speeds such as 1/30 or 1/60 second must be chosen. However, you may need it also for times when faster shutter speeds can be selected, but will not otherwise do the required action-stopping job.

FREEZING FAST ACTION

I've been taking action pictures of golfers, but the club head almost always comes out blurred. I use my top speed of 1/500 second. How fast a shutter speed does it take to stop this sort of motion?

It's a matter of camera angle and timing, as well as shutter speed. Even 1/1000 second won't stop the club of a good player if you shoot facing him, at right angles to his swing and at the bottom of the stroke when the club is moving at its fastest. You can do better by taking a position to one side and somewhat ahead of the golfer or behind him. Even a slow speed will give good results if you shoot at the very start of the swing or at the end of the follow-through.

BLURLESS FLASH

How does electronic flash capture fast action?

The action-stopping effectiveness of electronic flash depends upon using it so that incidental illumination does not register a second weaker "ghost image" while the shutter is open. This is accomplished either by shooting when incidental light is weak or by setting the camera to a shutter speed that is fast, but not so fast as the duration of the electronic flash. These units have a very brief flash (usually between 1/500 and 1/2000 second in duration) that is fired during the interval that the lens is open; it is this brief flash that takes the picture. If existing light is weak or if you adjust the shutter as mentioned, only movement during the flash itself will register on the film, and the flash is so short that few subjects move fast enough to blur.

LIGHT: ELECTRIC AND ELECTRONIC

I took a picture of a basketball game with electronic flash and the players all came out sharp enough, but one of them is shown against an electric light which appears to show right through his arm. What happened?

Evidently your shutter speed was fairly slow—slow enough for the electric light to register on the film. Electronic flash will stop fast action with slow shutter speeds if no other strong illumination is present, but you are likely to get surprises like this if your pictures include lights, windows or other sources of illumination that are bright enough to expose the film while the shutter is open.

SOMETIMES BLUR IS GOOD

Do action shots have to be 100 percent sharp to be good? I've seen a lot of published ones that were far from perfect.

Many photographers feel that a little blur doesn't hurt a good action picture and may even help make it more effective. It sometimes lends a feeling of authenticity or realism. If you show a skater at the peak of a leap, you don't need blur to prove he is really leaping because the camera shows he is up off the ice. Yet a shot of a Spanish dancer with both feet on the floor might easily look posed if there weren't enough blur in her swirling skirt to create a feeling of movement.

SHOOT THEM OFF IN SYNCH

How do professionals use electronic flash or conventional flash to cover a large area, like a hockey rink, for action pictures?

One system is to set up several lighting units, synchronized to fire at the same time. They need not be connected to the camera with wires; a single flash on the camera can be used to fire them with an electric-eye remote control.

MOTION-STOPPING COMPROMISE

What do the experts do when forced to make a choice between small apertures for depth of field in action shots and high shutter speeds (with the larger apertures they require) to stop motion?

Like all of us, they must often compromise as intelligently as possible and hope for the best. It would be nice if we could always use top speeds to stop action and smallest apertures for depth. But this isn't always possible.

THE EXACT MOMENT

How are action shots made at just the right moment, like a player's shoe denting a football as he kicks it or a baseball meeting a bat?

It's just good timing when pictures like these are caught during a game, but many of them are staged. You can use a photocell circuit, for example, to trigger electronic flash at the instant a beam of light is interrupted. This principle has many applications, and lets moving subject matter take its own picture.

RECOMMEND: SPEED TO SPARE

What is the minimum top speed a camera should have for taking sports pictures?

You can get by with 1/250 second for an occasional shot, but if you want to do a lot of sports photography and can't employ electronic flash to stop action, you will do better with an outfit that offers at least 1/500 and preferably 1/1000.

FAST-FOCUS PROBLEM

How do sports photographers manage to focus fast enough to catch action in a football game?

Prefocusing is the answer. They guess where the next play will take place and set their cameras for it. Other tricks help, too. If you find a play coming too close to you, you won't have time to focus at a shorter distance, but you can step back quickly and maintain the right distance to take your picture.

SHOOT A ROLL, PICK ONE SHOT

Are sequence cameras often used in sports photography?

The professionals use them to take pictures in a series or to be sure of catching a particular bit of action that can't be anticipated accurately. In this case they shoot through the action highlight, relying on the sequence to provide some one picture that shows it best.

GETTING CLOSE TO SAILBOATS

What is a good vantage point for taking pictures of small sailboats?

The mouth of a harbor is a fine spot to catch small craft, since it usually is narrow enough to bring them fairly close to your camera.

SHOOTING BASKETBALL

Could you suggest a good developer for available-light basketball shots made on Tri-X at 800–1,200 ASA?

Many professionals and amateurs are getting excellent results with Acufine and Tri-X. ASA 1,200 is the rating recommended for Tri-X with normal use, but you may want to vary this slightly after processing a test roll.

SHARP CAR, BLURRED BACKGROUND

A friend showed me a picture of a racing car. The car appears sharp, but the background is completely blurred. Why?

Yours is a good description of an action shot taken by panning the camera. This trick makes it possible to get sharp pictures of very fast action at slow shutter speeds. Here's how it works: Catch the approaching car in the viewfinder and swing the camera to follow it, keeping the subject centered in the finder. Trip the shutter when the car is where you want it. Continue to swing the camera, following through smoothly to avoid jerking at the instant of exposure. The car will be sharp because it hardly moved at all in relation to the film during the instant the picture was taken. The background will be blurred because the camera was moving relative to it when you clicked the shutter, and the blur often enhances the feeling of motion. This technique is of value in catching subjects that move in a straight line over a predetermined course.

FOR UNDERWATER SHOOTING

What type of lens is best for underwater photography?

Wide aperture and short focal length are the most important lens characteristics for this type of photography. Wide apertures are helpful because the light, at best, is dim. Short focal lengths are an aid because depth of field is greater at the wide apertures and close distances that must be employed. It is necessary to work as close as possible to your subject matter, even in the clearest water, because so much contrast and definition are lost. Objects appear about 25 percent closer underwater than they do in air. Because of the extra refraction as light goes from water through air in the water-tight housing, the effective focal length is increased. Hence, in focusing, set your distance marker for only 75 percent of the actual distance (unless your housing is designed to correct for the additional refraction). For an object 10 feet away, set your camera for 7½ feet.

NOON IS BEST AT THE BOTTOM

What hours are best for underwater picture-taking?

The hours around the middle of the day. More light penetrates the water when the sun is overhead.

IT ALWAYS LOOKS CLOSER

What are the most common shooting distances?

Best results are obtained if you work within 10 feet for black and white and 6 feet for color in water that is relatively clear.

SHOOTING LIVE PERFORMANCES

I have a question about using Kodak High-Speed Ektachrome color slide film at ice shows. Instructions in the film leaflet give a suggested exposure of 1/60 second at f/4 for this ASA 160 film. But on the other hand, I've seen lower exposures, such as 1/30 second at f/2.8, suggested elsewhere in print. Which one should I use? Who is right?

Both could be. First of all, remember that the Kodak suggestion is for ice show (and circus) acts that are illuminated by carbon arc spotlights. Quite logically, then, lower exposure suggestions would be perfectly valid for floodlighted shows. In addition, similar lower exposures could be the right ones to use when the color of the carbon arc plays a role. For instance, when the color of the carbon arc changes from normal whitish to rich red or blue or green, you probably have to open up or adjust the basic 1/60 and f/4 combination. The latter is just a suggested starting point for whitish arcs, and you should be able to vary exposures intelligently.

8
PHOTOGRAPHING PEOPLE

RINGLIGHT FOR PORTRAITURE?

Can a ringlight electronic flash be used effectively as the main light when making portraits indoors?

We don't advise this because results are generally flat and uninteresting. It's better to take the ring unit off the lens and hold it high and to one side, generally providing more interesting portraits and avoiding a condition known as "red eye."

The ailment is quite aptly named for the ways eyes can look in color pictures—even though the same setup in black and white causes the pupil of each eye to look white. In either case, the results disfigure faces and occur most often when the flash is around the lens or on the camera and the subject is looking straight at the lens, or when ambient light is so low that the pupils of the subject's eyes are dilated. Then light from the flash enters the eyes and is reflected back by a layer behind the retina.

So take countermeasures accordingly. If the ringlight must stay on the lens, try using it for fill, but turn on more room lights if possible to contract the pupils. Also, don't shoot the subject full face. If you must do this, have him or her look briefly into a bright light seconds before the exposure to contract the eye pupils.

A SMATTERING ON FLATTERING

I've heard there are special techniques for subduing the prominent facial lines found so often on older faces. How is this done with black-and-white portraits?

Softness is the key word for such portraits. Start by using soft, quite diffuse illumination, so lines won't be so prominent on the film. Then in printing try one or both of these techniques. Diffuse print images moderately. Your tool can be as simple as a piece of black nylon mesh stocking stretched over an inexpensive embroidery frame. (Choice of this darker color keeps contrast loss to a minimum.) Hold the homemade diffuser under the lens, moving the unit slightly, and keep it there for part of the total exposure—say half. Next, to soften the impact of lines more, try

printing on a fairly rough matte paper, possibly one with a kindly warm-white or ivory tint.

STANDARDIZED PORTRAIT SETUPS

Are there standard setups for portrait lighting that will always give good results?

There are a number of basic ones you can find in books on portraiture. One of the best and easiest to use is called 45-degree, or "Rembrandt" lighting. The main lamp is placed so it will shine down on the subject at a 45-degree angle and be 45 degrees to one side of the camera. With the subject facing straight ahead, the shadow of the nose will extend down the upper lip until it almost meets the corner of the mouth. Additional lights are employed for fill-in and to eliminate shadows from the background. It's fun to experiment with different types of lighting like this, but you'll get better results if you merely use them as a point of departure for working out an arrangement that brings out the best qualities of each subject.

LOOK INTERESTED, PLEASE

How do you get subjects to present different expressions? I feel silly asking someone to smile or to look more serious.

You'll get better expressions if you can keep your subject interested in something else besides picture-taking. Talk about things of common interest. Concentrate on your subject instead of your camera. If you do this, you'll find different expressions appearing as you go along.

OPEN UP FOR BOUNCE LIGHT

Does bounce light with floods call for much more exposure than direct lighting?

Yes, about two stops more, depending on the distance and color of ceiling and walls.

LEARNING ALL THE ANGLES

How can you predict the way light will bounce from a wall?

Think of a light ray as a rubber ball thrown against the wall from the lamp. It will bounce the same way the ball would. If you prefer more technical terms, the angle of incidence is equal to the angle of reflection.

DIFFERENTIAL FOCUS

How do portrait photographers get pictures in which the subject's eyes and face are critically sharp while his ears and the back of his head are blurred?

This is the natural result of working with a long-focus lens at a relatively wide aperture. Under these conditions you have very little depth of field, and you must focus carefully to place that shallow depth just where you want it.

USING REFLECTORS OUTDOORS

How can I soften the shadows in outdoor portraits?

One way is by using reflectors. You can make one by cementing aluminum foil to cardboard, or you can improvise on the spot by strewing newspaper on the ground, just out of camera range.

DOWN WITH HARSH SHADOWS

How can I avoid very dark shadows on one side of the subject that result from using an electronic flash high and to one side? I don't want to use bounce flash.

Why not try softening the flash by covering the reflector with a layer of a man's clean white handkerchief or a layer of white cleansing tissue? One layer of either is likely to cut light by about one f-stop, besides softening harsh shadows considerably. For more softening, try two layers. Run a few tests, in all cases, to verify needed exposure changes, as handkerchiefs and tissues vary.

HAZY-BRIGHT FOR FLATTERING PORTRAITS

What sort of lighting is best for outdoor portraits?

A hazy-bright day provides soft lighting that is flattering to all subjects. Sunlight that is somewhat to one side is better than flat, front lighting. Avoid overhead sunlight in the middle of the day. It casts deep shadows beneath the brows.

CURE FOR SQUINTING

How can I keep subjects from squinting in outdoor portraits?

Don't force them to face toward the sun. You'll get much better expressions by posing your subject in the shade or with moderate side lighting.

HOW TO AVOID DISTORTION

When I shoot informal portraits, sometimes my subject's feet seem out of proportion to the rest of the body or the head seems too big. How can I avoid getting this sort of distortion?

Remember that the parts of the body that are nearest the camera always seem larger than more distant ones—and the closer you are with your camera, the more noticeable this effect becomes. To avoid distortion, pose your subject so no part of the body extends very far towards the camera. If legs are in the picture, for example, choose an angle that puts them out to the side, not straight ahead.

WATCH THOSE BACKGROUNDS!

How can I make subjects stand out from outdoor backgrounds?

Pose them against contrasting backgrounds and avoid cluttered ones that draw too much attention away from the subject. If there isn't a natural background at hand that seems suitable, try using a low angle to shoot up against the sky or a high angle to shoot down against the grass. Selective focus—using a wide lens aperture and correspondingly high shutter speed—often can be employed to blur a background that otherwise might be objectionable.

NATURAL LIGHTING AT HOME

Can I show a light source, like a lamp, in a home portrait to get a natural effect?

You can, and it works very well. If you want to step up its illumination, replace the regular bulb with a No. 1 photoflood. Be sure the bulb doesn't come too close to a shade, or the cloth or paper may be scorched—floods burn much hotter than ordinary lamps. This trick is especially effective if you balance the surrounding lights so the lamp predominates but shadows are not dark in the rest of the setting.

KEEP IT PLAIN

What backgrounds are best for home portraiture?

A plain wall is very good. If you'd like a choice of backgrounds in one place, you can get rolls of wide paper for this purpose and hang them where you want them.

WALL BLENDS WITH FLOOR

How do photographers arrange the backgrounds for those high-key pictures you see where the wall blends right in with the floor?

This is accomplished by using a roll of extra-wide paper as the backdrop. It is suspended high on the wall and then pulled down to cover the wall and extend across the floor.

FORMAL AND INFORMAL PORTRAITS

Which makes the best portrait background, a plain wall or backdrop or a recognizable part of a room?

For formal portraits, the plain background almost always is best, but for informal pictures the setting can help you make your photograph tell a lot more about the subject. Perhaps you can include something that will provide a clue to the subject's hobbies, career or interests.

HOW TO SHOOT YOURSELF

How do photographers take self-portraits?

One way is to take your own picture in a mirror, which works fine if you want to show yourself holding the camera. Print the picture with the negative upside down in your enlarger if you want to make the lettering on the camera read correctly from left to right. Another way is by means of a self-timer, preset to trip the shutter after a measured interval. An extra-long cable release also can be used to good advantage. A mirror is helpful so you can see how you look as you get ready to shoot.

CONTROLLING PORTRAIT CONTRAST IN PRINTING

How do you control portrait printing contrast by exposure and development?

For more contrast, shorten the time of exposure beneath the enlarger and lengthen the time of development. For less contrast, increase exposure and shorten development.

THE "RED-EYE" PROBLEM

How do I overcome the problem of internal eye reflection when using an electronic flash? I consistently get a white spot in each eye of my subject on black-and-white prints.

Most people are familiar with this problem, known as "red eye" when using color film along with direct, on-camera flash. The light from the flash is reflected back by a blood-rich layer at the back of the eye. With black-and-white film, however, the spots are whitish on prints and also unpleasant.

The cure is the same in each case for direct-flash work: Get the flash off the camera, up high enough. It also helps to shoot subjects in a three-quarter-face pose and, if possible, have them look briefly into a bright light in the room just before you shoot. This is so the pupils of the eyes will be somewhat contracted. The problem is, of course, more prevalent in low light, when the pupils of the eyes are wide open.

SHOOTING ON STAGE

Several electronic-flash shots I took of actors on a stage some 30 feet away resulted in their having red-eye. Would removing the flash unit from the camera and holding it a few inches higher solve the problem?

Use a flash-extension cord so you can get the flash off the camera. Then don't settle for inches; instead, hold the unit up at arm's length but angled down at the actors. Another tip would be to shoot when the actors involved are not looking in your direction but somewhat to one side.

All this presumes you are shooting with permission, at a dress rehearsal or at some other time when there is no audience to be disturbed. It should be easiest to get permission to do this with amateur groups, but professional theaters are very difficult in this regard.

CANDIDS OF KIDS

How can I get good, unposed pictures of children outdoors? By the time I get my camera set up and focused, they're usually somewhere else!

First of all, try to interest them in something that will keep them busy within a reasonably limited area for a while. Then have your camera preset for the light that covers that area and for the shooting distance you want to use. As you shoot, don't try to refocus constantly. Instead, lean forward or back to bring the camera to the prefocused distance or to keep the subject within your depth of field.

CATCHING CHILDREN INDOORS

What lighting is best for informal indoor portraits of small children?

If you want to catch them at play, without tying them down to any one spot, you've got to be able to follow them. Flash on the camera is most convenient to use this way. An alternative, and a good one, is to employ bounce light to illuminate the entire area in which you will be working at about the same level.

ANGLE INDICATES ATTITUDE

Suppose I use a very high camera angle for a portrait of a pretty girl and then a very low one. What difference would there be in the picture?

All other things being equal, the high-angle shot might give your subject a more "intellectual" look, while the low-angle view could produce a more "glamorous" effect. A high camera emphasizes the forehead; a low one is likely to create the opposite effect, emphasizing the lips for more sex appeal.

9
SHOOTING INDOORS

BABY IS SAFE WITH FLASH

Will flash hurt a baby's eyes?

Absolutely not, according to Eastman Kodak. The only possible hazard in making close-ups of babies with flash is that very rarely a flashbulb may shatter. The danger of injury from flying glass can be avoided by always using a flash shield.

BOOK SHEDS LIGHT

I am an amateur who wants to go into studio-type color-advertising work for a living. Can you suggest a good book about lighting arrangements for various products?

There's no shortcut, of course, to learning this type of photography. But one excellent starting point is to get and study Kodak's soft-cover book, *Professional Photographic Illustration Techniques* (pub. no. 0-16). This excellent book has a great deal of information on such lighting, plus a wealth of color illustrations made entirely by working commercial photographers. The book's text describes the techniques or approach used to make each specific picture. And in many cases there is also a lighting diagram.

TO PUSH OR NOT TO PUSH

Do you have to develop your own black-and-white film to get good available-light pictures?

Not if you gear your exposures to the standard developing procedures of your photolab. This will cover many types of pictures where light is not too weak. If you decide to take pictures that require special processing, you have a choice between doing your own or patronizing a custom developing service that will "push" the film upon notice that it has been exposed at a given index that is higher than normal.

CHECKING ON THE PHOTO LAB

How can I be sure available-light pictures will come out all right when processed by a photo lab?

Select a lab whose black-and-white work is likely to be consistent, and then make some tests as this chart indicates:

HOW TO CHECK AVAILABLE-LIGHT PROCESSING

1. Arrange suitable subjects in what you consider to be a typical available light scene.

2. Set ASA calibrated meter at index of 400; take careful reading of subject, consulting meter manufacturer's instructions on procedure.

3. Expose two negatives according to the 400 reading. Keep shutter at same speed setting, close lens diaphragm down one stop to obtain an 800 rating, and expose two more negatives. Repeat, closing lens down one more stop to obtain a 1,600 rating. (If it is not possible to adjust exposures in this series by the lens diaphragm, use the next faster shutter speed to move from 400 to 800 to 1,600 ratings.)

4. If possible, consult with the lab before handing film in. Make it clear that you do *not* want any additional development, but want his normal, fine-grain treatment for high-speed films.

5. Providing your exposures were accurate, the average photofinisher's normal processing should produce dense (overexposed) negatives from the frames rated at 400, somewhat thin (underexposed) results from the 1,600 negatives and good results from the 800 negatives.

6. Most photographers will profit from repeating this test, modifying the procedure as the previous test or tests indicate as well as according to individual preferences. And most important of all, if you can possibly help it, don't work in a vacuum, but team up with other photographers.

DEVELOPING BY INSPECTION

Does development by inspection help in processing available-light shots?

It does if you know what you are looking for, which takes plenty of practice. Until you acquire experience, the film should be desensitized in a solution like Kodak's Desensitizer, which does not reduce effective emulsion speed. Even then, film can be inspected only for short periods by very weak (dark-green) safelight. The appearance of the film during development, with its unreduced silver not yet dissolved out, is so different from its normal appearance after fixing that you have to develop a new set of values.

MIXING EXPOSURES, THEN PUSHING

Can you mix regular black-and-white exposures with available-light pictures on the same roll when you know you will have to push the film speed in development?

Easily, if all the pictures on the roll are exposed at the same inflated tungsten index or its daylight equivalent, which is often slightly higher. However, you will obtain somewhat less quality than you would expect if the regular views had been normally exposed and developed on a separate roll. If your roll contains a block of normal exposures followed by a bunch requiring prolonged development, don't give the whole roll extended development. If you do, the normally-exposed negatives will be dense, grainy, blocked-up in the highlights and difficult to print. Try development by inspection instead.

SWITCHING FROM ROLL TO ROLL

How about shifting film rolls?

If you work with 35mm and keep close track of your film rolls, it is possible to shift from one to another in order to keep all available-light pictures on the same roll. When you want to change, note the exposure number, rewind the film into its cartridge—making sure that a piece of the film leader extends out of the cartridge—and then put it away in a container marked with the number of exposures made. When you reload with that same roll, cap your lens and advance to the number at which you took out the film, plus one for good measure to avoid danger of overlapping exposures. Be sure to wind off the same number of blank exposures at the beginning of the 35mm roll.

CANDLELIGHT PORTRAITURE

Can anyone take a portrait by the light of a single candle?

You can do it with an exposure of 1/5 second at f/2. Load with Kodak Tri-X film, place the candle one foot from your subject, and develop normally.

STEADY AS YOU SHOOT

How slow a shutter speed is it possible to use for hand-held exposures by available light without losing sharpness due to camera movement?

Many people can hold a camera steady for an exposure of 1/30 second. By training, however, some can learn to get acceptable sharpness in pictures taken at 1/15 second. At the slower shutter speed you are bound to get a certain percentage of pictures that must be discarded.

FOR SHARP IMAGES AT SLOW SPEEDS

What are some of the tricks for making hand-held exposures at slow speeds?

1. Make sure your shutter release works smoothly; have it repaired if it sticks.
2. Learn to trip the shutter by squeezing it smoothly, not punching it abruptly.
3. Brace yourself or the camera against a solid support like a wall, railing or chair-back when the occasion presents itself.
4. When the camera is hand-held, support it firmly by using a grip that presses it against your cheekbone or forehead or use tension on the neck-strap to hold it firm.
5. Control your breathing; hold your breath during the instant of exposure.
6. Shoot more than one picture. It takes a measure of luck, as well as skill, to come up with sharp hand-held negatives made at slow shutter speeds.

FAST LENSES WITH FLASH

Why use flash with fast lenses? Camera lenses with apertures down to f/1.4 can take pictures under almost any available-light conditions. Why are flash units offered for these cameras?

There are many reasons why photographers often prefer to use flash when available light would do. Here are three: First, depth of field is increased when you use the smaller apertures that flash makes possible, and the increased illumination permits shooting at fast shutter speeds to stop motion. Second, exposure is more certain, since a flashbulb always produces the same amount of light. Third, lighting can be controlled by placing the flash where you need it to get the effect you want.

A BOOST FOR AVAILABLE LIGHT

Can you use photographic lighting to boost available light for picture-taking?

Properly used, flash or flood can increase the brightness of available light and reduce contrast without destroying the feeling of authenticity that existing light creates.

BOUNCE FLASH FOR NATURALNESS

How can you fill in the shadows in available-light situations without washing out the natural light effect?

One good way is by using flash, but don't direct it at the subject. Bounce it instead. If you aim your flash reflector at the ceiling, back at a wall behind you or down at the floor, you can weaken and diffuse its illumination so the natural light still will set the key of the picture. This technique won't work, of course, if the available light is so weak that even bounced flash will overpower it.

MULTIPLE EXPOSURES

How do the professionals take pictures that show a subject going through several steps of the same operation, all in the same photograph?

These are usually made by multiple exposure on a single negative. When the action must be performed swiftly, a series of exposures can be

made with the aid of a stroboscopic light that fires at predetermined intervals. Most action can be posed and separate exposures made on the sheet of film for each step.

GETTING RID OF GHOSTS

How can you avoid a ghost effect in these multiple exposures?

Plan your pictures carefully, using a dark background containing no detail that will show through your subject. Move the subject enough between steps so images don't overlap, unless the overlapping that is common in such pictures will help put across the story you have to tell.

FISH-TANK PHOTOGRAPHY

What sort of lighting is best for pictures of fish in aquariums?

Flash usually is preferred. It avoids endangering the fish by subjecting them to excessive heat over a period of time and is strong enough to permit using small apertures for greater depth of field at the short working distances required.

FISH IN FOCUS

How do the experts get pictures of tropical fish in aquariums? I have trouble keeping them in focus.

Probably the most important of the many tricks in this type of photography is to insert a glass plate behind the fish in the aquarium and move it slowly forward so the fish are confined in a shallow space. This makes focusing easier, although you still have to shoot at just the right instant to catch them where you want them.

ANGLING CUTS REFLECTIONS

How do you avoid getting glass reflections in aquarium pictures?

Don't shoot straight through the glass at a 90-degree angle. Move a bit to one side. Keep light from striking anything in the room that will cause reflections in the glass area the camera takes in. You may find it desirable

to suspend a black cloth in front of the aquarium, positioned to eliminate reflections you don't want.

WAIT TILL DARK

How is it possible to show a large, stained-glass window and the interior of a church, all in the same picture? The window is brightly lighted during the day, requiring only about 1/20 as much exposure as the rest of the scene.

One solution, if you have the time and patience for it, is to set your camera up very carefully and make an exposure for the window. Leave the camera in place and do not advance the film. Wait until dark, and then use a longer exposure to register detail in the building itself by its own interior lighting.

A SWINGING KIND OF PHOTOGRAPHY

How do you make pendulum patterns?

These intriguing pattern shots are made in the dark, with shutter opened for a long time exposure, while a light suspended at the end of a cord traces patterns as it swings in the air. Exposure depends on the brightness of the light and its color. A variety of effects can be obtained —no two patterns come out exactly the same. The camera usually is placed on the floor, aimed upward.

WHEN A BULB GETS OLDER

Can I count on photoflood lamps and studio floods to deliver a fixed amount of light, always of uniform color?

You can expect fairly consistent results with reasonably new bulbs, if these light sources always are used at the same line voltage. Variations in voltage, however, are likely to cause significant differences in light intensity and color. As a general guide, a shift of 10 volts can be taken as approximately equivalent to an exposure change of one-half stop. A voltage drop shifts color toward the red; an increase makes the light more blue. Color studios use voltage-regulating equipment to avoid such changes. For the amateur a more practical approach is to shoot at evening hours when line voltage is unlikely to be depressed by peak industrial and commercial loads, and to use lines within the home that are not shared

by air conditioners, deep-freeze units, and other appliances which use large amounts of electricity. If you use an exposure meter, you will compensate for light intensity changes automatically. Only a color temperature meter will help measure shifts in color and enable you to compensate for them by using color-correcting filters.

MIXED LIGHT SOURCES WITH COLOR

What happens when you shoot color pictures by a mixture of light from different sources?

You get different hues in different parts of the scene. Suppose you shoot in a room lighted half by daylight and half by regular incandescent lamps. The parts of the scene lighted primarily by daylight will be more bluish; those illuminated by tungsten will be more reddish. You can use a filter on your camera lens to compensate for either one of these types of light, but not for both.

UNLOCKING THE HIGH-KEY SECRET

Does everything have to be light in a high-key picture?

For effective high-key work, all tones should be light except a few accents. The pupils of a subject's eyes are a good example—they should appear black.

SHOOTING THROUGH THE CENTER

How is a ring light used?

This doughnut-shaped lighting unit is mounted in such a manner that the camera can shoot through its center. The result is very flat lighting, excellent for high-key pictures or other photos in which high lighting contrast is undesirable.

MORE ON HIGH-KEY

Are special exposure and development techniques required for high-key work in black and white?

Ample exposure and minimum development work together to produce negatives of reduced contrast that are suitable for high-key pictures.

UNWANTED STRIPES

I have tried taking black-and-white photos from my TV set, using a tripod. Unfortunately, every shot showed a broad diagonal stripe. How can I solve this problem?

This stripe is caused by using too fast a shutter speed with a focal-plane shutter. Instead you need a suitably slower one so there is time for the entire TV image to be traced on the screen while the shutter is open. This takes about 1/30 second. So with some focal-plane shutter cameras you might be able to use a 1/30 setting. But with some others you may need to go down to a slower speed such as 1/15 second in order to get stripe-free pictures. At such slow speeds, remember to photograph when action and movement are minimal or nil.

TV COLOR IMAGES

When I make photographs off my color TV—with fast daylight color film—the pictures come out too blue. Is there some filter I should use?

You may only get a slight blue cast with some TV sets. And slight photo correction can be obtained with a skylight filter. More often, however, most people get a strong blue-green cast, in which case try a CC40R (color compensating, red filter with .40 density) that calls for about a two-thirds of a stop exposure increase. A through-the-lens metering system should be able to take care of this. You can use a glass CC40R filter or a less expensive gelatin square. However, if the square is held in front of the lens (rather than in a holder), it's best to have the camera on a tripod. This is a good idea anyway for exposures that are long enough to trace the entire image across the TV screen. With leaf shutters try, at most, 1/30 second. With focal-plane shutters, a 1/15 or 1/8 second exposure may be necessary in order to get the whole picture without any unwanted bands across it.

SCANNING LINES

Is there any way I can eliminate the scanning lines of a TV screen when making photographs?

None, if you want sharp pictures. Our best suggestion is to keep enlargements reasonably small, so scanning lines won't be objectionable.

THEATER PROBLEMS

What developer would you recommend for maximum shadow detail with Tri-X without blocking up highlights? I do a lot of theater photography in low, contrasty-light situations.

Sometimes no developer will save the day; the lighting range is too great for the emulsion. Then you have to decide how to use highlights and middle tones to get a good theater picture. In other contrasty but less extreme cases, Agfa Rodinal, diluted 1:75, works well for Tri-X exposed at ASA 400. At this dilution, the developer is soft working, gives you excellent tonal scale and doesn't block highlights readily. Acutance is excellent and grain pattern on 11×14 prints is moderate if you stick to the ASA 400 rating and enlarge most of the negative. In fact, grain is similar to what you'd normally get with Tri-X and Acufine—but contrast is much lower.

Develop Tri-X for 14½ minutes in Rodinal diluted 1:75 at 68°F. Agitate initially for 15 seconds, then for 10 seconds per minutes thereafter. If you rate Tri-X at ASA 800 and develop for about 16½ minutes, you will pick up somewhat more contrast, and results will be somewhat grainier.

PAINTING WITH LIGHT

What technique can be used when you want to photograph a large interior area and you don't have enough floodlamps to light it completely?

This is called "painting with light." The procedure is to set up your camera to cover the area you want to take in, focus, and select an aperture for a fairly long time-exposure. Then open the shutter and "paint" the entire area with light from a single floodlamp. It may be necessary to walk into the picture area to light distant parts of deep interior scenes. You won't show on the film if you wear dark clothing, keep moving and keep the light aimed away from yourself and the camera.

EXPOSURE WHEN YOU PAINT

How do you determine exposure for "painting with light"?

Select an exposure for the floodlamp you are using at a given distance. An example might be 5 seconds at f/11, with the lamp at a distance of 10 feet. Then move the light at a rate that will make it cover each point in the picture area for approximately 5 seconds from a distance of 10 feet.

IT'S ALL IN BLACK AND WHITE

How can I make silhouette photographs at home?

Pose your subject in front of a light background and direct bright, even illumination over the background without lighting the front of the subject. Another method is to hang a translucent material, like a sheet or tablecloth, over a doorway and light it evenly from behind. This has the advantage of keeping the room containing the camera and subject dark enough so detail in the shadow areas will not be picked up. Exposure should be somewhat less than normal for the background and development should be extended in order to increase contrast.

A TENT FOR SILVERWARE

What is the trick in photographing silverware? I've been trying to get pictures like the ones you see in advertisements, but all I get is the harsh reflections of my lights with black areas in between them.

Professionals often resort to "tenting" for pictures of curved, reflecting subject matter like silverware. They build a tent of white tissue paper on a frame and light it evenly from the outside. The broad expanse of lighted area then is reflected, eliminating harsh highlights and black shadows. Another approach is to spray the silver with a matte, non-glare spray.

COLOR CAST WITH BOUNCE LIGHT

Will bounce light work with color?

It will, but of course you have to avoid bouncing the light off colored surfaces or the picture will be contaminated by an overall cast of the wall or ceiling's particular hue. Even warm-white or cool-white walls and

ceilings can affect the color cast of bounce-light pictures. Many photographers set up pure white cardboards or sheets to direct the light for color photography.

THE EFFECT OF FILL-IN

How does a fill-in light affect exposure?

Most of the time you can base your exposure on the main light and forget about the fill-in, unless both lights cover the same area from the same side and angle. If the latter is the case, and the two lights are at the same distance from the subject, the intensity of light is not double, but 1.4 times the illumination from one light. So multiply your guide number by 1.4; with three such lights, multiply the one-light guide number by 1.7.

FLASH OFF THE CAMERA

What guide number do I use when I take the flash off the camera and hold it 2 or 3 feet away?

The same one you use for flash on the camera. As usual, divide distance of flash from subject into guide number to get the correct lens opening. However, if deep shadows are cast on part of the subject's face and you're shooting in black-and-white, you might want to open up the lens a half to one stop more for extra shadow detail.

MULTIPLE FLASH SHOTS

How do you place two flash units for best results in indoor picture-taking?

In a two-unit picture, one is used as the main light and the other as the fill-in. Often the main light is used on an extension, while the fill-in is on the camera. When both units are of equal power, the main light should be closer to the subject so its light will be more intense. When this isn't practical, reduce the fill-in by draping a white handkerchief over the unit.

FILTRATION FOR WILD COLOR

I've seen abstract color slides showing subjects lighted in different colors—perhaps the main light was a warm yellow and the fill-in a cool blue. How is this done?

Filters are placed over the spotlights or floodlamps used to light the picture. You can get large sheets of cellophane, sold for use in wrapping, which will do the job. Don't mount them so close that they will be damaged by the heat of the lamps.

CLOSE-UP TROUBLE

How can I avoid getting a hot spot in my color slides of close-up subjects exposed by 3200 K bulbs?

Try placing one or two layers of white Fiberglas cloth with a fairly loose weave over each reflector. These pieces of cloth act as "light equalizers" (for flood or flash) and should prevent hot spots caused by using the reflector close up. At the same time, experiment with somewhat different placement of the floods, moving them slightly to the left or right. After making all changes, take new meter readings and bracket exposures.

STARS AND SPIKES

I have seen several pictures taken at night where the street lamps had spikes of light emanating from them. How can I make such photographs?

One point is to be sure that the street lights are reasonably far away so you are dealing with small, strong light sources. Another is to stop the lens all the way down (say to f/16 if this is your smallest aperture) so you get the longest possible spikes around the lamp. Still a third tip is to experiment a bit with your time exposures. For example, when photographing the Empire State Building in New York City, we made a series of exposures at f/16 and 1, 2, 4, 8 and 16 seconds, with the camera on a tripod, using a cable release. Later we found the spikes showed up better around the lamp on the 2-second shot than on the 1-second shot. And at 2 seconds also the amount of background detail was right for the mood. The longer exposures, on the other hand, had more background detail than we wanted. But such long exposures are sometimes the best ones in other cases.

10
NIGHT PHOTOGRAPHY

CORRECT EXPOSURE AFTER DARK

How can I be sure of getting reasonably good exposures at night?

Shoot more than one. After you arrive at what seems to be the best exposure, double it for a second shot and cut it in half for a third. If you're shooting black-and-white or are really flying blind with color, use four times your estimate for the second exposure and one-quarter for the third.

EXPOSURE AND DEVELOPMENT

Is there special processing it would be advantageous to use in night photography?

The principle of overexposure and underdevelopment is useful wherever excessive contrast is encountered—and you find it frequently in night scenes with brilliant lights and deep shadows. If you are bothered by excessive contrast in black-and-white shots, try increasing exposure two to four times and reducing development by one-quarter to one-third.

COMPOSING NIGHT SCENES

Are there any special rules of composition for night pictures?

The usual rules can be followed, or broken, in this field as well as any other. To make foreground objects stand out, show them against contrasting backgrounds. The foreground may be lighted against a dark background or, if dark, shown in silhouette against a lighted scene.

CAMERA IN THE FOG

Is there much you can do with a camera on a foggy night?

101

Clear air shows night lights better, but fog lends an atmosphere all its own. It shuts out the more distant parts of a view, concentrating attention in nearby areas. It softens shadows and puts halos around lights. It gives a feeling of depth as objects at progressively greater distances seem to dissolve into it.

SHOOTING IN THE RAIN

Does the rain change the exposure requirements for a scene?

If you have been exposing to pick up shadow detail, you'll find that you can use slightly shorter times or smaller apertures. If you've been exposing for the brilliant highlights only, the rain won't make any difference except to increase the number of them.

KEEP IT DRY!

How can you keep your camera dry while shooting in the rain?

There's nothing like a helper with an umbrella to shield you and the camera, particularly if he wears a raincoat to keep himself dry and minimize the grumbling. Some shots can be made from doorways and other sheltered vantage points. If you've got to be out alone, keep your camera covered as much as you can and wipe it carefully when you come in.

NIGHT AND SNOW

How does snow affect night photography?

A fresh fall of clean, white snow is an excellent reflector and will give you far more detail by reflecting light into the shadows. Falling snow will have little effect on nearby lights in the scene, but will obscure the most distant ones and blur those that are just near enough to remain visible.

MAKING SNOWFLAKES VISIBLE

What can I do to show snowflakes in the air?

Choose a dark background area against which the flakes will stand out. Then fire a flash, near the camera, at some point during your time expo-

102

sure for the general scene. The flash will show nearby flakes as blobs of white.

STEADY IN THE NIGHT

Do you need a tripod for night pictures?

Brilliantly floodlighted buildings can be caught with hand-held exposures and you can find enough light for snapshots under a bright theater marquee, but some of the most intriguing subjects for night pictures require much longer exposures. A tripod opens up a whole new world of picture-taking after dark.

TIPS ON TRIPODS

Shouldn't a tripod guarantee sharp pictures? Some of mine show blur due to camera movement even though I used a sturdy tripod.

The tripod that is steady under all conditions just doesn't exist—and if it did it would be so heavy you couldn't carry it. If there is a strong wind, shoot between gusts to avoid the vibration it is bound to set up. Wait for the camera to stop vibrating after making exposure adjustments. Don't touch the tripod during a time exposure. Use as sturdy a tripod as you are willing to carry. These are some of the things to watch.

SQUEEZE—DON'T JAB

Is there any special trick to using a cable release?

Indeed there is! Misused, the cable release can cause camera movement instead of eliminating it. Fasten it securely to your shutter. Hold the cable release loosely so it curves. If you draw it taut, you'll move the camera as you take the picture. Squeeze the release smoothly but firmly —don't jab at it. During a bulb exposure, hold the plunger still and keep some slack in the cable until you have released the plunger to end the exposure. Your hand is bound to move some, but a curved cable release will absorb this movement.

MULTIPLE NIGHT EXPOSURES

How can I make several long exposures at night on the same frame of film? My camera has double-exposure prevention and no provision for side-stepping it.

Carry a piece of black cardboard with you or a hat with a black lining. Set the shutter at "time"—this setting is easier to handle here than "bulb" —and expose. If you want to interrupt the exposure briefly at any time, simply hold this black mask in front of the lens without touching it. Remove the mask when you want to expose for another interval. For intervals of an hour or so, a slip-on lens cap can be used if you are very careful not to jiggle or move the camera when removing or replacing the cap.

USING TRIPOD SUBSTITUTES

What can I do if I'm without a tripod and come across a picture opportunity that's too good to miss?

Look about for a tripod substitute. An excellent technique for long time exposures is to hold the camera against a wall, pressing its back into firm contact with the wall. You can get a good idea of what the camera will take in by holding it with its back parallel to the wall and checking through the viewfinder. This trick is especially valuable for taking interior views of buildings where tripods may not be permitted. You can also press the camera against a wall above your head—higher than most tripods will reach—but determining the field of view is more difficult. Face the wall when you hold the camera for this overhead technique. Outdoors you can use the same methods anytime you can find a wall in the right place, at right angles to the axis on which you wish to shoot. Other possibilities include steps, posts, flat-topped railings, automobile window ledges, and almost anything that is steady and of a shape that permits resting a camera on it or pressing a camera against it. An accessory that sometimes is useful as a tripod substitute is a clamp, with tripod head attached.

FOCUSING WITHOUT LIGHT

How can you focus in the dark?

Take along a flashlight to see your focusing scale. Ask an assistant to stand at the point of focus and hold a lighted match or hold the flashlight

while you focus by rangefinder or on the ground glass. If you're alone, you can pace off the distance and set your scale accordingly. Most night scenes contain very distant objects as well as closer lights. To get them all sharply, you can set your camera at its hyperfocal distance for the aperture you want to use or employ its depth-of-field scale.

STEADY AS A ROCK

How can I make rock-steady time exposures if I'm caught without my cable release?

It's easy if you can find something dull and black to hold before the lens. Get the camera set and open the shutter with this black mask in place. Keep it there until the vibration from handling the camera has died down. Then start the exposure by uncovering the lens and end it by covering the lens again before you close the shutter. If your camera has a self-timer device, you can use it to make any of the exposures within range of your shutter settings.

SOMETHING'S GOT TO MOVE

Some photographers take night pattern pictures made up of swirls of light. How is this done?

If groups of lights seem to follow the same pattern, chances are the camera was moved during exposure. Planned camera movement makes fixed lights form streaks on the film.

HINTS ON STREAKING

How do you get pictures that show automobile headlamps as streaks of light while other lights in the scene appear normal?

These are long time exposures. The length of the streaks is determined by exposure time and the speed at which the cars move. Your basic exposure will depend on the fixed lights and the areas they illuminate. You have your choice of taking that exposure in short form at wide aperture or spread out over a longer period with the lens stopped down. For long streaks, choose the long exposure time. Very long exposures on two-way streets, taken in color, can show white headlamps on one side and red tail-lights on the other.

AT DUSK AND TWILIGHT

Is there any special hour that's best for night shots?

There are pictures at any hour in a city, but there are times when some scenes are best. You need a calendar as well as a watch to keep track of them. Early evening is best when you want to show buildings outlined in silhouette against the sky. Shoot well after sunset, but before the sky is dark. If there are many office buildings in a city scene you want to shoot, you'll do better in December than in June. The reason? In summer it still is light just before 5 or 5:30 P.M. when the office workers go home. In December the lights are turned on because it is dusk long before closing time. You'll get many more lighted windows in a December twilight shot.

FOREGROUND FOR NIGHT PICTURES

How can I fill in the foreground of a broad night view of city lights?

Find a lighted building to use in the foreground, if there is one near the best vantage point for your picture. Otherwise, locate a bit of architecture, a statue or some other foreground object, and light it with flash. If you can't find subject matter, ask a friend to pose in the foreground of your picture, looking out at the scene. When you can find it, a pond, a lagoon or the pool beneath a fountain can be used to brighten the foreground of a night picture by reflecting city lights on its surface.

FIRING FLASH MANUALLY

How do you synchronize flash when making a long time exposure?

The easiest way is not to synchronize it at all, but to use the "open flash" technique. The trick is to fire the flash manually during the period your lens is open for the time exposure. If there are people in your field of view, fire the flash at the conclusion of your time exposure. Otherwise you'll find that most of them will move, turning toward the camera after the flash has been fired. This technique permits you to leave the camera to fire the flash from a position at one side of the picture area, which often is an advantage.

OFF-CAMERA FLASH

How can I use flash and still keep pictures looking natural?

The most important thing, probably, is to get the flash off the camera. If part of a street scene needs more light than you find there, think of a logical angle from which it could come. You might place the reflector high at one side to simulate a street light or lower to give the effect of light from a store window.

MAKING SHARP TIME EXPOSURES

How can you get sharp time exposures when people are moving?

Sometimes you can't, but you have some control over the amount of movement you will show. Watch for factors like traffic signals, which control pedestrians and traffic. You can get by with much less movement when people are standing at a crossing or in front of a store window than you can when they are walking briskly.

ELIMINATING MOVING OBJECTS

When is it better to use several separate exposures instead of a single one?

If the scene you want is empty except for occasional passing cars or pedestrians, you can cover the lens during the period when people or automobiles appear where you don't want them and then uncover it again to continue the exposure after they have passed. Opening the lens wider may enable you to make a single, shorter exposure that will catch the scene as you want it. One of the normal hazards of night photography is the fact that something can come up during an exposure and spoil the picture. Watch for such things and make a shot again if you feel it has gone wrong.

TWO EXPOSURES MAKE THE SCENE

How do photographers shoot sunset pictures that are full of bright city lights? It doesn't seem as though so many lights would be turned on so early in the day.

Probably they weren't! Pictures that show striking sky effects plus city lights often are taken with separate exposures, as much as an hour apart.

The procedure is to shoot the sky first, giving the minimum exposure for it so buildings will be silhouetted. The camera is left on its tripod, carefully guarded against stray dogs and small boys, until the sky darkens and the lights come on. Then a second exposure is used to record this part of the scene. The tripod must be a good, solid one to avoid any camera movement between the first and second exposures.

DARK SKY, BIG MOON

How can you get a big image of the moon in the sky above a night view of the city?

Those very big moons are obtained by using a lens of great focal length. One way is to take the entire picture with such a lens, selecting a distant viewpoint that enables you to take in as much of the city as you want. Another is to use separate exposures on the same film, shooting the city scene with a normal lens and leaving room for a large image of the moon. Then the moon is inserted by making a second exposure for it with a long-focus lens.

HOW FULL THE MOON?

Can you take pictures by moonlight?

Yes, if you're willing to make long time exposures. It calls for leaving the shutter open several minutes or more, with the lens wide open, depending on how clear the air, how full the moon, how fast the film and how anxious you are to be off to bed.

MOON PORTRAITURE

What exposure does the moon itself require?

To show detail in its face, you need about the same exposure you would use in photographing an average scene in daylight with the film that is in your camera. Two or three times this exposure will give a brighter image with less detail.

HEAVENLY DIRECTIONS

With so short an exposure required for the moon, how can you show it in scenes that take a much longer exposure?

By double exposure. If the moon is in the sky just where you want it, compose your picture and use a short exposure to catch the moon. Leave your camera just where it is on its tripod and wait until the moon moves out of the picture area. Then expose again for the general scene. You can reverse the order of exposures, shooting the scene first and then adjusting the camera to place the moon where you want it.

THE SKY WENT BLACK

How are sharp, contrasty moonlight scenes photographed?

They're usually faked. The photographer shoots by sunlight or at dusk while deliberately underexposing the scene and uses a filter to make the sky go black and increase contrast.

FAKE SCENES WITH FILTER

What filter is used for faking moonlight scenes?

A deep-orange or medium-red filter is used, and exposure is a fraction of normal.

REAL BUT FLAT

Why do scenes photographed by real moonlight seem so flat?

The long exposure they require gives the moon time to move quite a distance. Hence there are no sharp shadows and the lighting lacks the contrasty appearance you see when you look at a moonlit scene itself at any one moment.

ARCS IN THE HEAVENS

How do you photograph star trails?

109

Set up your camera, focused at infinity, on a clear and cloudless night. Make a long time exposure. If you aim toward the North Star, the paths of the stars will trace arcs of circles with their centers near it.

EXPOSING FOR STAR TRAILS

What exposure should you use for star-trail pictures?

An aperture of f/4.5 is a good one with which to start; wider ones give fatter trails while smaller ones make them thinner. Exposure time determines how long the trails will be. At the North Pole you could expose for 24 hours in winter, and stars near the North Star would trace complete circles.

INTRUDERS IN THE SKY

I've been experimenting with star-trail pictures, leaving the camera out on our back porch for several hours at a time. One of my negatives shows something new added —a broken line, like a series of dashes, which curves across the picture. What could this be? Did I catch a flying saucer?

Sounds more like a plane passing by, with its blinking navigation lights creating the series of dashes your film recorded.

THE TRAILS WERE BROKEN

What causes breaks in star trails? In one of my pictures, some trails near the top of the negative are broken while others are not.

If somebody held his hat over the lens for a few minutes, all the trails would be broken at the same point along their length. With only part of them broken, it is possible that someone stood in front of the camera and obscured part of the sky for a while or a cloud passed by and accomplished the same thing.

STAR EFFECT AT NIGHT

What makes distant lights look like stars in night pictures? I have one in which the lights have ten lines like points radiating from them. The effect appears in some pictures, but not in others.

Diffraction—bending of light as it passes close by opaque objects—causes this effect. The opaque objects are the ten segments of the lens diaphragm. At medium and wide apertures, the amount of diffraction is insignificant in comparison with the total exposure and the effect is not produced. At very small apertures, diffraction is greater. More of the light is bent to cause visible streaks.

SCREENING THE IMAGE

Is there any way you can get these radiating lines without stopping down all the way?

You can get them much more easily by mounting a piece of metal window screen in front of your lens. It will give you a four-pointed star. Two pieces of screen, mounted at a 45-degree angle to one another, will create an eight-pointed star. Screens of different-size mesh will provide variations.

BY ROCKETS' RED GLARE

How do you get fireworks pictures? Mine sometimes show only parts of the best rocket bursts.

The secret of taking brilliant fireworks shots is to mount your camera on a tripod, aim it at the sky area where the display appears, and then use a long time exposure to catch each burst. For an especially exciting effect, leave the shutter open while several rockets explode, one after another. You'll get them all in one picture that looks as though the rockets all went off at once.

FOREGROUND FOR FIREWORKS

How do you show lighted foregrounds in fireworks pictures?

First of all, find a place where there are both fireworks and an appropriate foreground. An amusement park can offer both. Choose a viewpoint which will show the foreground area you want and also cover the sky where the display will appear. Compute the exposure for the foreground at f/3.5 for slow color film or f/8 or f/11 for medium-speed panchromatic. When the fireworks start, open your shutter to catch a burst and keep it open long enough to expose the foreground properly. It's better to risk overexposure, however, rather

than terminate the exposure when one rocket burst is only half-opened in the air.

SHOOTING OUT OF FOCUS

I've seen night pictures in which lights appear as round blobs. How is this effect obtained?

By deliberately throwing the camera out of focus. Sometimes a straight exposure is made first and then an out-of-focus one is superimposed upon it. Related effects can be obtained by shooting through patterned glass.

VIEWPOINT WITH WINDOWS

How can I avoid distracting reflections in night pictures of lighted store window displays?

Professionals sometimes work with a pair of assistants, who stretch out a long, wide black cloth behind the camera to cut off the light which causes the reflections. You can keep reflections at a minimum by choosing your viewpoint with care. If you're on assignment, you can work very late when most window lights across the street have been turned off. A polarizing filter, mounted on your lens and rotated to the proper angle, will help cut down certain types of reflections. Finally, if you're after pictorial effects, you may be able to make the reflections serve as part of your picture.

LIGHTING BIG AREAS

Is it possible to illuminate a whole city block for a night picture?

The professional would be likely to tackle such a problem by stringing up a long line of flash units to do the job. If there isn't too much incidental light from windows and street lights, you can get the same effect without nearly as much equipment. Compute the longest time exposure possible for the lights that appear in the scene. It should be at least a minute or two to give you time to work. Set up your camera and open the shutter. Then walk right through the scene, firing flashes at intervals to cover everything you want to take in. Plan on keeping the flash far enough away from important areas along the way to give them correct exposure

at the aperture you use. Aim the reflector away from the camera so the direct light of your flashes won't record on the film. If there's no significant incidental light in the scene, you can select any aperture that will give sufficient depth of field and will make it possible to cover the area you want with the fewest number of flashes.

PAINTING WITH LIGHT

Is there any way of picking up detail in shadows of a night shot when there is a special reason for it?

If you plan a long enough exposure for the general scene, you can highlight an important detail within it by "painting" it with light from a flashlight at close range. Walk right into the scene during your exposure. It is important to wear dark clothing and to keep the flashlight turned away from the camera. Don't stand between the camera and the detail you want to catch.

DAYLIGHT FILM AT NIGHT

What color film gives the most accurate color rendition in night pictures?

Daylight film will give you more normal skies in early evening pictures, while rendering the lights somewhat strongly in red and yellow. Tungsten film makes twilight skies seem more blue than they appear to the eye, but gives more accurate color with incandescent lighting. Flash-balanced film is a compromise between the two. Don't ever pass up a chance to shoot an interesting night scene because you happen to have the wrong color film in your camera. You may find you like slightly distorted colors better than more accurate reproduction of the hues within the scene.

VARIATIONS IN NOCTURNAL EXPOSURE

Do night scenes call for accurate exposure?

Probably not, in comparison with other types of pictures. The contrast within a night view is so great that something is bound to be exposed right, and something is bound to be exposed wrong. If you were to select an exposure that would render the brightest highlights in a scene correctly, there would be little detail in areas around them and none at all

113

in the shadows. By overexposing the brightest lights a bit, you can pick up nearby detail that otherwise would be lost.

A SHADE MAY HELP

Is there any point in using a lens shade at night?

Perhaps even more than in daytime. Night scenes often contain lights, sometimes thousands of them. There are likely to be other lights around the scene you're shooting. A lens shade will reduce flare to a minimum and help you get better picture contrast.

11
SPECIAL EFFECTS

LOOKING THROUGH A PERSON

What trick is used to take "ghost" pictures? In one that I saw of a man at a piano you could see the keys right through his body.

Most such ghosts result from double exposures. Set up your camera on a tripod and make one exposure of the background without your subject in view. Then without advancing the film, make a second exposure with the subject in place. Plan the picture so something very light, like those piano keys, appears behind the subject. Then you can be sure your "ghost" will appear partially transparent. If your subject is posed against a completely black background, he won't have a ghostly appearance for there will be nothing to show through him.

THE WATER-DROP LENS

Is it true that you can take pictures by using a drop of water as a lens?

It is, and interesting pictures can result. The best way to do it is not to try to use the water-drop lens alone, but to photograph the image that it forms with your regular camera. A window screen that has been sprinkled with water supports dozens of tiny lenses, one at each aperture of the screen. By setting up your camera to make an ultra close-up of the screen, you can show many small images of the scene outside. Drops of water on a dark surface also can be used as lenses—reflecting lenses. Each will show a small image of things in view.

IN THE PALM OF YOUR HAND

I once saw a picture of a man holding a girl in the palm of his hand. How is a trick like this accomplished?

There are at least two ways. The simplest is to make a single shot by posing the man in the foreground with his palm outstretched and the girl

standing farther away at a point where she appears to be standing on his hand. Minor adjustments can be made by having him raise or lower his hand as you get set to shoot. By using a black background, you can get the same result with two exposures on one piece of film, and you can even show the girl holding herself on her own hand if you want to. Here the trick is to use a camera with ground-glass focusing and to pose the foreground figure with outstretched hand. Mark the position of the hand on the ground glass and make the foreground exposure against the black background. Then move the camera back, still using the black background and keeping light only on your subject, until you get the size image you want to show. Adjust the position of the subject and the tilt of the camera until the girl is standing on the line you have marked on the ground glass. Then make the second exposure. If you wish, you can make exposures on separate sheets of film, always with a black background, and then align the figures accurately as you sandwich the films together for printing.

SECRET OF SHADOWLESS LIGHTING

What is the trick of getting perfectly shadowless pictures with a single light?

A single light casts shadows, of course, but you can eliminate them by moving the light during exposure. Swing it in a circle around the camera, and it will fill in its own shadows quite effectively.

PUTTING CLOUDS WHERE THEY AIN'T

How are clouds printed into pictures that have empty skies?

Separate negatives are used for scene and sky. First, print the foreground scene while holding back the sky area. If its edge is a simple one, you can hold back the light by dodging with your hands. If it is more complicated, like a jagged city skyline, you may prefer to cut a mask to fit the skyline and move it slightly to avoid a harsh line during exposure. Next, cover the paper on the easel with opaque white paper, turn on the enlarger and sketch in where the foreground edge falls. Remove the negative in the carrier and insert the sky negative, moving it slightly to make its image align with the sketch. Turn off the enlarger and remove the covering paper. Now print in the sky area, again holding back light but this time shielding the foreground part of the picture. Use a mask if necessary. The result will be one print containing both foreground and

clouds. It pays to rehearse beforehand, making test strips to determine the exposure for foreground and for clouds.

CATCHING THE CUMULUS

How do you shoot cloud negatives?

First of all, you need a day when there are well-defined clouds in the blue sky. Use a filter to make them stand out. You may want to make up a collection of different types of clouds to fit pictures with different moods. Include a bit of the horizon. It will help you get the clouds right-side-up when you print them and will keep you from shooting clouds straight overhead. They just don't look right when you move them down to the horizon in printing pictures.

HOW TO IMAGE WRITING ON PRINT

How can you write on sensitized paper and get a photographic image of the writing?

Assuming that you want only the writing and not writing in combination with a picture, you can get black writing on white paper or white writing on a black background, whichever you prefer. For black writing, apply developer to the sheet with an ordinary pen in regular room lighting. The paper will burn black where developer has been applied. Fix the sheet in hypo to keep the background from darkening later on. For white writing, use a concentrated hypo solution, also in a lighted room. Then develop to darken the background and fix as usual.

BLACK AND WHITE ALL OVER

What exposure do you use to get silhouettes?

It isn't as much the exposure as the lighting that produces silhouettes. To get them the subject must appear dark, before a lighter background. Expose for the light background, using the minimum necessary exposure to be sure you don't pick up unwanted detail in the subject.

117

PICTURES WITHOUT A CAMERA

How do you make photograms—those black-and-white pictures exposed without a camera?

The basic technique is to place a sheet of sensitized paper on a table, place your subject matter on it, and then expose by the light of a single lamp placed overhead. Opaque objects appear white against a black background. When transparent or translucent objects are used, you are likely to get some middle tones as well as black and white.

EXPOSURE FOR PHOTOGRAMS

How do you determine exposure for a photogram?

Usually by test. The exposure is not at all critical, unless you include very thin materials or ones that transmit enough light to create middle tones. As a starting point, exposure is generally right if the background areas go entirely black upon development and the light areas remain pure white.

"A RAG, A BONE, A HANK OF HAIR"

What makes good subject matter for photograms?

Practically anything that will fit on the size paper you want to use. Small objects like marbles, bearings, tacks, grains of rice or wheat or kernels of corn often are arranged to create patterns. Larger objects like leaves and flowers may be shown for their own designs. You can even show a person in silhouette by this technique. Mount the paper on the wall and use the beam from your enlarger or projector to expose it in an otherwise darkened room with the subject posed in profile directly in front of the paper.

GETTING ALL THE DETAIL

Is it at all possible to show detail within objects in photograms?

This can be done if the objects are thin enough and transmit enough light. You can show the vein structure of leaves, for example, much as you would expect it to be revealed in an X-ray picture.

WAY-OUT AND NON-OBJECTIVE

What about making photograms without any subject matter as such?

These pictures are made by "painting" the image with moving lights or by holding back light from the paper with different materials. Variations in the transmission of the materials and in exposure times when materials are moved between several exposures are factors that are employed to achieve different tones.

PHOTOGRAMS WITH A CAMERA

Can you make photograms in a camera?

You can, either by loading it with film in the conventional manner or by employing fast enlarging paper instead. You can set up the camera in a darkened room, open its lens, and write your name in the air with a pocket flashlight. If you keep within the area the camera covers, everything you trace with light will appear in the picture. In much the same manner you can create abstract designs or pendulum patterns, made by swinging a light suspended from a cord.

ADDITIVE EXPOSURES ELIMINATE PEOPLE

How can I get a picture of a new building, on a street that is busy when the light is best, without showing pedestrians and traffic?

This trick isn't at all difficult if your camera permits making a number of different exposures on the same film. Use a slow film and the longest possible exposure for the existing light, like 1/30 second at f/22. Use the indicated lens aperture, but break up the exposure time into many small segments. Thus you might employ seventeen separate exposures of 1/500 second each, for example, to get a total of 1/30 second. Mount your camera firmly on a tripod and make the exposures, one after another, at moments when the area is relatively clear of traffic. Only objects that remain still for all the exposures, like sidewalks and buildings, will appear in your picture. People and cars, which move away after 1/30 of the exposure, will disappear. Any shutter except the focal-plane type is likely to give denser than normal negatives when used with the lens at small apertures in this manner. So don't be surprised if your first negatives made in this way come out slightly overexposed.

119

TWO PORTRAITS ON ONE FRAME

How do they take pictures that show a person twice? I saw one of a girl sitting across a table having lunch with herself, and she wasn't twins!

This type of trickery is based on double exposure. A little more than half the camera lens is covered with a masking cap you can make of black paper. It should be placed so that the edge of the covered area is vertical. With the left side of the lens covered, the left half of the film will remain unexposed when the picture is taken. Mount the camera on a tripod, focus on the picture setting, and place your subject in the right half of the scene to make your first exposure. Don't advance the film. Now rotate the improvised lens cap so the right side of the lens is covered and pose your subject in the left half of the scene to make the second exposure on the same film. When you are through, the same person will appear twice. There probably will be a faint line down the center of the picture, unless you happen to have cut the mask just right the first try. If the line is dark, the opening should be widened very slightly by trimming the vertical edge of the mask. If it is light, the two exposures overlap and the opening should be made a little bit narrower. If you are surprised to find that nobody at all appears in the picture, you have covered each side of the scene while the subject was posed in it by masking the wrong side of the camera lens.

LONG EXPOSURE CAPTURES LIGHTNING

How do photographers manage to catch lightning flashes in pictures?

This takes a combination of skill and luck—luck in having a flash occur while your shutter is open and aimed the right way, skill in having the camera set up right to catch it. When there's a thunderstorm in the air, set up your camera to take in an interesting area, like the skyline of the city. With medium-speed black-and-white film, use a fairly small aperture like f/16 or f/22, which will permit a reasonably long time exposure without burning out parts of the film and still will be large enough to register the lightning. When you think lightning may strike within the area your camera covers, open the shutter for a time exposure. Leave it open until the lightning does flash or until you feel the scene has been overexposed by other light within it. Then change the film and try again. It's amazing how many good lightning shots are made in spite of the difficulty in predicting when and where lightning will strike.

Holding the camera steady is imperative when using slow shutter speeds. Beauty contest winner (and an admirer) at Eskimo-Indian Olympics in Fairbanks, Alaska, were photographed at 1/30 second, *f*/2.

PHOTOGRAPHS BY HARVEY V. FONDILLER

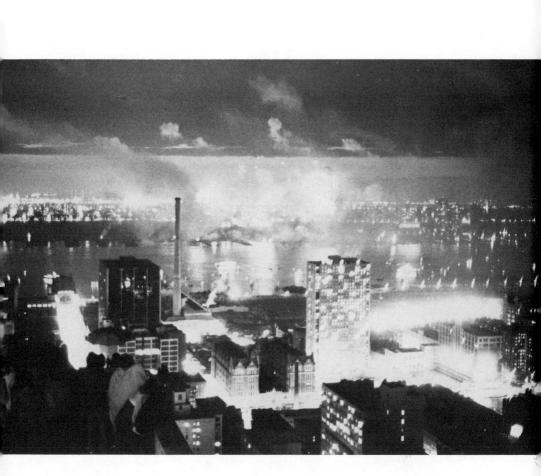

Fireworks at a Fourth of July celebration (*above*) were photographed by bracing camera against a wall; exposure was 1/2 second at *f*/2 on ASA 400 film. Overexposed areas in bottom half of the picture resulted from lights of office windows and moving cars. *Left*: fast focusing and shooting enabled the photographer to capture the momentary pause of sightseers inside the collossal statue of Morelos on an island in Lake Janitzio, Morelia, Mexico.

Appealing pictures of youngsters can be made almost anywhere. *Below*: prize-winning photograph of a little girl with flowers was made in Dinkels- bühl, Germany. Edges of the print were darkened slightly by printing-in during enlarging. *Right*: a twin-lens reflex with close-up attachment was used for portrait the photographer made across the street from his home in New York.

High-tension wires and towers are silhouetted against the sky, which was given sufficient exposure so that it would not register blank-white. *Facing page*: fast shutter speed (1/500 second) "froze" the whirling motion of a carnival ride, and slow-speed exposure (1/15 second) accentuated the blur. Automatic exposure mechanism of the 35mm single-lens reflex camera changed the shutter speed after the diaphragm was set manually.

Facing page: these pictures, made within a minute of each other, show how a slight variation in viewpoint and subject position can change the composition. The photographs were made from a bridge in a park at Düsseldorf, Germany. *Below*: a telephoto or zoom lens can be used to advantage with distant subjects such as this skindiver in Nassau, Bahamas.

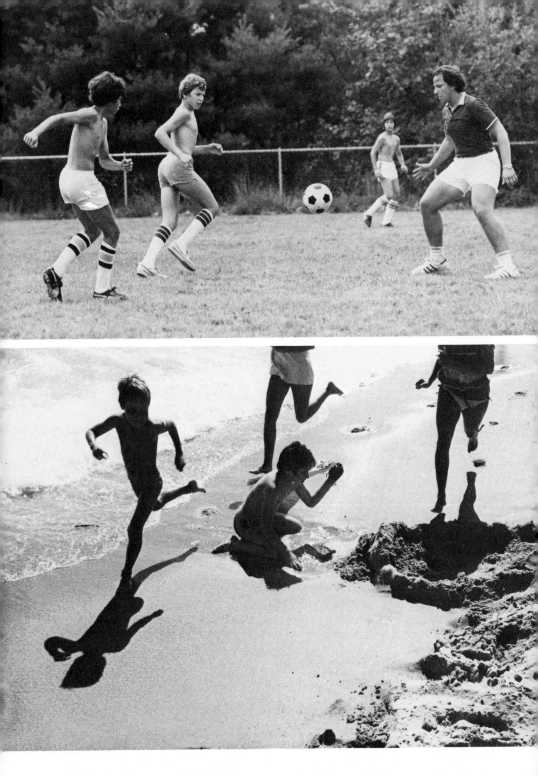

Action shots require fast shutter speeds (at least 1/250 second) and a sure sense of timing to catch the action at its peak. Soccer game (*top*) was photographed at a boys camp in Maine; beach picture with children running was made at Cannes on the French Riviera.

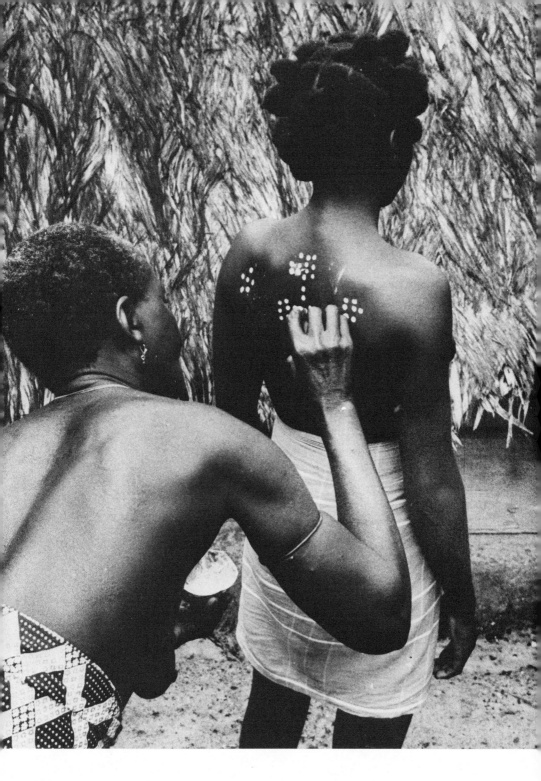

Native customs are often the subjects of interesting travel pictures. The tradition of decorating marriageable girls still survives in the Djuka tribe of Bush Negroes in Surinam, though many other ceremonies have disappeared.

Below: available light was the sole illumination in a London pub; this candid shot required quick focusing and shooting. *Facing page*: photograph in Windsor Castle, England, was made covertly, since picture-taking is forbidden there, as in many other museums and public buildings. First, adjust focus; then shoot inconspicuously and keep the camera out of sight between shots.

Whatever the subject, light makes the picture. Photograph of the venetian blind is a ''found'' picture. The composition with kitchen knives was ''made'' by placing the knives on a chair seat so that the largest one caught the reflection of window light.

Exposure of 1/30 second at $f/2$ on ASA 400 film captured the picture of candles in a church in Seville, Spain. Bottom photograph was made during a performance that combined live action with motion pictures and slides in Carnegie Hall, New York.

"Blind Minstrel," photographed at Acapulco, Mexico, required extensive dodging and burning-in to alter the original tonal values. The objective was to concentrate emphasis on the musician's face and hands.

THE ILLUSION OF MOTION

How do you get a little blur in such moving objects to make them seem more real? When they're absolutely sharp, the picture looks faked.

By moving the objects or the camera very slightly at the instant of exposure. If part of the picture must remain sharp, of course the camera can't be moved.

BACKDROP FOR MULTIPLE EXPOSURES

How is a black backdrop used in trick photography?

A big black backdrop is handy whenever you want to combine subject matter taken in two or more exposures. If you keep the background dark, you will have nothing showing through your subject matter. You can combine exposures on a single piece of film, if you wish, or you can make separate shots and then sandwich the films together as long as the pictures are planned so objects that show don't overlap.

WRITING ON NEGATIVES

How can you get writing as a part of a picture?

Use a fine pen and waterproof India ink, and write on the negative in an area that will print dark so the writing—which will appear in white —will stand out against it. If you write on the film base (the shiny side), your lettering will be correct in the finished print.

MAKING A BAS-RELIEF

What is the trick for making pictures come out in bas-relief, like the surface of a coin?

You start with the negative and make a contact print of it on another sheet of film. Reduce the development somewhat below normal so the film positive has less contrast than the negative. After it has dried, bind positive and negative together, slightly out of register, and print them by contact or in the enlarger. The effect can be changed considerably by varying the amount and direction that one film is shifted out of register in relation to the other.

WITH THE GREATEST OF EASE

How do professional studios make shots that seem to catch things flying through the air?

You can actually catch them in mid-air with electronic flash or by using a high shutter speed, but for better control most studio shots of this type are made by suspending the objects by black threads or wires and using a dark background so the trick won't show. Occasionally the picture can be arranged upside down, with objects suspended from the "floor" instead of the ceiling.

IMAGES THAT SEEM TO FLOW

What technique is used to produce pictures in which the image appears distorted by flowing, as though the subject matter were melting?

This description of the pictures fits the process, too. The emulsion is heated until it becomes soft, and then the film is tilted to make it run in a pattern. Next, the film is placed on a flat support to cool. Don't use a bare flame; the film will burn. Hot water can be employed or the blast of hot air provided by a small hair dryer. Film fixed in plain hypo without hardener will be easier to handle and will require less heat. Whenever experiments of this nature are made, it's best to work with copy negatives rather than irreplaceable originals so that you can modify your techniques and compare the results.

SOLARIZED PICTURES

What makes some pictures come out part positive and part negative?

This is commonly referred to as solarization. The film or paper is exposed in the usual way and partially developed under normal darkroom conditions. Then it is exposed briefly to light, which may be weak and diffused and may be colored. Development then is carried on to completion and the film is finally fixed and washed in the usual way.

GETTING A POSTER EFFECT

How can I take pictures with a poster effect, getting black and white and only a few gray tones in between?

Shoot with contrasty film and the minimum exposure required, as much as three or four stops below normal. Develop in a vigorous developer, as much as one-third more than normal time. Print on hard paper. If you find you want to carry the effect further, make a duplicate positive by contact printing your negative on film with underexposure and over-development, and then repeat the process to get a duplicate negative with still more contrast.

HOW TO DISTORT THE SUBJECT

I've seen some pictures in which the subjects were grossly distorted in different ways. How are such pictures taken?

There are several ways of introducing distortion. One is by shooting through glass of irregular thickness—glass bricks may be used. Another is by photographing reflections in curved mirrors, which can vary from the large ones found in amusement parks to curved ferrotype tins. Still another approach is to curve the paper on the easel when making an enlargement, using a small aperture for depth and dodging the high areas to get even density throughout the picture. To get distortion pictures that show people with enormous hands, feet or nose, shoot with a wide-angle lens from a viewpoint very close to the subject. The feature to be exaggerated, of course, must be closer to the lens than the rest of the subject.

123

12
COPYING

HOW TO FILL THE FRAME

Do cameras require special attachments for copying?

Not if the object to be copied can be photographed to fill most of the frame at the minimum focusing distance for your camera. Cameras with interchangeable lenses can generally be fitted with extension tubes to do the job. A convenient outfit to use is a single-lens reflex camera.

TUBES AND COVERAGE

Where can I get data for use of the extension tubes with 105mm and 135mm lenses?

It's easy to get approximate horizontal coverage figures yourself. With the right tube or tubes in place between the SLR body and the lens, just look through the camera's viewfinder, using a suitably long ruler as your target in good light. To get the *minimum* coverage for each particular setup, first set your lens to the closest focusing distance. Then move the whole rig in or out until the figures on the ruler look sharp and note the total area covered from left to right. To get the *maximum* horizontal coverage for the same tube (or tubes), repeat the operation but with your lens set to infinity.

Then go on and get other maximum/minimum figures. Most SLR 35s will actually give you a bit more coverage than you see this way. If this is needed, be sure to make pictures (with the camera on a tripod) of the ruler for each setup. Then after the film is developed, you will see the exact amount of horizontal coverage obtained.

PROBLEM WITH GOING CLOSE

When I put a bellows on my SLR 35 and add my 50mm lens at the end, why can I only make ultraclose-ups? Why can't I use the rig for less extreme close-ups and non-close-up work?

The problem here is that you can't rack the lens back far enough to get out of the ultraclose-up world. Even when the bellows has been com-

pacted as much as it can be, that lens still sits out too far from the camera. You can, however, switch to a special longer lens, designed to let you range from infinity down to the close-up world. This may be down to life-size images (1:1) in some cases. But your focusing range depends on the bellows/lens combination. Two basic lens characteristics provide this freedom. One is the longer focal length of the lens—often in the 100–150mm range. The other is the suitable physical shortness of the lens, which has a diaphragm but no focusing mount.

RECORDING ARTWORK

I want to copy some of my own paintings with color-slide film. What is a good way to do this indoors with an SLR?

The first item on your list should be a tripod or some other means of supporting the camera firmly. It would also be wise to acquire a cable release or reduce vibration by using your self-timer to make the exposures. Whatever light source you use should match the type of color-slide film. One combination used by professionals is Kodak High-Speed Ektachrome Tungsten (3200 K) film with 3200 K No. 2, 500-watt floods.

Typically, the painting is placed upright, parallel to the camera's film plane. Two floods (each in a reflector) will do, on opposite sides of the painting and at 45-degree angles for even lighting. Another wise procedure is to take an exposure reading off an 18-percent gray card or make an incident-light reading with the sphere aimed back (as usual) at the camera position. And remember: Bracket exposures by half-stop changes as small changes can be significant. And shoot very late at night when there is little drain on power to avoid color shift due to voltage drop (or use a voltage regulator).

FOCUSING AND CONVERTERS

I have an SLR 35 with a split-image rangefinder-focusing spot in the viewfinder. However, when I use an 85–205mm zoom lens with a 2X lens converter, half of the split-image spot blacks out, and I am unable to use the rangefinder for focusing. What is going on?

One fact of life here is that no blackout occurs when the zoom lens is used alone, and focusing is done wide open because then the effective aperture is wide enough for the rangefinder-focusing system.

But another is that when you add a 2X extender, you make the effective aperture two f-stops smaller. And if this is smaller than the focusing aperture required by the particular screen, blackout will show up in one

125

of the rangefinder halves. So if you must use the lens extender, learn to ignore this blackout and focus by using the ground glass around the center.

BLUEPRINTS TO BLACK AND WHITE

How can I copy blueprints in black and white so they will be legible? Pictures of them which I have taken make the blue background come out almost as light as the white drawing and lettering.

Blueprint contrast can be improved by copying through a red filter. This technique makes blue come out almost black.

ELIMINATING STAINS WITH FILTERS

I use a rubber stamp on the backs of my pictures, but sometimes the stamping ink transfers from the back of one photo to the face of another. I have lost the negative of one of my pictures that is stained this way. How can I make a copy negative without showing the red stain?

Photograph the picture by copying it through a red filter on panchromatic film. This will make the stain less noticeable and may eliminate it altogether. Any stain can be eliminated, or at least made much less apparent, by copying with a filter of the same color as the mark you want to avoid. You can get a good idea of how effective a given filter will be by looking at the print through the filter. Try a filter that is slightly darker than the stain.

COPYING TO IMPROVE ORIGINALS

Aside from stain removal, can black-and-white prints be improved in copying?

You can control contrast and overall tone of the print, making it lighter or darker than the original. When enlarging, you can make individual areas within the picture lighter or darker by dodging or burning-in beneath the enlarger.

CONTRAST CHANGES WITH COPYING

How does copying affect contrast?

Unless you deliberately strive to reduce it, contrast usually is increased in making black-and-white copies. When an original is excessively con-

126

trasty to begin with, use a low-contrast film, maximum exposure and minimum development.

CHOOSING THE RIGHT EMULSION

I've heard that some photographers use high-speed films for copying. Why should they do this when they could just as well use slower films and more exposure?

You're right as far as exposure is concerned, but these photographers are more interested in contrast control. It happens that many high-speed films also are low in inherent contrast, much lower than slow films. Photographers choose them for copying when an original is excessively contrasty.

BRACKETING SLIDE DUPES

What is the best variation to use when you want to "bracket" an exposure in slide duplicating?

About three-quarters of an f/stop is best. This produces enough variation to be significant, yet not so great a variation that the result you want is likely to be lost somewhere between two expsoures.

IMPROVING COLOR SLIDES

How do you know what filters to use to improve color slides in duplicating?

Use a filter of the color you want to add or one that is complementary to the color you want to remove. You can estimate the effect by looking at the slide through filters you are considering, holding the filters up to your eye, not on the slide. This effect is a bit hard to evaluate, however, for the filter will darken the slide and make it appear more dense than the duplicate will be.

ELIMINATING EXCESS MAGENTA

What filter should I use to get rid of a magenta cast?

Reducing magenta calls for the use of a filter in the green series.

127

BALANCING THE FILTER PACK

How many filters can you use in duplicating a slide? Isn't there loss in sharpness if you add too many?

There is, and the filters should be kept to a minimum. One way to do this is to remember that your filter pack can be used as a part of the correction. If you want to add a color that is complementary to one you already have in the filter pack, don't add another filter. Instead, remove part or all of the complementary filtering. Thus if you want to add magenta and already have green in the filter pack, you can achieve the same result by removing part or all of the green.

RECIPROCITY FAILURE IN DUPING

I've heard of reciprocity failure in color films. Is it an important factor in making slide duplicates?

Reciprocity failure results in color variations when films are given extremely long exposures or very short ones, even though the exposures are mathematically equivalent. You can avoid having to consider it at all in slide duplicating by arranging your setup so that exposures will not exceed three seconds in duration.

WHY COPY A PRINT?

Is there ever a reason for copying a print when you still have the original negative?

Often. It may be desirable to make corrections that can't be handled by retouching the negative. In this case a print is made, and the alterations are made on it before copying. Again, it may be desirable to combine several different photographs, along with artwork. Copying a paste-up of all these elements may be the best way to get the job done.

RETAIN THOSE DETAILS

Is there anything special to watch out for in making a print that you know will have to be copied?

The most important thing is to keep its contrast low. Hold plenty of detail in both highlights and shadows, even though the print won't exactly sparkle. This will help you to avoid ending up with a copy that contains too much contrast. You can always increase contrast easily in

128

copying, but it is more difficult to reduce it. Copying can't capture detail that isn't there.

FROM ROUGH TO SMOOTH

How can you get good copies of pictures printed on rough-textured papers? I've tried, and the paper texture of the original shows up in the copy.

You can eliminate the texture by careful control of the lights you use for copying. Some textures require additional preparation—covering the print with vaseline or mineral oil, or immersing it in a tray of water and copying from directly overhead. The oil or water will fill in the surface irregularities that create the texture, making the roughness invisible when lights are properly placed. In experimenting with lights, always view the print from camera position so you see it as the camera sees it.

COPYING FADED PHOTOS

How can I bring out more detail in copying an old photograph that is badly faded? It is very light in tone all over.

This is one of the rare instances when you want to gain contrast. Use a slow, medium-contrast film. Give the copy negative somewhat less than full exposure and use somewhat more than normal development time.

PRESERVING THE ORIGINAL FEELING

What can I do to make copies of old-time pictures seem more authentic? I've made some excellent ones that are clear and sharp, but they don't look natural.

Finish and mount such pictures in the style of the period they portray. You might use a selenium or sulfide toner to approximate the hue of a sepia original. Choose a paper with texture and base color in keeping with the original. Search secondhand stores and antique shops for suitable frames or cases.

SLIDES OF BLACK-AND-WHITE PRINTS

I've heard that one can make good slides of black-and-white prints by copying them with color-slide film. Is this true?

129

Yes, it is, if you follow good procedures. And this is the easiest way to make black-and-white slides of black-and-white work. A lot of people choose the combination of Kodak High-Speed Ektachrome Film, Tungsten Type (3200 K), matching it with floodlamps marked 3200 K.

Then we suggest you mount the camera on a tripod, making sure both film and copy are parallel. Use a small lens opening, such as f/16, and expose by cable release or the camera's self-timer. It's a good idea also to take your exposure reading off an 18-percent gray card placed over the print to be copied and bracket your exposures by half stops. Professionals also tend to use a voltage regulator to avoid the problem of voltage drop that can lead to an unwanted color cast instead of neutral tonality. If you don't have one, try shooting very late at night when the demand for electricity is low.

COPIES OF COLOR PRINTS

What filter should I use to get a good black-and-white copy of a color print?

Assuming you want an accurate copy and are using tungsten illumination, the light-green filter will enable you to get an accurate rendition of the color picture in terms of black and white. If you're interested in achieving another pictorial effect, you can use any filter you might have used in photographing the original scene.

SHARP RESULTS FROM ETCHINGS

What is the best technique for copying etchings?

Use a contrasty film and work for clean, sharp lines and maximum contrast. Etchings don't contain middle tones, so your task is to reproduce their fine, black lines as accurately as possible. Best results with 35mm come from using Kodak Micro-File Film and Dektol diluted 1:1.

REPRODUCING TINTYPES

Is it possible to get good photographic reproductions of old tintypes?

It is if they are in good condition. Since these pictures usually are inherently low in contrast, select your film and exposure-development technique to increase contrast slightly.

COPYING HALFTONE ILLUSTRATIONS

How can you get best results in copying a halftone illustration, like a picture from a newspaper?

Work for clean contrast throughout the copying process. The most accurate copy will show all the halftone dots sharply and when inspected with a magnifier will reveal only two tones—white paper and solid black. Where tones appear within the picture, they will be caused by the size of these dots and not by any variation in their tone.

SPECIAL COPYING PROBLEM

How do I photograph old letters where the ink has faded to a yellowish-brown? I want to darken the writing.

This is often done with a black-and-white color-blind film that is sensitive to blue, but not green or red. If you want to use panchromatic film (sensitive to all these colors), use a blue filter, such as the No. 47. It passes blue but absorbs red and green.

REPRODUCING OLD DOCUMENTS

What about letters written on paper which has yellowed with age?

If the ink is blue or black, use a deep-yellow filter and work for contrast with the other copying controls.

FILTERS FOR COLORED DRAWINGS

How can I bring out colored drawings in black-and-white copies?

Use a light-green filter. If there is any color that seems particularly weak and fails to come through in copying, use a filter of a color complementary to it. This is fairly easy when a drawing contains only one or two colors. It is difficult or impossible when all colors are present, since the filter technique that serves to darken one color will also lighten its complementary color.

FLASH FOR UNIFORM ILLUMINATION

Why use electronic flash for making duplicate slides? There's no action to stop.

Nevertheless, electronic flash is preferred by quite a few photographers for slide copying. Its very brief exposure helps eliminate the possibility of sharpness loss due to vibration of the copying setup. Since the condenser of an electronic flash outfit stores up only so much electricity, regardless of the current available to charge it, it provides illumination of more constant strength and color than many ordinary electrical circuits whose load varies from time to time.

WATCH THE LINE VOLTAGE

Are line voltage variations significant in copying color slides?

They are. A drop of only a few volts can cause a seemingly disproportionate shift in the color of tungsten illumination.

TESTING FOR EXPOSURE

How do you determine the exposure in a color copying setup?

For real accuracy, by test. To get a starting place for a new setup with any illumination except flash, you can use a reflected-light meter. Place the meter in contact with the slide to take the reading. This method is far from exact. Make tests at one-quarter and one-half the reading as well as at one, two and four times the indicated exposure. For flash, take a guess to determine a starting point and make a series of test exposures.

DEVICES FOR DUPLICATING

What do I need to make copies of my 35mm color transparencies?

That depends on the type of camera you have and the accessories available for it. Copying attachments are made to fit a number of cameras and are designed for making same-size reproductions of color slides. Some permit cropping the original, as do special devices for this purpose.

MAKING DARK SLIDES LIGHTER

How do you lighten dark slides in copying them?

Exposure controls the overall brightness of copies. You can lighten them by using more than normal exposure and darken them by using less.

COPYING AND COLOR BALANCE

Can the color balance of a slide be changed in making a duplicate?

It is likely to be shifted somewhat, whether you want it changed or not. The trick of making good duplicates is to plan the almost inevitable color shift so it will help your picture, not make it less effective. You can control color in making duplicate slides by using filters to alter the color content of your copying light source. A basic filter or filter pack may be required to match a given light source to a given color film. Other filters are added (or removed from a filter pack) to achieve any effect you want.

MAKE THE RECOMMENDED TESTS

Can you count on getting accurate duplicates if you use the right basic filters for your film and light source and then modify this filtration according to the manufacturer's recommendations, if any, for the batch of film you are using?

Even with these precautions, there is a chance of color variation—but you have a good starting place for making excellent duplicates. At this point, the thing to do is to test your setup by making exposures with the recommended filters and "bracketing" the exposures and varying filter correction. This procedure will reveal any need for film batch corrections with 35mm films.

IF LESS IS MORE

How can you change the cropping of a color transparency in copying it?

While employing extension tubes or a bellows focusing attachment—depending on the type of camera you have and the focusing accessories available for it—arrange your setup so that a portion of the original is enlarged to fill the whole frame of the new slide.

13
THE DARKROOM

HOW DARK THE GLOOM?

I have a darkroom that I can only use at night because some light leaks through cracks around my door. What steps do you suggest I take?

If you are just making black-and-white prints, a few of those very small daytime leaks may not be harmful to your enlarging paper. To find out, print the same negative at night and then during the day, but follow these two variations: First, after the daytime exposure, cover half the paper in the easel with cardboard and leave it there 5 minutes before processing. Second, for either print, have the safelight off at all times right through fixing.

Then compare the two prints. If part of the daytime print looks somewhat fogged compared to the other (or the shielded section), you need to add more antilight protection. This could be just a curtain of opaque black material. The room must, of course, be completely dark for loading panchromatic film. But you could resort to the use of a medium-size light-tight changing bag in order to load a tank even in room light.

WANTED: PURE WATER

I want to process black-and-white film at home but the water sometimes runs rusty at first. Is it all right to use for processing when it starts to run clear?

In all probability yes, if you first let the water run long enough to clear the line before mixing chemicals and before washing film. Often this simple precaution makes it unnecessary to mix most chemicals with distilled water or to add a special filter on the water line.

LET THE GOOD AIR IN

Is special darkroom ventilation necessary?

Unless you have a very large darkroom and use it only for short sessions, some system of ventilation is necessary to change the air. A pair

of ventilators, louvered to keep out light, will do the job best. For more effective air movement, place a fan in one of them to force the air out. If you work at night and the room outside is sufficiently dark, often the door can be left open.

PLACEMENT OF VENTILATORS

How should darkroom ventilators be placed?

Much depends, of course, on the layout of the darkroom and its surrounding areas. A good system is to place the intake ventilator low in the room and an outlet high, near the ceiling, where it can carry out the heated air as it rises. A fan will make the system more effective and should be used in the exhaust ventilator—not at the intake where it might help circulate dust from the floor.

UPSTAIRS DARKROOM—OR DOWN?

Which makes the best location for a home darkroom, the basement or attic?

In a temperate climate, each has advantages that are important to consider. The basement darkroom usually is easier to set up, because water and electricity are readily available and it is likely to avoid the temperature extremes in summer and winter. Its most common problem is excessive dampness in summer, which can be controlled by installing a dehumidifier. An attic location is more isolated from other activities, but is more likely to require special heating in winter and cooling in summer. A lot depends on how your own house is built and on the amount of time you expect to spend in the darkroom at different seasons of the year.

IT CAN BE COLD INSIDE

I plan on building a darkroom in a corner of my basement, where I need add only two walls. How does this sound?

In a mild climate it is a good idea. Where winters are cold, however, a room of this sort with two outside walls is likely to be pretty chilly and you will probably need to provide heating—which can offset the saving on walls.

DARKROOM DIMENSIONS

How much floor space must be enclosed to build a darkroom?

There's no set rule, but amateur darkrooms are likely to measure 8 × 10 to 10 × 12 feet or larger. Where limited space is available, good use can be made of it by carefully planning your layout of equipment.

COLOR IN THE DARKROOM

Should the walls in a darkroom be painted black?

If a darkroom is light-tight, it doesn't make any difference what color the walls are painted—and the lighter hues make a more pleasant place to work. They also reflect the illumination of safelights, providing more light in far corners of the room.

TRAPPING LIGHT, NOT AIR

How about solving ventilating problems with a light-trap door?

If you can afford the space for it, a light-trap door is a great convenience. It should be designed to provide a corridor that makes a 180-degree turn, at least twice as long as it is wide and should be painted flat black. It may be desirable to mount a conventional door at the outside of the light trap to ensure complete darkness when needed for fast panchromatic films and to provide a means of locking the room.

SOURCES OF WATER

Is running water essential for the darkroom?

You can get by without it if there is a source nearby and you don't mind a few additional steps. Solutions can be mixed outside the darkroom where water is available, and prints and films can be washed there after processing in the dark. If you don't have running water, the important loss is in its use for temperature control while processing.

CHOICE OF A SINK

What type of darkroom sink is best?

Stainless steel is usually the first choice. There are many types of stainless steel, and it is important to use one which is designed to resist photographic chemicals. Hence it is safer to buy a sink made for the purpose rather than to have one built of steel, which may not be best for this use. For color work, it is best to have a big sink which will hold tanks or trays in a large volume of water to keep them at a uniform temperature. Black and white can be handled conveniently in a smaller sink that has a large apron for developing trays.

SELECTING THE TRAYS

What darkroom trays are recommended?

Hard rubber, stainless steel and enameled steel trays are most commonly used. Enameled trays must be examined regularly to make sure their enamel does not become chipped, which exposes solutions to the contaminating action of metal. Glass trays are satisfactory except for the constant breakage hazard they present. You can save developer by using small trays when you make small prints. They provide enough depth with a minimum of solution. You don't need a full set of small trays to enjoy this economy. The fixing solution, which usually is kept for re-use, can be placed in a large tray without waste and will do a better job if the tray is not crowded. Washing is more effective in a large tray, regardless of print size. Only for developer and short-stop is the economy effective.

LIGHT IN THE DARKROOM

Do you need more than one safelight?

In a small darkroom you often can make a single one do very well. It should be placed where you get the recommended illumination over the developing trays because you need the light to judge the tones of prints as they develop. Less light is required for trimming paper and placing it beneath the enlarger, and often enough illumination will spill over into the areas where these things are done. Check the recommendations for each material you use, and make sure the right filter is in your safelight before you open the package.

137

CAUTION: LOW CEILING

My darkroom has a low ceiling and I like a high sink for developing prints. This combination makes it impossible to hold to the recommended 4-foot distance from safelight to paper and still have enough light where I want it. What can I do?

A good solution is to shift to a 10-watt safelight lamp in place of the normal 15-watt bulb. You can use 10 watts at a 3-foot distance without difficulty.

KEEPING PAPER SAFE

It is a nuisance to remove a single sheet of enlarging paper from its double envelopes or box plus wrappings and then close them again before turning on the white light to inspect a finished print. How can I avoid this bother?

You can buy a light-tight paper safe or make one yourself, if you're handy with tools. All it takes is a box with a tight-fitting door. For convenience the door can be mounted on spring hinges to close itself or be designed to open by lifting so gravity will close it.

SAFELIGHT SAFETY

What causes paper to fog in spite of good darkroom conditions? I have the recommended safelight, placed at the right distance, but I still get fogged prints. When I develop in total darkness as a test, they come out fine.

Safelight safety, at best, is only relative. A perfectly "safe" light will fog any paper if you expose the paper to it long enough. Here are some tips that will help you:

1. Remember that dry paper is much more sensitive than wet paper and arrange your safelight so only a minimum of illumination falls on areas where you handle the paper while dry—the enlarging easel and trimming board.

2. Shield the paper from light whenever you can. It's easy to arrange your setup so you stand between safelight and easel while inserting the paper and making the exposure. This reduces the chance of fog.

3. Carry the paper face down as you move it to the developer tray—it's the face you want to protect.

4. Turn the paper over several times during development so it isn't always exposed to the light, face up.

5. Maintain at least the minimum safelight distance.

138

6. Don't hold prints up to the light to inspect them.

7. Be sure your safelight is really safe by checking to see that it is right for the paper you are using and that it has not become faded.

KEEPING CHEMICALS FRESH

What are the requirements for storing photographic chemicals?

They should be protected from exposure to air, moisture and excessive heat, and should be packed in such a manner that you avoid possible contamination by other chemicals or by metals. Glass jars with tight screw-caps sometimes are convenient to use. The packages in which chemicals are sold usually are satisfactory for storing them after partial use.

BOTTLES FOR SOLUTIONS

What type of containers do you recommend for storing solutions after they have been mixed?

Amber bottles are best. Some solutions age more rapidly in the presence of light, and amber bottles keep out most of the harmful rays. They should be fitted with plastic screw-caps. It pays to have several sizes at hand for storing different quantities of solutions.

USEFUL DARKROOM ACCESSORIES

What other darkroom glassware is required?

You need a graduate, calibrated both in cc's (cubic centimeters) and in ounces, a glass or plastic funnel, and glass or plastic stirring rods. A 16-ounce graduate probably will be found most useful. Even if you prepare smaller quantities of solutions, wide-mouth gallon bottles are convenient for mixing them.

MARK THEM CLEARLY

What is a good way to label bottles of chemicals so I know what they are and, at the same time how old they are?

139

There are various choices here. Some people use regular adhesive tape, others use duct or gaffer tape. There's a unanimity of opinion about using indelible, nonrunning marking ink. Besides identifying the contents and date mixed, it's wise to indicate how many rolls of film were processed. This is particularly wise, for example, with solutions such as fixer.

STORAGE AND LEAKS

How can I protect my premises in case I get a leak in one of the relatively inexpensive plastic photo bottles I use for storing solutions? The plastic seems to be on the thin side.

Such leakage is not usual but can occur. It is more likely to show up with age as the plastic dries out. So take a good look at your bottles, discard those that are old or too thin, or both. When replacing them, it's a good idea to buy bottles that are thicker.

It's also wise to take another precaution. Just make it a habit to store all of your photo bottles in one or more inexpensive, small, plastic dishpans—ones that measure about 12 × 14 inches on top. Check for wetness on the inside bottom from time to time to make sure that no leak has started.

SMALL AND USEFUL

I recently saw several small plastic graduates in a photo store to measure 3/4 ounce and 1½ ounces of liquid. Is it true that they can be used for making Kodak HC-110 as a one-shot developer instead of mixing up all of the concentrate?

Many photographers do this, using a small graduate. To make 16 ounces of dilution B (with its 1:31 ratio) they simply take ½ ounce of the HC110 concentrate in a small graduate, put this in a larger graduate and fill this to 16 ounces with water. For a total of 32 ounces of dilution B, just double these amounts. But in either case, be sure to rinse all the residual syrup in the small graduate and pour this rinse water into the main graduate. If the small graduates are marked in U.S. and British Imperial (or English) oz., choose the right scale. And for the metrically minded, some units are marked in cubic centimeters or milliliters that can be used interchangeably.

THERMOMETER TOLERANCES

How accurate must a photographic thermometer be?

It should be accurate within half a degree, for this is the permissible temperature variation for some processes. The dial-type is most convenient to read, particularly under darkroom conditions, but usually is somewhat more expensive than the glass-tube type.

TEMPERATURE EQUIVALENTS

How does one derive degrees Fahrenheit from degrees Centigrade and vice-versa? This would be useful to me (photographically) when abroad.

To get degrees Fahrenheit (F), simply multiply degrees Centigrade by 1.8 and add 32. For example, if we start with 20°C, then 1.8 times 20 equals 36, and 36 plus 32 results in 68°F.

To get degrees Centigrade (C), first subtract 32 from the degree F figure and multiply the result by 5/9. At 68°F, the answer after subtracting 32 is 36, and 5/9 of 36 is 20°C.

MIXING LIQUID CHEMICALS

I get confused by the way ratios are given in mixing liquid chemicals. Can you please straighten me out?

Just remember that the first number, 1, always stands for the chemical, while the second number indicates the number of parts of water to be added. So if the ratio is 1:1—as it might be for Kodak D-76 film developer —you'd take equal parts of the developer stock and water. For example, 8 ounces of D-76 plus 8 ounces of water would make 16 ounces of working solution.

On the other hand if the ratio is 1:2—as it is with some paper developers—you'd take twice as much water as developer to make the needed amount of working developer. For example, 10 ounces of developer plus 20 ounces of water would give you 30 ounces of working developer with a 1:2 ratio. And so it goes.

FIXER MINUS HARDENER

Why is the hardener left out of some fixing formulas?

There are occasions when it is not wanted, and it is convenient to be able to add the amount of hardener you want. If you plan on toning prints after fixing, for example, the toner will work better if you use a plain hypo bath without hardener. Often it is desirable to use more hardener in summer than in winter.

TIMING FOR ENLARGING EXPOSURE

What is a good exposure time to use for enlarging?

A wide range of times will all give the proper exposure, merely by adjusting the lens aperture. Excessively long exposures are tedious; very short ones are hard to measure accurately. Hence most photographers prefer medium exposures in the range from 5 to 15 seconds. Another factor is that manipulation, like dodging or burning-in, may be required and control is only feasible with reasonably long exposures.

LIFE OF FIXING BATH

I've heard it said you can't tell exactly how many negatives or prints a given amount of fixing bath will handle before it becomes exhausted. Why is this?

There are many variables in the aging of fixing baths in addition to their use. The amount of unreduced silver salts in film and paper varies, depending on the proportion of light and dark areas within a picture. A negative of a night scene, transparent except for a few small areas, would contribute a great deal of silver to the fixing solution and hence would shorten its life much more than a negative of a bright beach scene in which the film would be dark all over. Nevertheless, figures given by the manufacturer provide a useful guide.

PRINT-DRYING TECHNIQUE

How do you dry papers with rough surfaces?

Blotter rolls or books are convenient for these papers. If you have a small dryer, you can use it, too. Just place the prints face up on the metal

142

drum (or flat area) and proceed as usual. The cloth part of the dryer, which covers them, will keep prints flat.

CRYSTALS IN DEVELOPER

I mixed Kodak Dektol paper developer at the recommended 100°F and let it sit in a bottle overnight at a room temperature of about 70°F. When I went to use it the next day, I found I had undissolved crystals, that wouldn't redissolve. What happened? This never occurred before in years of using Dektol.

As no cold-storage temperatures were apparently involved and you followed mixing directions, our best guess is that you may not have dissolved the chemicals completely, originally. Then it is possible that these pieces of hard-to-see undissolved chemicals acted as nuclei for re-crystalization to take place.

Next time, make sure to stir much longer when you mix, using a suitable stirring rod in gentle fashion. If the trouble should occur again, try using distilled water instead of ordinary tap water.

TESTING FOR HYPO TRACES

How do I make up Kodak hypo test solution HT-2 in order to test for residual hypo compounds on prints? Also, when I use the test solution and get a light stain on the print, where do I get comparison patches to see if the print washing time has been sufficient?

The recipe starts with 24 ounces of water, to which you add 4 ounces of 28% acetic acid, and 1/4 ounce of silver nitrate. Then add water to bring the total to 32 ounces. One method of testing is to place a drop of test solution on the white border of a typical washed print. Let the chemical stand for 2 minutes, then rinse off with water. Immediately compare the stain to the tint patches in Kodak's *Darkroom Dataguide* for black-and-white work, where the formula is also given. More finicky workers put the drop on the back of the print—on the theory that it is far more difficult to wash chemicals out of the base—so the test is more valid.

For those workers who do not want to mix the solution, ready-made products are available.

143

14
FILM PROCESSING

ON THE CHEMICAL SIDE

I am a beginner in photography. Can you recommend a basic book on the use of photo chemicals for black-and-white films?

A good starting point is to get Eastman Kodak's J-1 Professional Data Book, *Processing Chemicals & Formulas for Black-and-White Photography*. This not only covers the basics, but has a lot of practical information, including a chart of keeping properties and capacities of Kodak solutions, information on various packaged Kodak processing chemicals, and a formula section for mixing up a variety of Kodak solutions yourself.

BEST PROCESSING TEMPERATURE

Is it really better to develop general-purpose black-and-white film at 68°F than at 75°F, though both times and others in between are given on the film leaflet?

Not in our experience. So let's stop nitpicking here and settle down to making pictures, using the temperature in the given range that is most convenient. Some photographers first check the temperature of their mixed fixer, then use that as a standard. Subsequently, the water rinse is brought to the same temperature. If you use a developer such as Kodak D-76 and dilute it 1:1, you can add cooler or warmer water to arrive at the right temperature for the diluted solution.

REQUIREMENTS FOR AGITATION

How much agitation does film require during the developing process?

Five seconds' agitation during each half minute of development is the Kodak standard for small tanks that is usually taken into account in recommended development times. However, some developers call for once-a-minute agitation. Vigorous agitation speeds up development; lack of agitation slows it down.

UNEVEN FILM DEVELOPMENT

My 2 1/4×2 1/4 negatives developed in an inversion-type, metal-reel tank have dark edges along the sides (next to where Kodak has imprinted numbers or words). So on prints there is a dark center and light sides that show up mostly in light areas such as skies, but exist also in nonsky areas. What suggestions can you give me to avoid this problem?

This is usually due to agitation that was too vigorous and too regular —so that flow patterns caused the edges to be developed more than the center.

Therefore, after agitating initially for 10 seconds, and rapping the tank once or twice to avoid air-bubble problems, try agitating for just 5 out of every 30 seconds. And give the tank only two inversions in each 5-second period. In addition, to break up flow patterns, try pointing the tank in a different direction for each of the two inversions. Or if it is more convenient, after inverting once give the tank a half-turn twist (when the lid points up), then simply invert again as before.

SPROCKET-HOLE STREAKS

The last three rolls of film I developed had streaks at the sprocket holes. What caused them? Are they due to stale fixer plus insufficient agitation of this bath?

Yes, they are. The net result of this combination is that the fixer going through the sprocket holes stopped development just beyond the holes to create lighter areas (which apparently is what happened to your negatives). But other areas continued developing and became darker on the film.

It won't happen again if you start with reasonably fresh fixer and agitate sufficiently. Some very careful workers even agitate constantly for one minute at the start, then at very frequent intervals, such as every 20 or 30 seconds.

FOR MORE EFFICIENT AGITATION

What mechanical agitation can be used without getting oxidation or development patterns?

Nitrogen burst equipment gives good agitation but is expensive. It relies on discharge of gas at the bottom of the tank to agitate the solution in an irregular pattern. There is no oxidation, in spite of the bubbles, since they do not contain oxygen.

KEEP 'EM APART!

Why is it so important to keep developer and fixing solutions separate?

Even a small amount of fixing solution can render a developer ineffective. The presence of either one in the other can cause stains.

THAT SECOND TRAY

What is the function of an acid stop bath?

It stops the developing action and neutralizes the alkaline developer on the film, which prevents carrying it over to weaken the acid fixing bath.

SKIP THE STOP BATH?

Some darkroom workers skip the stop bath and merely use a water rinse between developer and fixer. Is there anything wrong with this?

Not at all, if you agitate the film continuously in the water rinse and for several seconds after placing it in the fixer—and if you don't mind replacing your fixing bath more often. Some 35mm photographers feel that their black-and-white negatives are of better quality when they use a water rinse and that there is less danger of getting pinholes.

NEGATIVE TROUBLE

My film has small light spots on it caused by air bubbles in the developer. I have tried many possible cures, including eliminating a stop bath and using a water rinse in its place. Have you any recommendations?

You seem to be confusing two things here. To prevent air bells, rap the film tank sharply on a hard surface at the start of development. This should be done five or six times within the first 15–30 seconds of development. If the spots are pinholes, it means that the emulsion actually has ruptured and the use of a water bath, rather than an acid stop bath, is an excellent preventive for this since it creates a gentler transition from the alkaline developer to the acid fixer.

146

OVER OR UNDER?

How can you tell the difference between underexposure and underdevelopment?

If a negative has been underexposed, it will lack detail in the shadows but its highlights will be of fairly good density, unless the error was very great. If it has been underdeveloped, there probably will be weak shadow detail but the whole negative will be thin and lacking in contrast.

UNDER AND OVER

What produces a negative that is very contrasty, with heavy highlights and thin shadows lacking detail?

This is often the result of underexposure plus overdevelopment, or underexposure of an available-light situation in which there is a great deal of inherent contrast.

THIN, FLAT NEGATIVES

What produces a very thin, flat negative that shows some detail throughout but lacks sufficient contrast?

This is generally the result of proper exposure, or perhaps even overexposure, plus insufficient development.

FOG ON THE NEGATIVE

What causes an overall purplish or greenish deposit on negatives which can be wiped off in the water rinse?

This is referred to as dichroic fog. It may result from an excess of sulphite in a fine-grain developer or traces of developer in the hypo or hypo in the developer. When scum is observed on the negatives after processing, wipe films with chamois or viscose sponges before they are hung to dry.

DENSENSITIZER PLUS INSPECTION

I took a roll of pictures with Tri-X film under very weak lighting without an exposure meter. I know that development should be extended, but I don't know how much. Is there a way to develop film like this by inspection?

Negatives can be developed by inspection without fogging, but until you acquire considerable experience it is wise to desensitize the film. Kodak Desensitizer is recommended for Tri-X as well as other films because it does not reduce the effective emulsion speed. Mix it according to instructions. Immerse your exposed film in the solution for 2 minutes at 68°F, then rinse in water at least 10 seconds and proceed with development. After half the normal developing time has passed, you can inspect the film by holding it not closer than 12 inches from a Wratten Series 3 (dark-green) safelight containing a 15-watt bulb. Keep inspection periods brief and examine the negatives by reflected light. Do not hold them up to the safelight and attempt to peer through them.

LOOKING AT PARTLY DEVELOPED FILM

What do I look for in developing by inspection?

Knowing that is half the battle, and it is hard to put into words. Before your first attempt, particularly with valuable negatives, it would be well to expose some shots normally, desensitize the film, and then develop it by inspection in combination with proper timing so you will learn what to look for. The film looks different under safelight conditions. Next, it might be best to run a test with some underexposed film. Set your timer for the normal developing time and don't start inspecting until the normal time has passed.

DEVELOPING DISPARATE EXPOSURES

When developing by inspection, how do I handle a roll that contains normally exposed shots along with some underexposed ones?

It's easy if all the underexposed pictures are grouped together. As soon as the normally exposed shots are fully developed, cut them apart from the rest of the roll and place them in a water rinse for 1 minute, followed by fixing. The underexposed pictures should be immediately replaced in the developer and kept there until the negatives acquire the proper density. To do all this quickly, with the safelight on as little as possible, line up rinse and fixer in extra tanks or containers that have lids so they can be made light-tight. Illumination from the safelight should only fall on the film during the brief inspections required and for the moment it takes to cut the film apart. Handle film carefully, by its edges.

HOW LONG IS A PEEK?

Is there a limit to the amount of inspection a film will stand?

Indeed there is. Even the safelight will affect it if allowed to strike the emulsion for a long enough period. There also is danger of chemical fog when you hold the film up, out of the developing solution, to look at it. For these reasons, inspection should be held to a minimum.

FILM-STICKING PROBLEM

How can I dry the reel of my developing tank quickly? I want to use it for several rolls of film in succession and unless it is perfectly dry the film sticks in its grooves.

Get a bottle of methyl alcohol, enough to fill your tank. Rinse tank and reel thoroughly and then fill the tank with alcohol and dunk the reel up and down in it several times, first one side up and then the other. Drain, shake off the excess alcohol, and it will dry in a minute or two. Save the alcohol in a tightly stoppered bottle for use again. The solution will work until it has absorbed enough water to make the reels dry too slowly.

ADJUSTMENT OF DEVELOPING TIME

Since my developer loses strength with use, how much do I lengthen development each time to get uniform results with every roll of film?

See the recommendations for your particular developer. With some, increasing the time is recommended. Others call for replenishment. Still other developers are designed for one-time use only, then must be discarded.

USE OF REPLENISHER

Why do developers require special replenishing solutions? I should think it would be enough merely to add a specified amount of new developer to compensate for use.

That would work out all right if all the ingredients in the solution were used up at the same rate—but they are not. The replenisher replaces used chemicals in proper proportion to retain the original developer strength. However, some manufacturers do recommend "self-replenishment," in which the regular developer is used for replenishing.

149

WASHING IN WARM WEATHER

Is it possible to wash films too long?

It is, particularly in warm weather. The emulsion continues to swell and to absorb water, to some degree, and the more it absorbs in washing the more it will give up in drying. This causes more pronounced shrinking which, in turn, produces a more grainy appearance. Films should be washed no more than the minimum safe requirement for eliminating chemicals, particularly with miniature camera negatives.

WATCH FOR WATER MARKS

My negatives have strange marks on them. The marks are roughly circular and are dark rings with light areas inside them. On prints they make light rings with slightly darker areas inside. What causes this?

The description fits water marks, caused by irregular drying of the emulsion. To avoid this, place a small amount of wetting agent in a final rinse. This will make the water flow off more easily instead of standing on the surface in drops. Some photographers sponge the film off in addition to using a wetting agent.

UNWANTED MARKINGS

Recently, I got some spiderlike markings on a few frames of a roll of 35mm black-and-white film. What are these and why did they occur?

These are nothing more than static marks caused by light flashes from a discharge of static electricity. Sometimes they look like forks of lightning, chicken tracks or rows of dots. It is a fact of life that they are much more prevalent in dry weather. So handle film especially carefully under such conditions to avoid a build up of a static-electric charge. It is sometimes enough just to avoid rewinding the film rapidly in favor of doing this operation quite slowly.

HELP FOR THIN NEGATIVES

I understand that Victor's mercury intensifier is no longer on the market. What could I use that is as simple and good as this ready-made, single-solution product?

There's only one single-solution, ready-made intensifier around nowadays. This is Tetenal intensifier that will give you effects about as strong

as Victor's intensifier did—but leaves negatives black and doesn't yellow them.

This is also a mercuric intensifier that is poisonous. (There's a skull and crossbones on the package and the word "Gift" which means *poison* in German.) Inasmuch as mercury can be absorbed by the skin and finger-nails, wear protective rubber or plastic gloves for mixing and use. Then treat one film or strip at a time through all wet stages. This begins with presoaking film for 5–10 minutes. Then follow directions for intensify-ing. Finally, wash each film or strip for 10–15 minutes, treat afterward in a dilute solution of a wetting agent, such as Kodak Photo Flo, and hang up to dry.

CONFUSION OF NAMES

Is the developing agent metol the same thing as Elon? I want to start mixing up my own developers that call for the use of metol. But it doesn't seem to be available by that name in any photo stores.

Your worries are over. Elon is nothing more than Eastman Kodak's trade name for a much-used developing agent generally referred to as metol in non-Kodak technical literature. Incidentally, the chemical name that is also printed on the Kodak label is "p-methylaminophenol sulfate."

CHEMICALS IN THE PLUMBING

Will the chemicals normally used in developers—such as D-76, Microdol-X and Dektol—stop baths or hypo be harmful to regular plumbing? I plan to process a few rolls of film and make two or three dozen prints per week with a maximum of five dozen on occasion.

We checked with several manufacturers and numerous individuals, and no one has ever heard of anyone's plumbing being damaged by amateur processing of the kind you describe. Certainly a normal amount of flushing with running water is good practice. The only real caution for amateurs was that if you dump large amounts of bleach or unused fixer you should flush the chemicals away by letting water run for about 10 minutes.

A CASE FOR CHEMICAL REDUCTION

I have some negatives that are so black from developing at too high a developer temperature that they require 8–10-minute exposures when making 8×10 enlargements and are very grainy. What should I do?

Try to lighten the negatives by treating them in a chemical reducer after thoroughly soaking the films in water for 10 minutes. Kodak's prepackaged Farmer's Reducer has complete directions. But you'll need two clean 16-ounce bottles for stock solutions A and B that you mix from powders in packets A and B. These solutions keep for several months in tightly stoppered bottles. But the life of the mix (consisting of equal parts of solutions A and B) is about 10–15 minutes; therefore, use only the amount of solution needed.

Stop treatment just before the required reduction has been reached. Remove the filmstrip from the tray and follow all postreduction directions, still keeping temperatures about the same. To save time, use a hypo neutralizer in the usual manner and wash film 5 minutes (instead of 15–20 minutes). Most importantly, treat only one strip at a time.

INTENSIFIERS, REDUCERS—AND CONTRAST

Do chemical intensifiers and reducers affect the contrast of negatives?

Yes, they are bound to. Intensification of a thin negative with clear shadows increases its contrast because only the existing image is intensified while clear film is not affected. Different reducing formulas, which dissolve away a portion of the image, can be employed to control contrast in different ways.

USE OF A SUBTRACTIVE REDUCER

What sort of reducer should be employed for negatives that are overexposed, very dense and yield prints that appear too flat, even on contrasty paper?

This calls for a "cutting" or subtractive type of reducer which removes equal quantities of silver from all areas, but has the effect of clearing shadow areas and increasing image contrast. Such solutions employ ferricyanide and hypo or potassium permanganate.

152

CONTRAST WITH OVERDEVELOPMENT

How can I improve very contrasty negatives which have been overdeveloped?

This calls for a flattening reducer, better known as a super-proportional reducer. Ammonium persulfate is the agent used, and the solution acts hardest on the highlights without destroying shadow detail. Be sure to stop as soon as the desired highlight reduction is achieved.

CORRECTING OVERALL DENSITY

What about negatives that have correct contrast but are too dense all over?

The best available answer is to use a proportional reducer that reduces negative density proportionately according to the original density. There is some reduction in contrast. Before bothering with reducing, however, it will pay to make a test and see if you can print such negatives by replacing your regular enlarging lamp with one of higher wattage or with a photoflood.

HOW TO MIX THE "SOUP"

Just recently I mixed Kodak D-76 film developer and wound up with bits of undissolved chemicals in the bottom of the container. Is this because I accidentally mixed the developer at 68°F?

It certainly is. The temperature was too cold to dissolve all the chemicals. Your D-76 should have been mixed at or close to the 125°F recommended.

As soon as you realized the problem, you should have tried dissolving the tiny undissolved bits by warming the solution to 110–125°F in a surrounding water jacket. Specifically, if your water doesn't run hot enough for this, don't heat the developer directly. Instead, heat *plain* water on the stove. Then pour this around your heat-resistant graduate (containing the D-76 developer) that is sitting inside a larger heat-resistant container. If the chemicals do not dissolve then with the usual stirring, toss the mix out and start with a fresh can of D-76, following the manufacturer's instructions.

153

IT TAKES MORE THAN JUST FIXING

I have had a problem with an unusually soft emulsion on washed Kodak Plus-X film that came off on my hand when I touched the film. After drying (without squeegeeing, of course), I could print negatives in the normal way. But for the sake of prevention, can you tell me what went wrong? The only different thing I did was to switch to another brand of fixer.

You've probably put your finger on the problem. The brand of fixer you used does not contain an acid hardener, but makes it available in a separate bottle instead. When this hardener isn't used in the fixer, the emulsion will be softer. And under certain circumstances, especially with long wet times, the kind of trouble you describe can result. The main part of the answer is to remember to add the hardener or switch to a fixer that includes this as an integral part. To minimize softness, in all cases, also cut your wet time by use of a hypo neutralizer, make your wetting-agent bath time brief (about 15–30 seconds), and don't wipe the film afterward except exceedingly lightly between the inner soft parts of two of your fingers.

EFFECT OF TEMPERATURE ON GRAIN

I'm getting somewhat more grain than I should on my black-and-white negatives due, I'm told, to erratic changes in the temperature of the running-water wash when processing film. But it's hard to monitor this wash when I have to lift a thermometer out of the water to read it. Have you any suggestions?

Yes. Just get a round dial-type thermometer that you can put in the wash vessel and monitor continuously while it stays there.

If the temperature starts to change by two or three degrees, first pull the wash vessel out of the stream, then adjust the temperature of the wash before putting the container back and continuing to wash your film. Try to keep variations within two or three degrees. And if you accidentally exceed these limits, try to avoid sudden temperature changes.

UNWANTED LIGHTNING

I hear it is possible to get lightning-like streaks on film. What are these marks, and how can one avoid getting them?

Such streaks are just one type of mark you can get on film, caused by static electricity. As the problem is more prevalent in winter when the

air is very dry, it is a good policy then to rewind your 35mm film much more slowly than is your usual manner.

HELP! FILM RATED WRONG

I shot a roll of Kodak Plus-X Pan (35mm) with my meter set at ASA 320, certainly not the recommended speed rating. Is it possible to have the film developed with reasonable results?

This isn't at all disastrous, even though the film rating officially given for the film is ASA 125. Just develop your film in a special developer, such as Acufine, using the normal times given with this solution. Or if you don't want to do this yourself, have a custom lab (*not* an ordinary commercial processor) do it for you. Results should be good if your metering was correct and the lab worker does the job right. Be sure to specify the film rating used, the developer desired, and ascertain that the lab really has it at hand.

WHEN LARGE IS SMALL

I have a four-reel tank for developing 35mm film. It seems quite large to me. So should I use the developing times for large tanks given in the tables on the Kodak Tri-X film leaflet?

Not by any means. All tanks for 35mm up through four-reelers (or ones holding two 120-size reels) are considered small, and the small tank times apply. We know these work well. And we are also told they apply to six-reel 35mm tanks (or the equivalent). Large tank times, on the other hand, logically seem to apply to big tanks for sheet film, holding 3½ gallons or more, and to really deep tanks of various sorts.

RELOADING FILM ON WET REEL

A friend told me he was advised not to take a roll of fixed, wet 35mm film off a stainless steel reel until ready to hang the film up to dry. The inference was that he would have trouble getting it back on the reel. Is this true?

It shouldn't be. With a little practice anyone who can load the film dry should be able to get the wet film back on a stainless-steel reel without messing up. Quite a few photographers do this wet bit regularly. These are people who want to see—immediately after film has been fixed com-

pletely and perhaps given a cursory rinse—if their exposure was right. After looking, they wind the film back on, handling film by the edges and being sure not to let the tender, wet film get scratched or harmed in any way. When you wind the film back on (so you can wash it easily and safely), be sure only to bend it very gently.

REEL-LOADING PROBLEM

I have a plastic developing tank with a plastic reel that simplifies loading film for development. Sometimes I have trouble getting 35mm film to wind on even though the reel is dry. What advice can you offer?

One trick is to start in room light with a square film end that is cut between the sprocket holes. So don't rewind your 35mm film all the way into the cartridge. Later on, pull part of the film out (including the leader) and look while you cut. After this, go into utter darkness to open the cartridge and proceed with the reel-loading step.

If you wind nicely for a while but at some point find it hard to advance the film, it could be that the curl of the lead piece of film is too great and has caused the film to bind. The answer is to unwind the film and try to remove some of the curl. Just wind 6–8 inches of the initial film end inside out, touching only the film edges. Finally—still in total darkness—try loading your reel again.

A VERY GENTLE DEVELOPER

I want an easy-to-use, inexpensive, soft-working developer to counteract the effect of high contrast in avail-light theater scenes. Someone recommended Kodak D-23. Can you give me the formula and processing tips?

There are only two ingredients besides water. First dissolve 1/4 ounce of metol (alias Elon, Pictol and some other names) in 24 ounces of water, at about 125°F. Then add and dissolve 3 ounces, 145 grains of dessicated sodium sulfite and add cold water to bring the level up to 32 ounces. Cool the solution before using. Normal suggested developing time for 35mm Tri-X Pan exposed at ASA 400 is about 8 minutes at 68°F. But for *contrast-cutting purposes,* with the same rating, *give a full exposure for shadow detail,* then try developing about 5½ minutes at 68°F. Agitate 10 seconds initially, thereafter 5–10 seconds out of every minute of development.

156

WHY NEGATIVES "TAKE THE VEIL"

What's the reason for faint marks on my film, and why are these same negatives slightly foggy or veiled overall?

The answer is that your fixer was too weak, either due to being mixed incorrectly, to age or to overuse. Hence the faint, overall creamy, or veiled, look as per your sample. But in addition, you didn't agitate enough, especially initially. So, you also got fixing streamers, or light marks, below the sprocket holes where the fixer acted and darker marks between the sprocket holes where the developing continued slightly longer.

FASTER PROCESSING STEPS

How can I get set up fast for developing film in Kodak D-76 diluted 1:1? It still takes me too long, even though I mix powdered developer and fixer ahead of time so they are both at room temperature.

One approach for more speed is to first determine the temperature of your fixer. Then if it is in the 68–75°F range, simply make your other solutions about that temperature. For example, suppose your fixer is 70°F. It's easy to make your diluted D-76 about that temperature by using warmer or cooler water, as need be. (Here, of course, you use half D-76 and half water to make the total amount needed for your tank.) No time need be wasted either in making a water rinse (for use before fixing) that is about that temperature. Just keep each solution within two to three degrees of the previous one.

HANDLE FILM WITH CARE

I notice a dark crescent shape on some but not all of my negatives. What causes this problem?

This is due to bending the film too much when loading a reel so that it buckles. Then, even though no light has reached this section of film, the pressure of the buckling renders it developable. It may be more evident on clear areas in night pictures, but it can show up just as well in other photographs. To avoid this, take care not to let the film buckle by not bending it as much the next time you load a reel.

WHICH SIDE IS UP?

What's an easy way of determining which is the emulsion side of a transparency after I remove the film from a slide mount? I've been making Cibachrome prints, and some help here would simplify inserting the transparency so the emulsion side will face the easel.

Just hold the transparency by the edges and look through it, making sure the image is correctly oriented from left to right. If this is the case, then the base side will be facing you, and the emulsion will be on the other side.

REVERSAL-FILM TERM DEFINED

I've heard photographers use the term "D-max" when talking about color-slide films and their characteristics. Just what does it mean?

D-max stands for the maximum density, or the maximum blackness that is found in a piece of slide film that has received no exposure to light. If such a piece of film comes back along with your processed slides, hold it up to a lighted tungsten bulb and look at it. Ideally, the color of the bulb and areas immediately around it should be neutral when seen through the completely unexposed piece of slide film. But in actuality, the color of the D-max seen in this fashion tends to vary from film to film. So, for example, the D-max may characteristically look greenish-black in one case, bluish-black or purplish-black in another, or even brownish-black with still another film.

FIREPROOFING HINT FOR NEGATIVES

What is a practical way to fireproof valuable black-and-white negatives?

There may be various suitable answers. But about the best one is to put your most valuable negatives in a safe-deposit box in a bank. The bank vault is also a good place to store negatives or slides of a home photographic inventory. Then, too, some people even use a large safe-deposit box to store cameras they don't want to take on a trip as a precaution against their being stolen or destroyed when no one is home.

ACCENT ON POSITIVES

How does one hold a negative to view it as a positive?

Hold the negative with the emulsion (or dull) side up, so rays from a nearby bright lamp strike it in a somewhat slanting fashion. And be sure the background under the film is black, or very dark. Then tilt the film slightly back and forth until you see a positive image. This technique works best with moderately thin or very thin negatives. It is extremely helpful in choosing frames to enlarge when you don't have the time to make a set of contact prints.

EMERGENCY FILM CHANGER

I've heard it is possible to use overcoats to make an emergency changing bag outdoors in the field so you can cope with film that has jammed in the camera or even ripped. How would one do this?

This is quite easy if you start with at least one dark, tight-weave overcoat that is opaque to light. So check this out by putting the coat over your head snugly and looking up at the sun. You shouldn't be able to see any light.

Then make your changing bag as follows or use variations on the theme as necessity requires. First, button the coat down the front and lay it button-side down on a clean surface (if you can find one). Where possible, work in the shade or use your body so the "bag" is in the shade. Next, put your unopened camera inside the coat along with a light-tight film can to hold the film that you may need to remove from the camera in the blackness of your makeshift changing bag.

At this stage, tuck both the neck and bottom coat areas under as securely as you can so no light can get in at these ends. For greater protection, be sure to wrap another opaque coat (or tight-weave dark blanket or some other cloth that is as opaque as possible) over the makeshift bag, tucking it well under neck and bottom areas. This can make a big difference. Then put your arms well up into the coat sleeves, so light can't get in there either but enabling you to work easily inside this homemade changing bag. Be sure to do this gently, however, so you don't disrupt the makeshift lightproof contrivance.

RINSING ACUFINE

I have been using Acufine developer undiluted for pushing two rolls of Tri-X film at a time to a rating of 1,000, then tossing the 16 ounces of solution out. This works well. But should I be using Acufine replenisher to reuse the developer? If so, how is this done?

It is an excellent approach for maintaining normal Acufine developing times and saving money.

To set the ball rolling, start off with equal amounts of freshly mixed Acufine developer and replenisher—say a quart each mixed as directed —and placed in suitably marked bottles. Then begin developing as before with fresh developer. But this time pour the used solution back in the developer bottle.

Later, at some convenient time—as while film is drying—add 1/2 ounce of Acufine replenisher to the Acufine bottle for each roll of 36-exposure 35mm film developed. Use a small graduate, such as a plastic 1½-ounce one, for sufficient accuracy when measuring replenisher. And each time you process film, follow the cycle of pouring the used developer back into the bottle and then replenishing it.

If you start with equal amounts of Acufine developer and replenisher you should be able to keep on replenishing until the replenisher is used up, *provided* the solutions remain good. Store the bottles at cool room temperatures—not in the refrigerator. And mix both cans of powdered chemicals with distilled water.

ELIMINATING WATER MARKS

I get water stains on my negatives, even though I use Kodak Photo-Flo wetting agent. Please advise how I can remove the existing marks.

You probably are just being too generous with the wetting agent. This can lead to streak marks. So, follow directions. And if in doubt, use a scant capful of the wetting agent rather than an overflowing one. Also, don't leave the film in the bath too long—about 15–30 seconds is fine. Then hang the film up to dry without wiping it. At the most, if your fingers are smooth, wipe the film very gently between the index finger and the next one. But please be very gentle here to avoid scratches.

To get rid of existing water marks or streaks, try rewashing each strip individually. (After all, you don't want the sharp corners of one piece of film to nick the soft emulsion of another.) Then, re-treat the strips in dilute Photo-Flo solution and hang up to dry.

160

FOR THOSE SWEET PICTURES?

I got some crystalline deposits, possibly sugar, on the base of some black-and-white films when cutting them into strips of six on the kitchen table. Do I have to rewash each individual strip?

Probably not. First try using a piece of clean lintless cloth that has been slightly moistened with water. If just wiping the base with this dissolves the deposit, there is no need to rewash. But repeated applications to the glossy base may be necessary before you dry the film with another clean lint-free cloth. However, if deposits on the base resist this gentle water cure or show up on the dull emulsion side, try an antistatic film cleaner, like Ecco Photo-Sweep or similar products made by Edwal Scientific. And always remember the virtues of avoiding trouble by working initially on a spotless surface.

COLORED SPOTS ON BLACK-AND-WHITE FILM

In the last six months I've noticed a recurring problem when developing 36-exposure lengths of 35mm film on stainless-steel reels. The film end—that is, the part closest to the outside of the reel—has large tannish-brown spots. Is this caused by loading? My reels are in good shape.

You named it—that's usually a reel-loading problem. The outer section of the film was not wound on properly and got stuck to the film below it during processing, so some areas of the outer section were not fixed. These spots are actually undissolved silver salts that never got removed by the fixer. Just remember that a film end can be a bit tricky.

So don't force it on, but curve the film more across its width (from sprocket hole to sprocket hole) and let it seem to flow onto the reel. Even experts sometimes have to go back again, unwind this last turn of the film, and then wind it on again until the film feels right.

FLASHING IN THE DARKROOM

When I load my 120 roll-film tank, will the very slight, brief glow made by pulling off the tape on the film end fog my pictures?

Not in our experience. But if the slight light visible from removing the tape bothers you, reduce this or eliminate it by taking the tape off more slowly.

DEVELOPING WITH HC-110

I use Kodak HC-110 film developer, selecting Dilution B as times are not overly short. Is it true that you can mix up just the amount needed for one-time use?

Yes it is, although Kodak doesn't recommend it. And a number of pros find the approach quite convenient. Instead of mixing up the entire bottle of syrupy concentrate, just take the amount you need, using a small graduate, like about a 1-ounce size, to measure amounts accurately. Dilution B stands for a dilution of 1:31, so to wind up with 16 ounces of developer combine ½ ounce of concentrate with 15½ ounces of water. On the other hand, for a 32-ounce total double these amounts. In either case, be sure to rinse out the small graduate so every last bit of the syrupy concentrate goes into your main graduate. Such care is particularly important if you follow this less conventional approach with this developer.

A D-76 PROBLEM

My Kodak D-76 developer has turned gray although it was stored properly, is only a month old and has not been overused. Furthermore, I must underdevelop when I process with it. Can you tell me what is going on?

The gray color of your D-76 is completely normal. The cause is a precipitate of silver that comes out as the developer stands. It has no effect on the usability of the developer. If you're bothered by the color you can filter the developer. However, the grayness has no relation to your other problem. The need to underdevelop probably is caused by over-replenishment.

CURL HAIR, NOT FILM

How can I get flat Tri-X negatives like those that come from commercial labs? Mine are very curly.

Try not to let the films get overly dry. As soon as they are completely dry, cut them into strips and insert these in your negative sleeves. This procedure alone may be enough. If it isn't, put a moderate weight, such as a telephone book, on top of the combination overnight.

WHEN NOT TO FILTER

What are the dark particles on the bottom of my bottle of used Kodak Microdol-X film developer? I've been filtering them out and using the rest of the developer again, and that seems to work just fine.

These are simply silver particles that show up after use of the developer. They need not be filtered out. But since you are using Microdol-X straight (not further diluted), it would be a good idea to replenish the solution after pouring it back into the bottle to maintain developer consistency plus normal developing times.

Mix up the separate replenisher powder and put it into a separate bottle. Then replenish by adding 30 milliliters (1 oz.) of this replenisher to the developer bottle for each roll of 36-exposure 35mm film or 120 roll developed. You'll need a suitably small graduate (such as a 1½-ounce size) for this. And make it a rule to replenish soon after pouring the used developer back into the bottle, so you don't forget to do the replenishment.

UNSTAKING 35MM FILM

I usually pry the flat end of a Kodak 35mm cartridge off by using the bottle-opening end of a hand can opener. When I misplace this, as I did recently (and the film end has been wound inside the cartridge) how can I get this cap off so I can get the film out and load it into a developing tank? The cap is on there very firmly.

Even though caps on Kodak cartridges are "staked" on so they won't come off easily if the cartridge falls, you can get them off in various other ways. One is to find a very hard surface, such as concrete, and bang the protruding end of the spool hard against it a number of times until you get the cap off the flat end. But since the cartridge must be opened in complete darkness, a far easier and less exasperating way is to resort to an ordinary pair of inexpensive pliers if you have one.

Just use it on the edge of the cap on the flat end in a reasonably gentle fashion to pry this piece off a bit. Then get a firmer grip on the raised section and remove the cap completely, again without using excessive force.

NEGATIVES TURNED TAN

I have a batch of negatives that are turning a dark tan color. Is there anything I can do?

Try refixing and rewashing. Specifically, we treated some similar samples in fresh Kodak Kodafix diluted 1:3 for 8–10 minutes and found most (but not quite all) of the color disappeared. So select the negatives that are the most important, treat them one at a time in this fashion and wash well.

If you use a neutralizer for about 2 minutes with frequent agitation (after a 1-minute rinse), follow all this by rewashing one strip at a time in running water for at least 5 minutes. Naturally, watch your temperatures. And finish off with a 15-second immersion in a dilute wetting agent. Then hang up film to dry with the clips outside of the picture area.

CORRECTING EXPOSURE ERROR

While on a trip to Europe, I shot a roll of Kodak Tri-X Pan 400 speed black-and-white film at a rating of 64. How can I develop this so the negatives will be printable?

A good first step is to develop the film normally in Kodak Microdol-X, diluted 1:3, following the times given. Then try printing. If exposures are too long because negatives are too dark and you therefore get excessive grain, try reducing that negative density in Farmer's Reducer. This treatment not only takes away unwanted density, but also improves the contrast. The net result should be pictures that have noticeably less grain and can be printed using normal times. When you work with the reducer, treat a single strip of film at a time after presoaking it in water for about 10 minutes. Follow the directions given with the reducer and don't over-reduce.

15
ENLARGING

ENLARGING PAPER FOR CONTACTS

Do you need contact printing paper to make contact sheets?

Enlarging paper will do just as well and is much faster. A convenient way to make contact sheets is to place the paper face up on the easel and place the negatives on it, emulsion-side down. Then press a sheet of heavy plate glass over the negatives to hold them in contact with the paper and make the exposure by the light of your enlarger, using its aperture to control the light and get a convenient printing time.

BIGGER AND BETTER

What is an enlarged contact sheet?

Here, as with a standard contact sheet, all film frames are printed on one sheet of photographic paper at the same time. But the negatives are enlarged onto it, rather than having the paper and film in direct contact. And in order to do this, the strips of film are placed in the carrier of an 8×10 enlarger.

If you want this done, contact a custom lab and ask for prices. The least expensive approach (that costs more, of course, than a standard contact) is to have the strips enlarged onto an 11×14 sheet so each frame is about half again as big as it is on film. However, larger-size "contacts" on 14 ×17 and 16×20 paper are also usually available.

TIPS FOR GRAIN FOCUSING

When enlarging, I use a grain-focusing device to focus on the grain to make sure the image will be as sharp as possible. I've heard it is wiser to do this at the aperture to be used, rather than with the lens wide open. Is this true?

Very often it is. This is because stopping down the lens may cause a slight shift in focus. Another grain-focusing tip is to use a focusing sheet

in the easel—perhaps an old print—with the white-base-side up. Then if the paper is the same thickness as the printing paper you will be using, you will be focusing on the same plane as the one where the image will be formed during the actual exposure.

DOWN WITH DUST!

What are the various ways to reduce the problem of dust on negatives when making black-and-white prints? I dislike the chore of spotting out the resulting white marks.

Two popular tools are an antistatic cloth and antistatic brush for removing dust from the film just before inserting it into the carrier. Many people also like to give the film a blast of air (using one of the canned products or an ear syringe). They may do this just before inserting the negative into the carrier or just before putting the loaded carrier into the enlarger or at both stages. There are also liquid antistatic film cleaners that some darkroom workers prefer.

So pick the combination that meets your needs and follow fundamentals of cleanliness. To diminish buildup of a static charge, you may want to ground your enlarger to a pipe, using wire for the metal-to-metal contact. Before setting up, too, it can help to settle the dust by the very moderate use of a small room humidifier. Remember, also, that dust is generally less of a problem in humid weather.

EXPANDING ON MAGNIFICATION

Just what is meant by diameters of magnification in enlarging?

This generally refers to linear magnification. So at five times (5X) magnification, for example, actual width of the picture image would be five times greater than the negative width, and length would be five times greater than the length of the frame on the film. It's useful to know that magnification of about $6\frac{1}{2}$–10X or 11X is often used in making 8×10 prints from full-frame 35mm negatives. Turning to 11×14s, we often use magnification of about 9–13X. A great deal depends on how much cropping is done. And these figures are, of course, often exceeded.

DETERMINING ENLARGEMENT FACTOR

How do you figure out the magnification you are starting out with when enlarging? And if you raise or lower the enlarging head, how do you determine your new magnification?

For either case, try this procedure. First note the width of the picture area on the easel. Then, without changing enlarger height, remove your negative and insert instead a piece of fixed film on which you have scratched a straight line horizontally, plus short, vertical scale marks in the inch or millimeter system. Next, turn on the enlarger and read off on the easel how much of this scale negative is being used. Finally, divide this number into the picture width of the negative being used to get your image magnification. So if picture width is 9½ inches (as it is for an 8 × 10 with ¼-inch margins), and the width of the negative being enlarged is 1¼ inches, then 9½ divided by 1¼ gives you a linear magnification of 7.6X.

JUDGING EXPOSURE TIME

What is the best way to determine exposure for a black-and-white enlargement?

There are several, adapted to different needs and working methods. The photographer who turns out a lot of prints may elect to adjust the enlarger to get the size print he wants, focus, stop down the enlarging lens, and then simply give the picture as long an exposure as he feels it needs. If his first print comes out too light or too dark, he throws it away and makes another. Although expensive, this method has its advantages. If you guess right, you've got your print. If part of the picture requires local control, you can estimate how much will be needed. This system is very wasteful, however, unless you keep doing enough printing from day to day so that you maintain a "feeling" for the exposure a negative requires and your guess is likely to be pretty nearly correct.

Test strips provide a more economical solution to the same problem. A sheet of paper is cut into several strips of convenient size, which then are kept in the same package with the full-size paper. It is important to test with the same type and contrast grade of paper you will be using for the print itself. With the enlarger lens stopped down ready for the exposure, place a strip of paper on the easel in a position where it covers important highlight and shadow areas of the picture. Make your test exposure. Then develop the strip, fix it and inspect it under white light. Most fans prefer to test several exposures at the same time. If you antici-

pate a correct exposure of about 20 seconds, for example, you might use 10, 15, 20, 25 and 30 seconds for your test. This is accomplished by exposing the whole strip for 10 seconds and then covering progressive areas of it at 5-second intervals. To keep important areas represented in each test exposure, it usually is desirable to shield the strip along its length rather than across its width. Using a 1×8-inch strip, for example, you can get five steps of exposure by holding a sheet of cardboard above it to mask off areas as they are exposed.

Kodak makes a Projection Print Scale which will give you the same information as test strips, with somewhat less bother, for the investment of a larger piece of paper. The scale is round and is made up of wedges of different densities. Place it on the paper, expose through it for a full minute, and you then can compare the results of ten different exposures ranging from 2 to 48 seconds. Each segment of the test print is automatically marked with the exposure time required, in seconds, to get a print of the same density it shows.

DENSE-NEGATIVE PROBLEM

What can I do to shorten the printing time for very dense negatives?

The best solution to this problem is to give your pictures less exposure, and you'll get better negatives that are easier to print. Less development may be indicated, too. But if you're already stuck with some dense negatives you can shorten your printing time by focusing very accurately and closing down the lens only one stop from its maximum aperture when you print. Using a brighter lamp will cut exposure time, too. The No. 211 is most commonly used. Shifting to a No. 212 cuts the exposure time considerably. Substituting a 213 further reduces the exposure time. Go back to the regular bulb for normal negatives, though. The 213 probably will give printing times too short for convenience at normal apertures. For extremely dense negatives, try a photoflood lamp. Watch for excessive heat, which will develop if you take too long to focus and compose your picture on the easel.

ENLARGING THIN NEGATIVES

I'm having difficulty in making black-and-white enlargements because exposure times are too short for dodging or burning in. Should I change to a weaker enlarging lamp to gain longer exposure times?

Problems of this sort sometimes arise when the negative is very thin or you are making rather small enlargements or both. Then use of a weaker enlarging bulb is one good answer. But another is just to use a gelatin neutral density filter—preferably in the filter drawer—to reduce light when this is important. To double your times use a 2X neutral density filter (usually marked ND .30); to quadruple it, use a 4X ND (usually marked ND .60) instead.

EXPOSURES FOR TEST STRIP

How much exposure change is required to make a significant difference in an enlargement? What should I do, for example, if I make a test strip with a 20-second exposure and it comes out entirely too light?

If you want to keep the exposure around 20 seconds, simply open the enlarger lens one stop. That will give the paper twice as much exposure in the same period of time. Minor adjustments, on the other hand, are most easily handled by changing the exposure time.

INCREASING IMAGE CONTRAST

How can I get more contrast in my enlargements?

First, make sure your negatives are properly masked in the enlarger so no white light spills out around them. This stray light can fog highlights and rob your prints of their proper contrast. Then, if necessary, switch to a more contrasty grade of paper (for example, to No. 3 instead of No. 2) or to a filter which produces higher contrast with variable-contrast paper.

DARKROOM BUDGET SHORTCUT

I want to make several 8×10 borderless enlargements, but I don't want to buy another easel. How can I do so?

Here's an easy way to do it. First position your easel arms to leave just an 8×10 area showing. Then put down double-stick tape (the kind that is sticky on both sides) so that you outline the rectangle, and your paper will just cover the tape. This setup is used first to hold your focusing sheet, which can be an old 8×10 print, white-base-side up. Then after composing and focusing, this is replaced with a fresh sheet of unexposed

169

enlarging paper in the usual emulsion-side-up position. Press it down gently, making sure your hands are dry and clean.

When you remove either the focusing sheet or the printing sheet, make sure the double-stick tape stays on the easel. The tape, of course, is easy to remove from the easel when you've finished the borderless print-making session.

SPECIAL PRINTING TECHNIQUE

How can I get black margins on my prints—like the ones used in some advertisements?

Often a satisfactory visual effect can be obtained merely by mounting the trimmed print on black board. But if you want the richer black of printing paper, simply expose the usual way, then cover the image area and flash the uncovered picture margins with light from the enlarger. The red enlarging filter is useful for positioning. And you can flash all four margins at once if your covering material (thin metal, perhaps) is cut to picture size and has clean, sharp edges. Otherwise, cover your image area with cardboard but use a material with a sharp edge for flashing one margin at a time.

BRIGHTENING HIGHLIGHTS OF PRINTS

How can I get extra brilliance in the highlights of my prints? I don't want to make a major contrast change—all the pictures need is a little brightening.

Some photographers achieve this sort of brightness by applying Farmer's Reducer to prints after they have been fixed. It acts first on the highlights, whitening them in a few seconds without producing a noticeable change in the middle tones or shadows. Avoid too much bleaching or you will get chalky highlights without detail.

RECOMMENDED: SKILLFUL DODGING

I have a fine picture except that my wife's face was shaded by her hat and is too dark in enlargements. There is detail in the negative all right, but it doesn't show up in a normal print. What can I do to preserve it?

This situation calls for "dodging" beneath the enlarger. The problem is to hold back light from the face for a portion of the exposure, while

170

letting it strike the rest of the picture. This usually is accomplished most easily by mounting a piece of black paper on the end of thin wire. Tear the paper roughly to the shape of the area you want to hold back, but a little bit smaller. You can adjust the size of the shadow cast beneath the enlarger by moving the device up or down. Keep the dodger moving slightly throughout the portion of the exposure for which it is used to avoid showing sharp edges around the lightened area.

DETERMINING DODGING TIME

How do you know how long to dodge a portion of a picture to lighten it?

Test strips provide the best answer. You really need to know two exposure times—one for the area you want to lighten and the other for the rest of the picture.

A CASE FOR BURNING-IN

Suppose a face comes out too light in a picture that otherwise is just right. How can I darken the face without affecting the rest of the enlargement?

This calls for "burning-in," the opposite of dodging. The idea is to give the rest of the picture the exposure it requires, and then hold back light from it while permitting the image to print longer within the area you want to darken. You can introduce a piece of black paper or cardboard, with a hole of suitable size and shape, beneath the lens as a convenient tool for burning-in. Keep it moving during the exposure. With a little practice you can use your hands for a variety of different areas. Raising and lowering the burning-in tool permits you to make the spot of light passing through it larger or smaller.

HOW TO FLASH

How are prints darkened in areas that contain detail in the negative when the detail is not wanted? Simple burning-in to give the area more exposure won't do because the detail is likely to be made more apparent.

This is accomplished by flashing in the areas to be darkened, using the rays from a small flashlight. The flashlight makes a convenient tool for this purpose if its lens is covered with a cone of black paper so the area that it illuminates can be much more easily controlled.

171

CONTRAST CONTROL IN DEVELOPING

What control do I have over print contrast when developing the print?

One method of contrast control is to vary the relationship between exposure and development. For less contrast, use a longer exposure and a shorter developing time. Have an acid stop bath ready and remove the overexposed print from the developer when it reaches the tone you want. Be sure not to pull the print out too soon. For one thing, it will look lighter after fixing and washing when you view it by regular light than it does by a dim safelight. Prints that do not have at least a minimum of development seem to be washed out, without rich tones or a feeling of depth. For more contrast shorten exposure time and increase development. The point at which to cut development short is either when the print looks right or just before it gets a grayed look, noticeable in light areas and in the white borders.

Varying developer dilution is another useful technique for controlling contrast. The easiest way to handle this is to set up three trays, clearly marked "normal," "stronger than normal," and "weaker than normal." The greatest contrast is obtained by developing in the stronger soup, less than normal contrast by using the weaker one. Developing times must be varied from normal slightly for good results.

REDUCING PRINT CONTRAST

Just what is the "hot water treatment" that is mentioned from time to time?

This is another way of lowering contrast, by developing the print in a tray of hot water (130° to 140°F). Immerse it in developer just long enough for it to become thoroughly wet. Then transfer it to the hot water while development continues. The procedure can be repeated several times if necessary to get enough density, but the paper is likely to become fogged or stained if treatment lasts too long.

SPEEDING AREA DEVELOPMENT

Is it possible to darken one area within a print after the image has started to appear in the developer?

This can be accomplished by applying concentrated developer to the area with a cotton swab.

172

A PROBLEM IN CONTRAST

What special factors lead to lowered image contrast in black-and-white printing? I'm not talking about the grade of paper.

A number of things can cause this problem. But first check out the darkroom for too much light from one of various sources. For example, the enlarger might leak light excessively. Or the problem might be light emanating from sides of an unmasked negative. To correct it, use the adjustable masks found on some enlargers or cut a mask out of black paper. Still another cause of lowered contrast is a safelight that isn't safe. Perhaps it needs to be moved farther away or needs a weaker bulb or even a new safelight filter. Some other possibilities that should be taken into consideration are outdated paper, worn-out developer, or a diffusion-type enlarger, which will provide less contrast than a regular condenser unit.

SHOULD A LAB DO IT?

Can I get custom developing and printing that is as good as I would do myself?

You can if you are willing to pay the price. Such service costs more in money and, just as important, in the time you take to make sure the finisher knows just how you want your pictures developed and printed and what controls you want used.

FIRST, STUDY THE CONTACTS

How can I tell the custom printer what controls I want used in enlarging?

Order contact sheets first, so you will know what's in your negatives. Mark them up with a red grease pencil. Use straight lines to indicate definite cropping instructions and wavy ones to show where cropping can be varied to fit the full paper size. Where you want an area darkened, indicate burning-in by cross-hatching with short, straight lines. For dodging to lighten an area, make little circles on it.

OPAQUING AND AIRBRUSHING

How do they remove backgrounds from commercial illustrations?

This work usually is done on the negative by covering the background with photo opaque, which is applied with a brush or by airbrush. The

edges of the subject must be followed with great accuracy, but once the job is done properly any number of prints can be made with ease. Occasionally, the same effect may be obtained by painting out the background on a print with an airbrush. Copies then can be made if more than one print is required. Opaquing is made easier if the picture is taken against a white background.

LET THE CHILDREN DO IT

How can I incorporate the greeting in a photographic Christmas card?

The easiest way is to make it a part of the original picture setting, letting children write it on a blackboard, trace it in the snow, or spell it out with alphabet blocks or anagrams. This handling places it in the negative along with the picture, where it will print automatically.

COMBINATION-PRINTING FOR CHRISTMAS CARDS

What are the ways of adding the greeting to a Christmas card picture that already has been taken?

One of the simplest is to write the words on the negative. Use black India ink in a transparent area. The result will be white writing against a dark background. Usually you have to plan a photo of this sort, leaving space for the greeting when you compose the picture. Another way is to make a very good print of the picture, add the greeting to it, and then copy this combination to get a negative for producing finished cards.

SUBORDINATING THE GRAIN

I have some important but grainy negatives. How can I enlarge them while keeping the grain as unobtrusive as possible?

Use a matte-surfaced paper to help conceal it. Diffusion helps, too, but results in lack of definition. You can use the latter in pictures where extremely sharp detail is not necessarily desirable, such as portraits and some types of landscapes. Work for medium contrast. Grain is emphasized by the contrasty papers.

174

LOOK AT PRINTS BY WHITE LIGHT

The first enlargements I make at a printing session often come out too light with not enough highlight detail, while the last ones usually are much better. Is this because it takes time for my eyes to become accustomed to working in the dark?

It could be, but it is possible that those first prints may be just as good as the last ones when you place them in the fixing solution. If you allow pictures to accumulate in the hypo during a printing session, the first ones will remain in it too long and will become bleached out in the highlights. Time your fixing, like developing, and get the prints over into the wash when they have been fixed. Inspect your prints by white light after they have fixed long enough to make it safe. If they look right then, they should be right after completion of fixing and washing. It's easy to lose track of fixing time while making prints, and prolonged fixing robs pictures of their quality.

FLATTERY BY DIFFUSION

I want to experiment with diffusion for portraits. What materials would you recommend?

For diffusion in enlarging you can use cheesecloth, dark chiffon, a piece of silk stocking, tulle or other net-like fabrics. Ordinary window screen also can be employed, or you can use a piece of cellophane, prepared by crumpling it and then flattening it again. These materials can be mounted in small embroidery hoops or mounted over apertures in sheets of heavy cardboard. Always move diffusers slightly throughout the exposure.

HERE IT'S SHARP, THERE IT'S NOT

Is it possible to diffuse part of a picture and leave the center sharp?

This is accomplished with the aid of a diffuser that has a hole in it. If you use net or cellophane, you can burn a neat, round hole in it with a cigarette. Diffusion requires longer exposure time, since part of the light is held back by the diffusing medium. To avoid having the center of a portrait come out too dark in relation to the rest of it when the center is not diffused, make part of your exposure for the edges of the picture only, holding a circular dodger beneath the enlarger where it will prevent light from striking the center.

DOUBLE-DIP FIXING

What is the value of two-bath fixing?

Some photographers prefer to use two trays of fixing solution. Prints are partially fixed in the first, then transferred to the second where the process is completed. Since the first bath does most of the work and is most likely to be contaminated by carry-over, it becomes exhausted much faster than the second. When it is discarded, the second is put in first position and a new bath takes second place. This system guarantees that prints will be fixed in a strong, clean bath. Such a bath works better and washes out more readily.

WHEN DARKER IS BETTER

What is meant by the suggestion that "you need to print down"? I've heard it used occasionally.

This is a colloquial way of saying the photographer should give somewhat more exposure and make the picture effect a bit darker. It is often advised to give an enlargement a richer tonality with better blacks. It is especially applicable to many beginners who have the tendency to print far too light. However, it should not be mistaken for giving so much extra exposure that the picture is just too dark.

Instead, printing down should enhance the images and stop short of spoiling them. And since there are many styles in printing, with some people opting for darker images, a great deal depends on individual taste.

HOW BIG ARE BLOWUPS?

How can I tell the degree of magnification of my black-and-white prints as I am making them? I've heard that it is possible to determine this by putting a specially marked negative in the negative carrier. Exactly what is the procedure here?

Simply leave the enlarger head at the same height you have used for making your picture. But remove the negative and insert your specially marked negative. This special frame should be one you don't care about, upon which you have scratched a straight line plus a number of even divisions, possibly using a sharp pin. As the metric system makes things easier here, try scratching half-centimeter divisions along your straight line. Then simply see how many centimeters (or half centimeters) of film image are projected onto the easel below. Naturally, to find the degree

of linear magnification you just divide this figure into the linear picture measure. For example, if you project 3mm worth of film horizontally onto a picture area below of 24mm, by simple division you would have 8X magnification.

AN ENLARGING PROBLEM

Can I use a 25mm lens on my 35mm enlarger to increase magnification effectively without increasing girder height?

This works well if you want to make a big enlargement of a limited portion of a full-frame 35mm negative. And it's far easier than the alternative of turning the enlarger head around and projecting onto an easel on the floor. But the 25mm lens covers only about half of a 24×36mm, 35mm frame, give or take a little, depending on the lens mount. You'll still need your normal lens for a great deal of work.

FULL-FRAME FANATIC

The negative carrier of my enlarger does not permit projecting the entire 35mm negative on the easel. Is the problem a defect in my carrier, or is it common?

It is quite common. And the reason is that a full-frame 35mm image is not always the usual 24×26mm size. Actually, it can be somewhat larger or smaller, depending on a number of factors, including the lens. For instance, with some 35mm wide-angle lenses you may get an image about 24½ × 36½ mm, while with a much wider lens the image may actually be 25×37mm. There are all sorts of moderate variations here. Even with various 50mm lenses differences of say 1/2–1mm in image size can show up. The negative carrier, on the other hand, tends to be a single size such as 24×36mm or, in some cases, 24×35mm. But most of the time this is not a problem as photographers rarely crop so accurately when shooting.

For a temporary full-frame carrier, try making a substitute out of black cardboard or heavy black paper into which you have cut the right size opening. For a more permanent special carrier, check with the manufacturer of your enlarger.

MAKING THE BIG ONES

I'm interested in making photo murals. How can I expose them? My enlarger won't raise high enough for as large an image as I want.

If your enlarger is designed to rotate on its column, you can place weights on the easel to hold it steady and then pivot the enlarger head around the column to form an image on the floor. If your enlarger head is made to tilt, you can turn it 90 degrees and throw the image on the wall. Some enlarger heads can be removed from their columns and placed on one side for horizontal projection. If you have a projector, you can use it for this purpose in a darkened room.

OVERSIZE PRINTS WITHOUT TRAYS

How can I develop big prints without buying oversize trays?

You can improvise a large tray by making a shallow plywood frame of the right size and depth and lining it with oilcloth or plastic. Fold in the corners, don't cut them. To develop a print, place it in the tray after exposure and then pour the solution over it, using a cotton swab to circulate it over the entire surface and keep it moving during development. To stop development, tilt the tray and pour out the developer and then immediately flood the print with a stop bath. Drain the stop bath off and pour in your fixing solution. Wash the print in the bathtub.

FORMULA FOR STAIN REMOVAL

My darkroom trays are beginning to accumulate stains. How can I remove these?

One way is to dump your stop-bath solution into the developing tray and let it stand overnight. The weak acid of the stop bath will remove the stains without affecting the tray itself. If you make this a regular part of your clean-up procedure, you need never resort to stronger tray cleaning solutions.

REMOVING SINK STAINS

I sometimes use a silver-nitrate test solution to check that wash time has been sufficient for a batch of prints. Yet now I have dark stains on my white sink. How can I remove them? Kitchen cleansers don't do the job.

There may be several ways of removing these stains: One is to use a strong enough silver cleaner. We had best success with repeated applications of a clear, instant-dip, liquid silver cleaner that called for the user to wear rubber gloves. Just apply the liquid with a piece of rough, old toweling, leave it on the spot for about 30 seconds, then rub briskly, and repeat. You might need to do this about ten times with older stains. At the end, be sure to wash the area thoroughly.

HAZARD OF OVER-FIXING

A test strip made on a sheet of Kodak Polycontrast Rapid RC paper stayed in the fixer for about two hours while I ran an errand. When I returned, it had this brownish, sepia tone. And after an hour's wash it stayed that color. What happened, and is this a practical way of toning?

This sort of coloration can occur due to sulfurization of the fixer—a condition where sulfur has been precipitated in the bath. And this can result from fixer exhaustion, fixer that is too old or was stored in too hot or cold a place, or even a combination of these reasons. Then if you leave the strip in the fixer a very long time (as you did), the precipitated sulfur can attack the silver in the paper to create a lot of silver sulfide and this brown color. It is not, of course, a practical way of toning.

FOR NO-CURL PRINTS

Every time I make a print it curls. Do you have any information that will help?

There are various useful basic facts of life here. Double-weight paper is, of course, less of a problem than single-weight. Some brands of double-weight paper will lie flatter than others. And curl, as expected, is more of a problem on dry days than on humid ones. Such matters aside, however, you might try using a print flattening solution as the last predrying step. A number are available in your camera store. It is also a good idea to dry prints slowly and without heat, as in a blotter roll. Drying in this manner gives the prints a reverse set, which is an additional anticurl measure.

DRYING RC PRINTS

I recently started using resin-coated black-and-white paper and made a mistake. Instead of just wiping off the prints to dry them, I tried drying them face down on my ferrotype surface at high heat. The resin coat stuck to the plate and won't come off. How can I remove it?

You may or may not be able to get it off. Try soaking the outer paper off first, using a clean wet sponge. Then gently scrub off the remaining filmy resin, if possible, with a paste of Bon Ami cleansing powder, using a sponge or wet toweling. This worked for some people we know without apparently spoiling the tins. But it is possible to abrade the chrome-plated surface as you rub in this fashion. So you'll just have to take your chances. At any rate, rinse the tins very well afterwards and then repolish with ferrotype polish. Resign yourself to the fact that if this doesn't work, you'll have to get some new tins.

CONTROLLING CONVERGING LINES

How do you control perspective in enlarging? I want to correct the vertical lines of a building. They now converge at the top of the structure, and I want to make them parallel.

Tilt the easel beneath the enlarger to bring the image of the bottom of the building closer to the enlarger lens than its top. With a little experimental shifting about you can find how much tilting is required to get the effect you want. Then use books, blocks of wood or other objects to hold the easel steady in the required position. Focus on the middle of the picture and stop down your lens to a small aperture to bring top and bottom into focus, too. You will find that the bottom of the building will print somewhat darker than the top, with easel tilted. To get an even tone, hold back light from the bottom by dodging for a portion of the exposure time.

ON CONTAMINATING FIXER

Does frequent bleaching with a dilute solution of potassium ferricyanide make the fixer become exhausted faster than usual?

Such contamination should certainly be avoided. And an easy way to do this is just to rinse the ferricyanided print off well in cool running water before immersing it into the fixing bath.

180

The less experienced should also note that they can bleach as soon as it is safe to view the print by room light. At this point, lift the print out of the fixer, blow on its surface to remove visible moisture from areas to be bleached, and hold the print over a spare tray while you apply a limited amount of the pale-yellow solution of dilute ferricyanide. Some printers do this with cotton swabs or tufts; others prefer bamboo artists' brushes (having no metal). Additional tips are as follows: Work slowly by repeated applications of ferricyanide, with each cycle including rinse and fix; for the most natural-looking results, keep your bleaching moderate and confined to various gray-looking areas; avoid bleaching very dark areas as you can get a faded, gray, unnatural look.

OUT WITH THE HYPO!

What makes hypo-eliminators work?

These solutions are designed to facilitate removal of small traces of hypo. They convert it into other products that are more readily soluble in water.

AN EMERGENCY HYPO TEST

If I don't have any special test solutions, how can I check black-and-white film fixer to see if it is still good? Is there a film test?

Yes, there is. First put some of your fixer in a small tray or a graduate, assuming the solution seems in good condition. Add a bit of black-and-white film, such as a piece cut off the leader of a fresh roll. Be sure it is covered by the solution. Then agitate moderately and intermittently, noting how long it takes for the film to clear.

Finally, apply the old rule of thumb: The right fixing time is twice the clearing time. For example only, if your bit of film clears in 4 minutes, total fixing time would be 8 minutes. So if the fixing time range is 5–10 minutes for the total time, your fixer would still be usable. And the fixer used in the test can be saved. In borderline cases, however, it's usually best to throw the whole batch of used fixer down the drain and start out with fresh solution.

ELIMINATING RESIDUAL HYPO

I've heard that you can test for traces of fixer left in a print after washing. How is this done?

This is a very good idea in order to make sure you are washing sufficiently in your particular setup. You have two choices. With each you apply a drop of a silver-nitrate-type solution to a white area of a washed print (preferably on the base, as fibers there retain chemicals more than does the emulsion). Then compare the stain produced to a set of tint patches for the product or formula. If you are a mix-it-yourself type, see the Kodak *Darkroom Dataguide* that provides the formula (silver nitrate, 28% acetic acid, and water), instructions, and tint patches.

PICKING THE BEST WET PRINT

I frequently make a number of slightly different prints from the same negative. And my procedure each time is to turn on the room light (after sufficient fixing for this) and decide whether the print I just made is good enough or if I need to try again. What is a good way of marking a wet enlargement to indicate it is the best of the lot?

Probably there are a number of different answers. But one that is widely used for prints having generous white borders is just to tear off a small piece of one corner of your best enlargement. A logical follow-up on this idea is to tear off a bit from each of two corners for the second-best print, from three for the third best, and from all corners for the fourth.

FOG IS CREEPING IN

I have an annoying black-and-white enlarging problem. Once in a while I make an exposure of 2–3 minutes with the lens stopped down moderately to get good print sharpness. But then I get foggy-looking results with slightly grayed highlights, although print margins are white. What could be happening? My paper and chemicals are fresh, and my safelight (which goes off during exposure) checks out safe.

Undoubtedly there may be other answers. But one explanation often fits the bill. First there is usually a fair amount of light leakage from the enlarger head. Next, this light is in turn reflected back by light-colored, surrounding walls nearby. While it is possible for this condition to be apparently harmless during reasonably short exposures (under 1 minute),

182

when those exposures get quite long, paper can be fogged noticeably.

To check this out, try taping up some black (or dark) cloth or paper temporarily on the possibly offending wall areas. Then make some long-exposure prints to see if cutting down the reflectivity solves your problem. If it does, keep the cloth or pieces of paper there when printing or paint such areas black (or a dark color) if practical.

If, on the other hand, it becomes necessary to block off enlarger-light leaks (usually around the negative carrier or on top), be sure to contact the enlarger manufacturer and see what is advised. The idea is to keep enlarger operation convenient and, at the same time, avoid temporary or permanent light-blocking methods that might cause the enlarger to overheat.

AVOID TATTLETALE GRAY

Sometimes in summer my paper developer gets on the very warm side. If I don't cool it down, I can get a slight, sort of gray, foggy look on my prints. Is there anything I can add to the developer to prevent this? I need assistance because it is impractical for me to periodically lower the temperature of my processing solutions.

A good measure of relief can be obtained by adding an anti-foggant to the paper developer. Many photographers prefer to add benzotriazole because, with moderate use, there is little or no warming effect on print tone. For the record, it is available in liquid form (Edwal Orthazite) or in tablet form for you to dilute (Kodak Anti-Fog, No. 1). Results tend to be far more pleasing than when potassium bromide—that old classic anti-foggant—is used. With the latter, tonal change occurs quite easily, and results can have a decidedly unpleasant warm type of tone. Both substances, however, do slow down developing to a degree, so you will have to increase exposure time accordingly.

BATTLING THE CURLS

I occasionally use Estar-base 35mm film, and when I do it curls badly. Does this mean I have to abandon use of my sheet of heavy plate glass for making contact prints?

No. Just tape the filmstrips down onto printing paper with small pieces of clear tape (that will show only slightly on the finished print). Some techniques follow. First, the bits of tape should be placed along film edges near the ends of each strip so picture areas are not covered. Avoid touch-

ing such areas. Next for convenience, try fastening only four strips of six exposures, each on a sheet of 8×10 paper, leaving enough space in between the negative strips. After covering the combination with your glass and exposing, remove the tape from the paper and film, and develop the paper.

HANDLE PAPER WITH CARE

Why do I sometimes get thin white lines on some of my prints? In this case, two prints were made, one right after the other on Kodak Polycontrast F paper using clean filters and condenser, without moving the negative in the enlarger. Yet one print has the marks shown, while on the other the marks are differently shaped and placed.

This probably results from abrasion to the print surface prior to exposure. To avoid this problem, more care is necessary when handling the paper.

FORMULA FOR CONTRAST CONTROL

Recently I was printing on a Sunday, and I ran into a problem. The No. 4 paper was too soft for the picture, and No. 6 paper (the next grade I had on hand) was too contrasty. Was there any answer besides waiting for Monday to buy No. 5 paper?

Very often you can solve such a problem just by changing the developer dilution. Instead of using that classic Dektol developer at the normal 1:2 dilution, try it at 1:1 or even straight for your No. 4 paper. One of these approaches might just give you the extra contrast you need. On the other hand, if you start with No. 6 paper, diluting Dektol 1:4 or even 1:8 might do a better job visually of softening contrast just enough. You have to experiment a bit here. The approach is, of course, useful for other cases and other contrast problems with other paper grades.

STICK TO THE LAST?

I was using Dektol paper developer (by mistake) at 1:4 dilution. When I changed to the recommended 1:2 and made several prints, results were not as good in quality as at 1:4. What should I do?

Stick with that 1:4 dilution, naturally, since you like it. Some photographers who have somewhat higher than normal contrast negatives or shoot contrasty subject matter actually prefer this greater dilution. On

the other hand, there is a contingent that quite regularly uses Dektol at 1:1 dilution, to get slightly more contrast than 1:2 dilution affords.

LEVELING ABOUT LINT

Do linty prints mean it is time for me to buy a new blotter roll?

Not necessarily. A blotter roll can be used for a long, long time, provided that you don't contaminate it with residual chemicals from your prints and that it stays in good condition otherwise. To minimize lint, try squeegeeing each print on both sides before putting it into the blotter roll. Then remove any lint on dry prints with a solution such as rubber-cement thinner or lighter fluid, using a lint-free cloth.

Another answer is to use a more expensive type of blotter roll, where the picture side of the print is placed against a muslin-faced, nonlinty type of blotter surface, rather than on regular blotters. One of this special type is made by Eastman Kodak, which holds eight 8 × 10 prints. Like any other blotter book, it is designed for drying regular-base paper.

ELIMINATING THE RIPPLE

I squeegee black-and-white prints before putting them in my dryer. Why do I get a ripple on edges of dry prints?

You probably need to lower the drying temperature suitably. However, if the thermostat isn't very good or there is none, lower the temperature by turning the dryer off periodically (for a short while each time), and then turn it on again. With a little practice, you'll soon get the knack of this procedure.

RESCUING OLD PRINTING PAPER

About two or three years ago I read that you could eliminate the grayish tone of outdated black-and-white printing papers. What chemicals are used?

An anti-foggant is added to the developer. The usual chemical suggested is benzotriazole, because when used normally it does not give the enlarging paper an unpleasant brownish cast the way potassium bromide often does. Benzotriazole is available in liquid form (Edwal Orthozite) or in tablet form (Kodak Anti-Fog, No. 1). No matter which product you buy, be sure to follow the manufacturer's directions for use.

A RERUN ON STAIN REMOVAL

What is the formula for getting rid of yellow stains on enlargements that result from bleaching locally with potassium ferrocyanide and fixer?

Sometimes it's enough to just put the print back in the fixer for a while. But if that doesn't do the job in a few minutes, you could add some lemon juice (of the bottled type, if you wish) to your fixer. A good brew can be made with Kodafix, for example, by taking 4 ounces of Kodafix concentrate, 20 ounces of water and 8 ounces of lemon juice. Immerse the print in the mix. After a brief while the yellow stain should disappear. As soon as this occurs, wash the print thoroughly for the usual time. Or wash several minutes, use a hypo neutralizer, then wash the print again.

CREATIVE PRINT CONTROL

I want to use a concentrated solution of Phenidone in Dektol paper developer to darken areas of enlargements that weren't given quite enough burning-in. How should I mix it and apply it?

Try starting with about four ounces of Dektol working solution (where dilution is 1:2) at 70°F or thereabouts. Then add a scant ¼ teaspoon of Phenidone (a developing agent in crystalline form) and agitate in the usual manner for a while. The exact proportions are not critical. If you've added a bit too much, the slight excess that doesn't dissolve will sink to the bottom of the graduate (which, preferably, should be small). And this fallen residue that may or may not dissolve in time should just be ignored.

The usual working approach is to wait until the print has received full or nearly full development. Then dip a hunk of cotton into the Phenidone/Dektol solution, squeeze somewhat, and apply the nondripping cotton gently to the areas needing moderate darkening. Remember, it is no cure for considerable print underexposure. And you must learn to stop short of the point where you fog light areas. Phenidone is the Ilford trade name for 1-Phenyl-3-Pyrazolidone. You can buy just two ounces for under $5, but your photo dealer must order it from Ilford. (And considering the small quantity used each time, this amount goes a long way.) Otherwise, try a chemical supply house and see if you can buy less than a pound.

DOUBLING UP

I want to make multiple exposures on black-and-white prints by sandwiching negatives. But the four film-guide pins of my Omega negative carrier make it difficult to sandwich film freely for best positioning. What do you suggest?

Why not make a multiple-exposure carrier out of two pieces of black cardboard to achieve about the same total thickness as you have with your metal carrier? Just take a sharp matte knife or single-edge razor blade and carefully cut a full-frame 35mm opening in each piece of cardboard, so the openings align when the two pieces are put together. Finally, you can use an indelible black marker to black out the white frame inner edges. This homemade device should give you the freedom you need for your sandwiching.

A FOGGY-FOGGY-DO

Why do I get an overall grayish look on enlargements when I use exposures of over one minute? Prints made at shorter times, such as 15 or 30 seconds, with the same paper and setup are fine, with clean whites, good blacks, and good scale between.

It may be that your safelight isn't really safe, except for short periods. When you exceed the limit, the combination of safelight plus long exposure is just a bit too much for the paper, and a grayish overall fog can result. This is characterized by a lack of any real white, except at the margin areas, which were under the easel arms during exposure. But if these areas are also gray, then you probably fogged the paper in handling before exposure or at some other point, such as in processing trays, or perhaps even both.

Therefore, try turning out your safelight (or safelights, one at a time), and see if that solves matters. If so, then move the offending safelight farther away or use a weaker bulb. Finally, to make sure the safelight is really safe for longer exposures, make comparison prints with it on and off.

BACK-STAMPING PROBLEM

How should I stamp the back of Polycontrast RC (resin-coated) prints so the ink doesn't offset to the face of another print when they are stacked up? This occurred even though I allowed a day for the ink to dry, with the prints fanned out. Now while additional washing for 4 minutes has almost entirely removed the stamped

187

impressions from the backs, the smears offset onto the emulsion side are as strong as ever.

The problem here, of course, is that the resin coating resists absorption. So Kodak advises using fast drying—not slow drying—inks. For specific data, get Kodak publication E-67, *Finishing Prints on Kodak RC Papers*. This lists suitable stamp pad ink to use as well as pens and lead pencils for marking the base side. As far as the ink that has penetrated the emulsion is concerned, we are told there is very little likelihood that it can ever be removed.

ENLARGED COLOR NEGS TO BLACK AND WHITE

Can I make enlargements of color negatives on regular enlarging paper?

You can, but the results may not be too satisfactory. Blue skies will print light, red lips appear very dark, and tones of other colors won't come out just as you expect them to.

PAPER HUE BEFORE PROCESSING

Is unexposed Kodak Ektacolor 37 RC color-enlarging paper (for use with color negatives) supposed to be a bluish color when you get it? Some other color-printing papers have a different initial color. So I was worried that the bluish color might indicate a color shift.

Stop worrying! The bluish color doesn't indicate trouble but is the normal tone of the emulsion *prior* to use. And the coloration disappears, of course, in processing.

DIRTY PICTURES, BUT NOT X-RATED

I hope you can help me with my problem. A friend dropped some of my Kodak color prints on a wet, dirty floor. What solution should I dip them in to clean them?

These prints can be washed with clean tap water, and this might do the cleaning job. But it is best to restabilize them afterwards or print life will be shortened—although such change is long-term, not immediate. At any rate, if you are not equipped to restabilize the prints yourself and don't know anyone who is, you have several options. You can wash the prints; then at a later date when the change shows up, have new prints

made. Or you can try your dealer and see if he knows of a photo lab that will render this special service of cleaning and restabilizing. Finally, it might be easier and cheaper just to have some new prints made.

CIBACHROME PRINT FILTRATION

When you print directly from color slides onto Cibachrome print material, can other makes of color-printing filters be used instead of Ciba ones?

Other sets of magenta, cyan, and yellow color-printing filters are suitable. But be sure you have enough yellow filtration, as with some print material batches (and some kinds of slides) needs can run as high as 115Y (yellow), give or take a little. For this reason it pays to have a broad enough selection in yellow, like densities of 5, 10, 20, 30, 40 and 50.

Naturally, all filters go above the lens, along with the needed heat-absorbing glass and a UV (ultraviolet-absorbing) filter. This UV can be the Ciba one, but others, such as the Kodak 2B, will also work very well.

16
WHAT WENT WRONG?

THE BOGEY OF RETICULATION

What are the crackle-like marks that seem to be on all the shots of one roll of film that I developed?

The marks on your pictures seem to indicate "reticulation" of the film during processing. They indicate that at some point (probably during the wash) the film was exposed to too great a change in temperature. For example, it's not uncommon in some homes for the temperature of the running water to rise suddenly and then run much cooler after a little while, first swelling the emulsion excessively and then shrinking it. If the change is great enough, you can get this orange-peel-like look on the emulsion. However, if the change is less great, you may only get an unwanted increase in graininess called incipient reticulation.

So keep all processing solutions, including the wash, within about two to three degrees of each other And keep an eye on the thermometer during the entire wash time. If the temperature starts to vary by three degrees, first pull the wash vessel, then adjust the faucets so the temperature is right before starting the wash process again.

HOW TO KEEP 'EM SHARP

What causes unsharp pictures? Some of mine are as sharp as can be, but others on the same roll may be hopelessly blurred.

The most frequent causes of lack of sharpness, in order of likelihood of their appearance, are camera movement, subject movement recorded at too slow a shutter speed, errors in focusing or gross errors in exposure and development.

KEEP MOVEMENT IN SUBJECT

How can I identify blur due to camera movement?

If you fail to hold the camera steady, the whole picture will be blurred. Lack of sharpness will be more apparent at a distance than in the near foreground. If any part of the picture is sharp, then you know that blurring is probably due to subject movement or to incorrect focusing.

A MATTER OF METERS

What is wrong with my camera? When the film rating is set at 1,200, I sometimes can't get a meter reading in low light. Yet the meter works fine in the same light when the film rating is lowered to a setting of 400.

There's probably nothing wrong. Your SLR 35 may simply limit you to a specific range of shutter speeds for each film rating. This is the case with a number of SLRs having match-needle control. For example, the range with some cameras may be 1/60 to 1/1,000 second for a rating of 1,600 or 1,200. And if you have selected 1/30 or a slower speed, the meter won't function. However, by a rating of 1,000 or 800, some cameras provide a range from 1/30 to 1/1,000. By 400 there may be a range of 1/15 to 1/1,000 and so forth. In your 1,200 problem case, you could make a reading at a speed like 1/60 where the meter works. Then adjust this reading for the slower speed you desire to use. Or, do as you do—lower the film rating, enough to let you meter at the slow shutter speed desired. Then adjust the reading so it is correct for the faster reading of 1,200 and set the camera accordingly.

CORNER-CUTTING LENS SHADE

Some of my negatives are light at the corners, while others are all right. I always use a lens shade, but if it were at fault wouldn't all the negatives come out the same?

Not necessarily. If a lens shade just barely cuts corners, the effect will appear in pictures taken at some apertures and not at others. To be sure, make pairs of comparative pictures with and without the lens shade, both at a wide aperture and at a very small one.

UNPRINTABLE NEGATIVES (WEAK VARIETY)

What makes negatives come out too weak to print?

Underexposure or underdevelopment. Development is insufficient if the film is immersed for too short a time, if the solution is at too low a temperature or if it is weak due to improper mixing, contamination or exhaustion.

RESULT OF INSUFFICIENT AGITATION

What causes very small, transparent spots on negatives that result in black spots on prints?

A frequent cause of this trouble is air bubbles on the film during development. To avoid them, agitate the developer, particularly when the film is first immersed. Spots due to this cause are perfectly circular.

NEG-POS NEGATIVES

What makes a film come out part negative and part positive? Everything was normal when I took the pictures.

Partial reversal can take place if light is permitted to strike the film part way through development. It may be a brief flash of light from striking a match or from opening the darkroom door a crack, or it may be a longer exposure like that caused by using too bright a safelight for intermittent inspection.

INSUFFICIENT FILM WASHING

Some of my negatives have a white, crystal-like deposit on them. What could it be?

This probably is hypo, carried over from the fixing solution and not sufficiently washed out. It can be removed by proper washing. If allowed to remain on negatives, it will cause spotty fading.

PRINTS: DARKER BY SAFELIGHT

My prints look fine when I take them out of the developer, but after they have been washed and dried they often seem too light. What's wrong?

There are two possibilities. In judging a print under the safelight, everyone has a tendency to pull it out of the developer too soon because it looks right under the dim safelight. You've got to learn to take into consideration the fact that a print looks darker by safelight than it will in brighter illumination. There also is a possibility that your prints may actually get lighter after they are developed. Leaving them too long in the fixing solution will bleach them, producing an especially noticeable effect in the highlights. They should be fixed no longer than the recommended time, then be placed in wash water where they can be allowed to accumulate until you are ready to dry them.

LIGHT FLASHES ON SCREEN

What causes flashes of light to occur as movie films are projected?

This sounds like edge-fog, caused by loading or unloading the film in excessive light. If this is the case, the flashes will appear near the beginning and end of the roll (and at the middle in the case of double-8). Individual frames may be blank if the camera stops with the shutter open when it runs down at the end of a scene. To avoid edge-fog, open the camera only in subdued light. To avoid white frames, keep the camera wound sufficiently so it never runs down while you are filming.

KEEP THE CAMERA CLEAN

What causes movie film fuzz that won't rub off? Every time I show one of my movies, a clump of dust gathers in one corner of the picture and I can't get rid of it. Other films don't do this.

The clump of dust seems to be *in* the film, not *on* it. This can happen if dust gathers in the camera at the time of exposure. It casts a shadow on the film, which makes it look like dust itself. The remedy is to keep your camera clean and to make certain you clean its aperture plate before loading.

"RAP" SESSION REQUIRED

What is the cause of the light circle in the sky of a picture? And what can I do to solve it? I run into this problem occasionally, although the light spots are usually much smaller.

The spot is due to an air bubble affixing itself to the film during development. You get a dark ring-like area around the spot due to developer flowing over the air bubble and collecting at the bottom before continuing its flow. As a result there is greater action of the developer in such areas around each bubble. Quite obviously, the answer is to rap the tank several times against a hard surface, after pouring in the developer and after agitating for about 10 seconds. Then continue developing in the usual fashion. This amount of rapping should be enough. If you use a hard plastic tank, however, just be sure not to rap so hard that you crack the tank.

REVERSE ACTION IN MOVIES

Why do wagon wheels seem to turn backwards in motion pictures?

The intermittent nature of movies, like stroboscopic light, can make swift-spinning wheels seem to stand still or to move more slowly in either direction. When a film is made at 18 fps and it shows a wheel turning at 18 revolutions per second, each frame will catch the wheel in exactly the same position and it will appear to stand still. If it is turning at very slightly more than 18 rps, it will appear to be going forward slowly; at slightly less than 18 rps it will seem to move in reverse. Since each spoke of the wheel is identical with every other spoke, there are many additional opportunities for near synchronization as the wheel turns at different speeds. The fact is, it's unusual for movies ever to portray this type of movement just as we see it with our eyes.

COLOR REFLECTIONS

Recently I took some color portraits of my daughter in the park. One shot showed particularly good expression, but the shadows came out green under her chin. Was there something wrong with the film?

This sounds like the shadow was illuminated by light reflected from the grass, which of course was green. Hence green shadows! It's important to recognize the fact that light bouncing back from any surface near

194

the subject will take on the hue of that surface and transfer it to the subject. The reflected light may have little effect where it overlaps bright sunlight, but it is likely to show in shadow areas that have no other illumination.

FERROTYPE TROUBLE

How can I avoid getting small, unglazed specks on my glossy prints?

Specks tend to appear when prints receive excessive hardening in the fixer, when the wash water is either too cold or too warm, or when the water contains suspended impurities.

The most common cause is an air bubble that has been trapped under the print and broken into dozens of tiny bubbles as the print is squeegeed. To sidestep this problem, carefully wipe the surface of each wet print with a sponge so no clinging air bubbles remain. Re-immerse the print in water, and as you apply it to a super-clean tin, be sure that a layer of water is under the print. Carry over as much water as possible with the print and let the wet print *slide* onto the tin, rather than drop on it.

GLOSSIES MARRED

Although I polish my ferrotype print dryer's surface and it has no visible scratches, I often get fine scratch marks on my glossy prints. What is this caused by, and how can I remedy it?

Take a really close look, and we'll bet you will find some fine scratches on the metal ferrotype surface, which generally are the cause of such scratches showing up on the prints when dry. There's not much you can do to get rid of them on the metal surface. But you could ignore the scratches on your prints if they are minor. Or try one of several other procedures.

For instance, you could stop ferrotyping your prints. It's quite the fashion today to matte-dry glossy paper by placing the emulsion side against the dryer cloth. However, if glossies without scratches are a must, try getting a set of new ferrotype tins that can be used in various flat-bed-type dryers, perhaps yours. Still another alternative is to print on a resin-coated glossy paper that never loses its gloss in the first place and can be air dried.

A MATTER OF IDENTIFICATION

What are the round white spots that I get once in a while on my black-and-white enlargements?

They seem to be the result of letting drops of fixer hit the enlarging paper at some point before development. When this happens, spot edges are sharp on the processed print, so the next time around be more careful. Rinse your hands free of fixer and dry them before handling a fresh sheet of enlarging paper. Or avoid wetting your fingers with solutions by the careful use of tongs during all stages of processing.

GETTING A FIRM GRIP

I have trouble tightening the round knurled rings on the legs of my tripod. And once someone else gets them tight for me, I have difficulty loosening them. Have you any suggestions, aside from using a pair of pliers that mars the metal rings unless I use a protective cloth? Isn't there something that's easier to carry and use?

Go to a good hardware store and ask for a piece of flexible, relatively thin piece of rubber about 5- or 6-inches square, such as the kind sold for cutting gaskets; it's about 1/16-inch thick. And remember to take this with you when you go out shooting. Then use it in the palm of your hand when tightening or loosening those leg-lock rings. It's also handy for opening and closing jars.

An alternative selection for tripod use is a piece of rubber sold in some hardware stores that is made expressly for the purpose of opening and closing jars. Even large rubber bands slipped over the legs and around the locks will be of help.

FLASH, BANG, ALL BULBS GONE

I was in a museum one day when all of a sudden all the flashbulbs in my gadget bag exploded when I touched it with my finger. What's the explanation for this?

Our guess is that you first took the bulbs out of their cartons to save space in the bag. Then, static electricity from your finger was somehow conducted to one of the bulbs and fired it. It's not clear from your letter exactly how this static electricity was conducted. But it does seem obvious that the rest of the flashbulbs went, too, in what is called sympathetic firing. The odds against this happening are very good if you leave the bulbs in their protective sleeves. Note, too, that there is less danger of

having such an accident with flashcubes, we are told. Just the same, these cubes also should be left in their sleeves when being carried anywhere.

STATIC IN THE PICTURE

Could you please explain why lightning appeared in a photo I made of people seated in a gymnasium?

These lightning-like marks are due to the discharge of static electricity that can affect film in different ways. For instance, your marks indicate one common form, but others are chicken-like tracks or rows of dots. Whatever form such marks take, static electricity is more of a problem in dry weather, particularly cold weather. Try winding and rewinding your film much more slowly than usual.

A FIG ON NEWTON

I'm getting irregular, ring-like marks on my 35mm prints. These blemishes are not visible when I view negatives after they have dried, but they appear when I put a negative in the enlarger. What is causing them to show up on my blowups?

Sounds like you have Newton rings. You wouldn't see these on the film when viewed alone. But they can result with some enlargers if two smooth surfaces, such as the glass condenser and the glossy film base, are nearly but not quite in contact at various points. Then the result will be a fringe-like interference pattern. Try using a special mask to separate the condenser and film slightly. The manufacturer of your enlarger may provide a metal one. If not, make one yourself out of smooth, black paper thick enough to keep the negative and the condenser from almost making contact, as mentioned above.

NOT GETTING THE WHOLE PICTURE

Recently, I was at a wedding taking pictures by electronic flash. Quite by accident the shutter speed was turned to 1/125 second. Upon receiving my pictures, the few I did take at this speed showed one-half of each print to be black. Why were there no images on the dark side?

You must remember that the flash duration of electronic flash is very short. And the fastest shutter speed to use is the highest one at which the entire frame is being exposed at one time—which is probably 1/60 second

for your camera. At 1/125, however, with your camera, a slit traverses the film plane, exposing sections consecutively; so your flash recorded imagery for only part of the 1/125 exposure. When other sections were being exposed there was no flash illumination, so such sections were grossly underexposed and would look dark or black on prints, depending on the existing light. Other readers please note: The same principles apply, even though the top speed at which you can use electronic flash may be higher or lower than above. If you exceed the proper top speed, you too can get only partial flash exposure. And unexposed (or badly underexposed) film area will also vary with the shutter speed used, being larger as the shutter speed is higher.

AN OILY CATASTROPHE

Due to an unfortunate accident, I now have about 1,000 strips of black-and-white film covered with 30W motor oil. How should I clean these negatives?

It's a good idea to treat each strip individually in a good oil solvent, such as benzine or lighter fluid—both of which are, of course, highly flammable. Be sure the room is well ventilated. All sources also agree that you must wipe film very carefully after immersion so the film isn't scratched. Some people use cotton T-shirting or special tissues, such as Photo Wipes. Be sure you have enough of this soft cleaning material on hand. You'll use up a lot in cleaning that many negatives.

AT LEAST THEY'RE NOT UFOS

Could you tell me what causes small hexagonal shapes in pictures and how I can avoid the problem in the future? It has happened before.

These are due to internal lens reflections and show the six-sided (hexagonal) diaphragm opening of your lens. The shapes often show up when you shoot directly toward the sun, as shown by your picture.

In the future, with backlighted scenes try having the sun outside the picture area if the effect isn't wanted. Even then, use a suitable lens shade to cut off unwanted rays.

MATCH FILM RATING WITH LENSES

I've been getting overexposed color slides when using my automatic 35mm SLR camera outdoors with Ektachrome-X, a 64-speed film. They were a little overexposed with my normal lens and especially light with my 135mm lens. Should I set a different ASA rating to compensate?

Very possibly, yes. But first make sure that you are getting the extra lightness in each case no matter what emulsion batch of film is used and no matter who does the processing. Then, if your outdoor slides are all consistently overexposed, it is likely that a number of slight, permissible variables are all adding up wrong for you consistently, instead of canceling each other out. This can happen. And the answer is to personalize the film rating for your camera and for different lenses, if necessary.

Specifically in your case, with the normal lens first try raising the film rating the equivalent of a one-third f-stop change—here, from ASA 64 to ASA 80. (The latter is often indicated simply by a dot below the 100 figure on most film-speed-setting indicators). Then raise it more if necessary. On the other hand, with your 135mm lens start by raising the rating from the given ASA 64 to ASA 100, the equivalent of a two-thirds f-stop exposure decrease. And see if this brings you closer. If not, make further changes.

17
PICTURES ON DISPLAY

CRITERIA FOR CONTEST WINNERS

What do the judges look for when they are selecting pictures for a print or color slide exhibition?

Basically, they are trying to pick the best pictures. Usually they consider three main points—subject matter and interest, photographic technique, and composition.

DON'T SPLIT THE INTEREST

What does a print or slide judge mean when he says a picture has divided interest?

It is commonly understood that an exhibition picture should have one center of interest—one main point that stands out among all the things the picture shows. If several things compete for this central position, interest is said to be divided.

IF PICTURES SHIFT

I have a large portfolio I show with photographs in clear acetate pages. And I sometimes have two prints to a page. What is a good way to keep these pictures in position?

Simply get yourself some tape that has stickum on both sides. Then use this, out of sight on the back of each picture, to fasten it to a sheet of paper that will fit inside the clear page. If you don't want to use the black paper that usually comes with such pages, make your own. A little of this tape on the top and bottom will usually do the job.

NOTEBOOK PRINT PROBLEM

I'd like to put all of my 8×10s into a looseleaf binder, flush mounted. What is the best way to do this without making any holes in my pictures?

You have to decide which approach suits your need best. One answer is just to flush mount on three sides, but leave one inch (or more) extending on the side where you will punch the binder holes. A second approach is to slip your mounted 8×10s into suitably-sized acetate sleeves. The third method is not to mount at all when you use these sleeves. They come with a black paper insert sheet, and the combination affords quite a bit of protection for unmounted 8×10s.

BEST WAY TO MOUNT

How are prints fastened to mounting boards for display?

Today's most common procedure is to use dry mounting tissue, which comes in the same standard sizes as enlarging papers. The tissue melts to form a strong adhesive, both front and back, when heat is applied to it. First it is "tacked" to the print at a few points with the tip of any household electric iron or a special tacking iron. Then mount and print are trimmed to size together. The print is now placed in proper position on the mount and is fastened by applying heat with a dry mounting press or with a flat iron. A sheet of brown paper over the face of the print protects its surface. The iron should be in the range from 185° to 250°F. For irons with automatic temperature controls calibrated for different fabrics, use a setting slightly above the one for rayon and below the one for silk.

USING RUBBER CEMENT

How are prints mounted with rubber cement?

Double coating is the best system. Place the trimmed print on the mount and mark off its corners lightly. Then apply a coating of cement to the back of the print and the mount area it will cover. Allow both to dry. Next place the print on the mount, aligning one edge first and then rolling it into contact so no air pockets are trapped beneath it. Surplus rubber cement at the edges of the print can be rolled off with the fingertips. Eventually the cement causes yellowing of prints and of spots it has touched on mounts. To simplify alignment, place a sheet of wax paper

201

under the bottom two-thirds of the print and attach the top third first. Then move the wax paper down a section at a time and continue pressing print into contact.

MOUNTING OVERSIZE PRINTS

I've been making 30×40-inch black-and-white prints. What glue can I use to mount them on hardboard? And how do I apply it?

When you cannot or don't want to dry-mount large prints, wet mounting is usually resorted to with a water-soluble adhesive. For this purpose, in its pamphlet G-12, *Making and Mounting Big Black-and-White Enlargements and Photomurals* Kodak suggests a product called printers padding compound. This adhesive is used first as directed. The wet print is then positioned and usually wrapped around the board. Next, to equalize drying stress, another wet print or some wet kraft paper is mounted on the back. Full directions on procedures are given in the pamphlet.

TRANSPARENCY ILLUMINATORS

How can I display color transparencies?

There are small illuminators available. Some of these are essentially light boxes with electric light bulbs behind the diffusing glass on which transparencies are placed. Often the diffusing glass is either vertical or at a 45-degree angle.

MOUNTING A SEQUENCE OF PRINTS

What is the best way to present a series of prints, all on the same subject?

A small sequence can be mounted in an accordion-type print wallet to good advantage. If you prefer larger prints, they can be assembled in order and mounted back-to-back or on thin mounting board and then put together with plastic spiral or tube binding. For more flexibility, prints can be assembled in a looseleaf notebook containing transparent acetate sleeves that will take a pair of single-weight prints, back-to-back, and still permit easy removal or rearrangement when desired.

TAKING OUT THE CURL

How can you straighten prints that have curled?

Moisten their backs, using a well wrung-out swab of cotton or viscose sponge. Then stack them face to face and back to back and place them under weights to dry.

SPOT TO COVER IMPERFECTIONS

No matter how hard I try, I can't avoid having a few dust marks show up on my prints. How can I eliminate them?

These light marks can be removed by careful spotting, using spotting colors selected to match the print in general tone and suitable for its surface characteristics.

ETCHING AND SPOTTING PRINTS

How can I get rid of dark spots on prints?

In some cases they can be lightened by covering them with spotting colors of a lighter tone. In others it is better to remove the dark spot by bleaching or by shaving away the emulsion with an etching knife and then to darken the resulting light spot to match the surrounding area.

BRUSHES FOR SPOTTING

What size spotting brush is best for filling in tiny white spots, white lines or white squiggles on prints when working with Spotone spotting colors? Various friends swear by different brush sizes, such as No. 0 or the smaller No. 00 or the even smaller No. 000.

As you've noticed, there is a wide difference of opinion. Complicating things further, good brushes tend to come with a special series number. And not all spotting brushes with the same size number but different series number look alike or have the same kind of point.

If you examine two same-brand No. 00 brushes from different numbered series, both purchased at art stores, you are likely to find that one is not only smaller with shorter hairs, but seems to have a slightly sharper point. This kind of brush is often a better choice for individuals who are

203

less gifted spotters. It makes it easier for them to lay the spotting dye down just where it is wanted.

SCRAPE GENTLY, WHEN ETCHING

How can small spots or facial blemishes on prints be etched off?

This can be done easily, after some practice, with a homemade etching knife. Fashion one by breaking a nonstainless steel blade in half (in its protective paper), then breaking the half into quarters. Remove the paper and apply protective tape on the ragged side. To etch, hold the "knife" at a slight angle with the sharp point down for etching small spots and the rounded one down when lightening larger areas. Scrape gently, *towards yourself only,* until the right tone is achieved—never gouge. Etching does mar the paper surface; but a good cover-up is spraying the entire print surface with either a glossy or matte aerosol spray fixative.

A SHADING PROBLEM

A friend of mine insists that you don't have to mix Spotone 1, 0 or 3 spotting dyes to get just the right hue for the enlarging paper when spotting out white specks on black-and-white prints. However, the leaflet that comes with the Spotone colors says to do this. Who is right?

Neither is wrong; both sources are correct. It's not at all necessary to mix tones when dealing with small white spots. Most photographers just use the No. 3 "neutral black" bottle, diluting small amounts of the dye suitably. If the density is right, the spot seems to disappear, even though the dye hue is not identical with print tone. However, mixing for just the right tone can be essential in spotting some larger spots or sizable white lines. Then, a match in tone is necessary so difference in color won't be noticeable. Yet it is amazing how much spotting can be done without any mixing at all.

MIXED-PRINT STORAGE

Is there any harm in storing coated Polaroid Land black-and-white prints with conventional black-and-white prints?

Not according to Polaroid Corp. They tell us that though the coating contains chemicals, the residual material becomes inert when the coating

204

is completely dry. You are left with a protective "skin" that shouldn't harm your other pictures.

BLACK AND WHITE, BLACK AND BLUE

How can I get blue transparencies from black-and-white originals? I want to end up with black type on a blue background.

It's easy: Just bind in a blue gel of the right density, perhaps using a ready-made slide binder. Your photo store may have such gels or try an art supply house. Incidentally, light-colored gels can also be an answer to correcting some color imbalance in color slides, thereby saving shots you might otherwise discard.

SPECIAL PRINT MOUNTING

How can I attach a photographic print onto ordinary material such as cotton?

One good way is to use regular dry-mounting tissue and an iron set at "low" heat. The tissue should be tacked lightly onto the back of the print at the four corners and should not extend beyond print edges. Then protect the print face with brown wrapping paper and iron on top of this covering material. (Use a hard surface, not an ironing board.) Note that you may have to iron the entire surface several times and the edges still more to achieve a firm bond. We suggest this approach for material that is not to be worn or is to be worn for relatively brief periods of time, such as a costume.

A COLORFUL SITUATION

How should I mount large color prints, such as 8×10s, that I want to frame under glass?

It's wise to matte the print so there will be about 1/16-inch separation between the picture surface and the glass. This is to prevent the glass from sticking to the print in spots.

First, neatly cut a window in a matte material sold in art-supply stores. Then put the enlargement behind the window. One approach here is to mount the print beforehand on mounting board the same size as the matte (using good techniques). Then put the sandwich under glass in a photo frame of the proper size.

205

If you are not good at cutting windows, one simple approach is to buy a ready-made mount with a window of the right size, usually designed for portraits. Or you could find out what an art store would charge to do a custom matting job.

Whichever approach you do choose, remember that even though the photograph is under glass, it should never be placed in direct sunlight but in indirect daylight or moderate artificial room light to prevent fading.

SHARPNESS BEYOND THE LENS

I like to flush-mount my prints so no mounting board extends beyond the picture edges. What is a good, inexpensive way to trim prints after mounting, as the combination is too thick for my regular print trimmer?

An excellent way is to hold a good metal straightedge firmly on the mounted print so you can trim off the white margin and the excess board underneath. Then use a good matte knife or a good utility knife and cut with only moderate pressure along the length of the straightedge. Repeat this procedure until you have cut all the way through.

Such tools with large handles are a lot easier to use for the job than a smaller knife or a single-edge razor blade. In all cases, however, be sure you have a safe cutting surface under the mount so you won't cut your table. After cutting, you may want to blacken the cut edges with an indelible marking pen, as many professionals do.

18
SHOWING SLIDES

GETTING RID OF DUST

Do you have any suggestions on how to remove dust from mounted color slides without damaging the film?

Simple dust removal can be done with various tools: antistatic brush, antistatic cloth, or blasts of air from a large syringe or use of a special aerosol product. However, another approach is to imbue the film with an antistatic quality by use of special film cleaners; apply gently with a clean, soft, and lint-free cotton cloth.

ELIMINATING PRINTS ON SLIDES

How do you clean fingerprints from slides? And how quickly must it be done?

The cleaning job should be done just as soon as possible, as the acids in oils from the fingers can eat into the film. The longer the fingerprints remain on the film, the greater the chance of a permanent mark. So, try one of a number of film cleaners, possibly one of the antistatic types. Apply it with a soft, lint-free cloth following the manufacturer's directions. And handle slides only by the mounts.

HOW TO SPOT SLIDES

Why are slides often "spotted" (or marked) for projection purposes?

There are eight ways of inserting a 2 × 2 slide in a projector, and only one will show the subject matter right-side-up and correct from left to right. Thumb-spotting (a form of labeling) helps make certain slides are inserted correctly. With a slide held up before your eyes in such a manner that the image appears correct, the spot should go in the lower left corner of the side facing you. This will place it in the upper right corner when the slide is inverted to insert it in the projector.

GLASS MOUNTS: PRO AND CON

Are glass mounts necessary to preserve color slides?

Not at all. In fact, there are instances when glass mounts can hasten film aging by trapping moisture within slides. They provide valuable protection, however, when slides must be handled, and they limit variations in focus during projection.

RAINBOW-COLORED RINGS

What are the roughly circular, colored marks that appear in the skies of some of my glass-mounted slides? They have rainbow-like colors. They were not in the film before mounting.

These are probably Newton rings, caused by an interference pattern between two smooth surfaces that are almost in contact. Some wavelengths of light are reinforced while others are canceled out, producing the light and dark bands you see. There are several remedies, but a combination of them may be required. One is to use a mask thick enough to keep the backing side of the transparency from contacting the slide glass. (These are the two surfaces at which the trouble occurs.) Another is to reverse-roll your film before mounting, which counteracts its natural tendency to curl.

DON'T KEEP AUDIENCE IN THE DARK

Is it necessary to have a room completely dark for showing slides or movies?

No. Viewing is more comfortable if some room lighting is maintained at a very low level during projection. It should never be bright enough, however, to wash out any portion of the image on the screen.

FOCAL LENGTH VS LIGHT OUTPUT

How does the focal length of a projector lens affect its light output?

The light output depends on its aperture, not its focal length. A 3-inch f/3.5 lens will give you just as bright a screen image of a given size as will a 5-inch f/3.5. The only difference will be that the 3-inch lens will fill the screen from a shorter distance. Under special circumstances this may

affect brightness, independently of the optics involved. In a smoke-filled banquet hall, for example, you are likely to get a brighter image with a shorter projection throw simply because the beam does not have to pass through as much smoke-laden air.

WEEDING OUT SLIDES

Where do I start in editing a slide show?

Start with the slides, arranging them in order and discarding any that are unfit for showing because of technical defects in exposure or sharpness. Weed out duplicates, too, unless they show a subject from angles that are different enough to help tell your story.

TO KEEP OR NOT TO KEEP

A few of my slides are pretty badly overexposed, yet I want to tell the story of places they show. Am I justified in leaving them in even though they are of poor quality?

Only you can be the judge, but here are points you should consider. How long is the show now? If it is around an hour in length, there is a good chance that cutting would make it more enjoyable. Those overexposures are a fine place to start. How important are they, really? The photographer always misses things he takes out; viewers rarely do because they never knew they were there in the first place.

GETTING THE ORDER STRAIGHT

What is the best order for presenting slides taken on a trip?

The obvious sequence is the order in which places were visited. If you did any backtracking, covering the same locations twice, of course it might be just as well to forget this detail and group views of each locality together to keep your presentation simple. If your itinerary should happen to create what seems to be an illogical sequence, by all means abandon it in favor of any other pattern that makes more sense.

INFORMATION, PLEASE

Is it important to know the names of people, places, towns and buildings and to provide this information as a part of the show?

Usually it enhances enjoyment of a show to mention points of interest by name. People who have seen the places before will be pleased to recognize them and to have their recognition confirmed. Those who have not will be interested in knowing what they are seeing.

IMAGES WITHOUT WORDS?

Does a slide show require titles?

Not unless you want to use them, but titles often can serve very useful purposes at the start of a program and along the way. Use them whenever you want to transmit visual information that isn't in your pictures, like locations on a map, or when you want to tell part of the story you can't handle as well by narration.

ADVICE ON CONTINUITY

I have slides from England, France, Spain and the Netherlands. They make a show that is pretty good, except that there are gaps as I jump from city to city and country to country. What can I do to smooth things out?

What you need are some transition shots. Maybe you have them, but not in the places where you need them most. Think of how you traveled from place to place and see how many pictures of modes of transportation you can pick up. By inserting them where you need a transition, you put something appropriate on the screen while your commentary takes the audience from one place to another. Some travel shots, like views of clouds over the wing of a plane, are pretty much interchangeable. If you have a few, you can insert them where they will do the most good. On another trip it will pay to think in advance of this transition problem and to shoot roads, trains, buses, planes, airports and railway stations along the way. If you have the materials at hand, you can still shoot close-ups of maps, sections of guidebooks and other literature that might be of help.

FOR A CHANGE OF PACE

How can I change the pace of my slide show?

Present pictures for different intervals. To build up a feeling of excitement, show several pictures that occupy the screen for only a few seconds each. Some street scenes might do this job in a travel picture. These might be followed by several strong pictures, more rich in interesting detail, that are worth holding on the screen much longer.

LET SLIDE'S CONTENT DETERMINE SCREEN TIME

How long should I leave a slide on the screen?

That depends on its content and how it fits into the story. A few seconds is long enough for a picture that can be grasped readily. As much as 20 or 30 seconds may be desirable for a picture rich in detail that people like to explore.

FILL IN THE GAPS

What should slide-show narration tell?

It should provide information not afforded by the slides themselves that will help an audience understand and enjoy them. It should never describe the scenes—the viewers can see them. Often anecdotes of personal experiences associated with the scenes will help make them more informative or entertaining. Narration should cover pretty much the same things you would mention if you were sitting down and showing your pictures to a friend while telling the story behind them.

SYNCHRONIZATION PROBLEM

How can I synchronize my slide show with narration and background music on tape?

Start with slides, arranged in order. Prepare your tape, mixing narration and music as required and allowing sufficient viewing time for each slide. By the time you have finished this job, you will know where the slide changes come. To present the program, let the tape run and change slides to keep the pictures on the screen in step with it.

THE FUNGUS AMONG US

Has any chemical been developed to prevent or deter the growth of fungus on slides? I live in a damp climate in a house that cannot be air-conditioned.

The best answer we know of is to have your important slides Vacuumated by the Vacuumate Corp. In this process the moisture in each slide is replaced by a fungus-resistant resin that is inert and also resistant to scratches and chemicals. In fact, Vacuumated slides can easily be wiped with a damp, soft cloth.

The process is good for fungus-free slides and for some slides where the fungus is minimal and hasn't eaten into the emulsion. However, if the fungus has really gotten into the emulsion, Vacuumating won't replace the emulsion. But it will stop it from going further. For more information, write to Vacuumate Corp., 114 W. 26th St., New York, N.Y. 10001.

19
MOVIE-MAKING

TRACING THE JIGGLE

My movies seem to jiggle on the screen. Is there something wrong with my camera?

There could be, but there is a greater likelihood that you aren't holding your camera steady. Make a test by shooting a scene or two with the camera mounted on a sturdy tripod or braced on a rock-steady support. If your films jiggle, your camera needs looking into. If this eliminates the trouble, you will know your camera handling is at fault.

STEADY AS YOU SHOOT

Are there tricks for steadying the hand-held camera?

Plenty of them. Take a good firm stance with both feet firmly planted on the ground. Brace the camera against cheek and forehead, depending on its finder design. Sometimes you can use a tree, bench, or the corner of a building to help you hold the camera steady. There are tripod substitutes, too, like the one-legged unipod that extends to various lengths and the length of chain with tripod-socket fastening in one end and a loop in the other. To use the latter, you anchor the loop with your foot and then pull up against it to hold the camera steady.

TRIPOD: A USEFUL ACCESSORY

Why do many experienced movie-makers suggest you use a tripod?

There are two reasons. First, the tripod holds the camera steady to avoid pictures that jiggle on the screen. Second, and of no less importance, using the tripod forces you to plan your shots—to select just the area you want to take in and just the viewpoint from which you want to show it. With the camera on a tripod you can study the scene before you shoot and change camera angles if you find this desirable, while decreasing the likelihood of giving in to a wild impulse to pan the camera.

PAN SHOTS AND AUTOMATIC EXPOSURE

Does the movie camera with automatic exposure control guarantee proper exposure throughout a pan shot?

It does if the entire shot is brightly enough lighted to be within the range of your lens and if you pan slowly enough so the mechanism has time to keep up with the changing exposure requirements of the scene before the camera.

SLOW MOTION FOR WATERFALL

I have been trying to get scenes of a waterfall, but the water itself never seems to look right. It comes out as just a white blur. What can I do?

This sort of subject often looks better if you show it in slow motion by using a fast filming speed. Use 32 fps instead of the customary 18, or go all the way to 64 fps if your camera has that high a speed and there is light enough to permit using it.

MORE LIGHT THROUGH THE LENS

Is there any way I can get properly exposed movies when my light meter says there just isn't quite enough light to shoot, even at my widest lens aperture?

There is a trick you can use if the scene doesn't contain any important action or if you can control whatever movement there is in the scene. Suppose you have an f/1.9 lens and the shot calls for an aperture of f/1.4. That's almost one full stop difference. If you shoot at your normal speed of 18 fps, the film will get just half the exposure it should. However, you can double the exposure by cutting your filming speed in half. Shoot at 9 fps instead of 18, and you will get correct exposure. Remember, though, that movement in the scene will appear twice as fast as normal when it is projected. If someone walks into the scene, be sure to have him move at only half his normal speed so the action will come out right on the screen. Avoid action that can't be controlled, like pedestrians and traffic in the background, or you're likely to get a comic effect.

SLOWING UP THE ACTION

How do moviemakers get the effect of slow motion on the screen?

This is accomplished by operating the camera at high speed when filming and then projecting at normal speed. If you film at 18 fps and project at 9 fps, for example, the movement on the screen will take place at just half its normal speed.

SPEEDING UP THE ACTION

How do you make things move very fast on the screen, like old-time movies?

This is done by filming at a slow speed and then projecting at normal speed. Old-time movies were produced with hand-crank cameras that often were operated slowly. If shown on today's sound projectors at 24 fps, the movements look more jerky and speeded up than they did in their own day. If you shoot at 9 fps and project at 18, motion on the screen will appear twice as fast as normal.

FAST-MOVING CLOUDS

I've seen exciting movies of clouds in the sky, which seem to form rapidly and to move very fast. How are such films taken?

By shooting at a very slow speed with conventional movie cameras. Usually such shots are made by single-frame exposure, rather than letting the camera run. If you trip the single-frame lever at 1-second intervals, and then project at 18 fps, the action on the screen will appear 18 times as fast as normal. If you trip it every ½ second, the action will seem 9 times normal speed. Be sure to continue filming long enough—you need 18 frames for each second's screening time.

MATCHING THE ACTION

How do professionals make one movie shot blend so naturally into the next?

One of their tricks is matching action. If a long shot shows a boy getting off his bicycle, the medium shot will show him setting up its stand or leaning the bike against the side of the house, doing whatever normally comes next.

OVERLAP THE SCENES

Can professionals start and stop their cameras accurately enough to get this sort of precision?

Instead of trying to film it with accuracy, they shoot a little overlapping footage in each of the two scenes. In the example above, the long shot might show the boy riding up, getting off his bicycle and leaning it against the house. The medium shot then would show him leaning the bicycle against the house again and then swinging open the back door and rushing in. By careful cutting, the scenes are spliced together at the same point in the action.

DISCONTINUITY OF PLACE

How are scenes made to blend together well when they are taken in entirely different locations?

A device often employed here is simply to place the subject of the second scene in the same relative position within the movie frame that was occupied by the subject of the first one. Since the viewer's eyes are following the subject in the first shot, they are fastened on the subject of the second one automatically the moment it appears on the screen.

PARALLEL ACTION

How do movies manage to show what is going on in two places at once?

The cut-away shot is employed here, often to build suspense. In the silent-picture days there was often a title that read, "Meanwhile, back at the ranch." Now we are likely to see the film cut away from one bit of action to another related part of the story taking place somewhere else. The hero is being bound to the stake, but cut-away shots show that the cavalry is coming. Suspense heightens as the camera cuts back and forth, even though we know the cavalry will get there in time. The same technique can be applied to home movie subjects—we may see a youngster feverishly wiping up spilled jam in the kitchen between cut-away shots of his mother's feet coming up the front steps. There is the same element of suspense: Will he get it cleaned up in time?

TIME-PASSING TECHNIQUES

How does the movie-maker account for passage of time when the timing is important and yet the interval is too long to be shown in detail on the screen?

It takes careful timing to fit a pair of scenes together properly. Suppose, for example, one shot shows a subject in the garage and the next is to reveal him doing something in the garden. If the first shot ends with the subject just starting toward the garage door, the second one must open with the garden empty and must continue for a moment before he walks into the scene. When movement starts in one direction and is cut, it continues in the same direction in the next scene.

DISCUSSION OF DISSOLVES

What is the purpose of a dissolve or "lap dissolve" in which the action in one scene fades from the scene while that in the following one appears?

This technique of joining a pair of scenes is sometimes employed to indicate action that is going on simultaneously. For example, this technique could take us from a sleeping actor to what he is dreaming about. It is frequently used to show a lapse of time. In this case, the same subject or scene appears in the new shot with some elements changed. Windows may be darkened in a shot of a room at night. When the same scene dissolves onto the screen again and they are bright, we know morning has come.

REAL TIME VS SCREEN TIME

Does action on the screen necessarily take as long as it would in real life?

Not at all. Unimportant activities frequently are compressed so they are accomplished in much less time than they actually would take. Key action, on the other hand, may be expanded so that the camera takes more time to show it than actually would be involved. Thus the movie-maker can slide quickly over unimportant details and dwell on the action that counts.

217

EDITING IN THE CAMERA

What is "editing in the camera?"

Professional movie scenes are shot in the order that is most practical and convenient, with little regard for the final sequence in which they will appear on the screen. The film is organized by editing—cutting, splicing and discarding footage until the picture emerges in its final form. Many amateurs choose to "edit in the camera" by shooting all scenes in proper order and of the right length so the film will be ready for presentation as soon as it comes back from processing. The results aren't perfect, by any means, but editing in the camera produces a far better film show than a series of shots taken in random order with editing in mind—but then never actually cut apart and edited properly for orderly presentation.

MOVIE-SCENE LENGTH

How long should a movie scene be?

That depends on the job it is supposed to do and its place within the sequence where it belongs. A view of a city from a nearby hilltop might last for 20 seconds or more if it contains rich detail your audience will want to explore or if it shows different points of interest you will want to introduce while the scene is on the screen. To show the effect of teeming traffic in the center of the city, you might choose to present a series of crowded street scenes only a second or two in length—almost a kaleidoscopic view. Long scenes set a leisurely pace, appropriate for quiet subject matter. Short ones step up the tempo of a film and create a feeling of excitement and action. Most movies need both.

HOW LONG . . . HOW SHORT?

When are short scenes desirable?

A scene a few seconds long will reveal the expression on a face in an extreme close-up or make any point that is easily grasped. A series of short scenes builds up excitement. Use a short scene whenever it will do the job it has to accomplish in telling your film's story. Longer scenes are useful to establish the location of a movie sequence or to reveal action that takes time. They fit in with more quiet portions of a film. They keep the screen occupied when you know you will have quite a bit to say. If you

find yourself shooting too many long scenes, though, try to find ways of using two or three shorter ones to do the same job.

WHEN TO USE THE PRINTED WORD

Must movies have titles?

Spoken words can take the place of most titles, but prepared titles still provide a good start and a satisfying ending. Frequently you can use them effectively in between. A title should always come first, before the scenes it describes.

HOW TO MAKE TITLES

Do I have to have a titling setup to make my own titles?

Not at all. You can shoot them as you go along, using city limits signs and those at airports, bus and railway stations. There usually are appropriate markers at places of historic interest. If you drive, you can use self-adhesive letters to prepare a title on a car window and then shoot it with an appropriate background scene.

TO PAN OR NOT TO PAN?

I've read many times that the amateur should avoid panning his movie camera. Yet you see pan shots in professional films. Often they are good ones. When is a pan justified?

One of the advantages of being an amateur is that you can do what you want, when you want to, and there's no law against panning every movie shot. Films are easier to view, though, if panning—by moving the camera horizontally as you shoot—is held to a minimum and employed only when there is good reason for it. One of the things a pan shot will do is establish the relationship between two scenes that are too far apart to show in an ordinary single shot. Suppose, for example, you want to show that your hotel is near the beach—even though it isn't directly on it. Find a distant, high viewpoint from which both hotel and beach are plainly visible. Line up a pan shot, starting on the hotel and ending on the beach. Such a shot will tell your story, particularly if you accompany it with a bit of narration. Pan shots are useful, sometimes quite essential, when there is important action to follow. If you're watching a race from the

219

stands, chances are a pan is the only type of shot you can use and still keep the horses on the screen for a long enough period to make it worthwhile.

FOR BETTER RECORDINGS

How can I avoid picking up projector noise in recording magnetic sound on film?

Get the microphone away from the projector, even if this means you must enlist an assistant. One solution is to project through a doorway from one room to another. Perhaps you can hang blankets between the recording area and the projector to deaden the sounds you don't want.

ELIMINATING BACKGROUND NOISE

I've been experimenting with recordings of live sound while filming, but I find I pick up too much background noise. How can I reduce it?

The closer your actors are to the microphone, the better your chances of picking up their voices without catching other sounds. See if you can't conceal the mike in a better location on the set. A more directional microphone, properly aimed, may help. If all else fails, maybe you can even write the microphone into the script—if you want someone to sing, make the occasion a broadcast or a recording session where the microphone would be justified.

USING CANNED SOUND

Where can I get sound effects?

An amazing variety of them can be purchased on phonograph records, in assortments to fill different needs. Check your record dealer. Unless you live in a large city, he probably won't carry many records of this sort in stock, but he can order them for you.

20
PICTURES AND THE LAW

The amateur photographer's right to pursue his hobby is essentially unrestrained by law. Yet there are restrictions that prohibit taking pictures of some types of subject matter and in some places. Whether amateur or professional, the photographer also has a right to show his pictures and to sell them. Yet there are laws that limit the conditions under which they can be used. The questions that follow are typical of the ones that have been asked of George Chernoff and Hershel B. Sarbin and quoted in their book, *Photography and the Law,* published by Amphoto. It is an authoritative source to which the photographer can turn for more detailed information on his legal problems.

PHOTOGRAPHING ACCIDENTS ON A THRUWAY

Can pictures of accidents on a state thruway be taken without obtaining a special permit?

Pictures may be taken on a state thruway or any other highway whether it is a toll road or not. No permit is necessary.

PICTURES IN PUBLIC PLACES

Can I take pictures in "public" places? Can the management of a railroad station, library, department store or theatre prevent a camera from being brought in or used for the purpose of taking candid pictures of the crowds?

Pictures can generally be taken in public places. However, libraries, museums, theatres, etc., do have the right to prohibit cameras from being used on the premises or to make whatever restrictions they wish to impose on the taking of pictures. Note that the right to take a picture is not the same as the right to use it, however. Persons who have their pictures taken in public or elsewhere may have a claim for invasion of privacy if the use made of the pictures can be classified as being for advertising or trade purposes.

221

IS A SUBJECT'S PERMISSION NEEDED?

I plan to go to Europe this year and will want to photograph as much local color as possible. In snapping candids of people in their own surroundings, the element of spontaneity is often lost when the subject is approached to ask permission to photograph before taking the picture. Is it advisable to take a candid photo without the subject's permission?

It can generally be said that it is not necessary to obtain someone's consent just to take his picture. You must remember that the reason for getting a release or written consent is to permit you to use or publish the picture for advertising or trade purposes. As long as the use which you make of a photograph taken gratuitously is not for advertising or trade purposes and is not libelous in nature, you will generally have no problem.

PICTURES OF PHOTOGRAPHS

I would like to take pictures of photographs that I have seen in your magazine. Do I have to ask for permission from the publisher?

Under our copyright laws it would be incumbent upon you, before copying any pictures from magazines or other sources, to find out whether they are copyrighted, for the copyright owner of a picture is the only one who has the right to reproduce it. If the magazine carries a copyright notice, you should obtain permission of the copyright owner before making copies.

PRIVACY IN A HOSPITAL

I am an amateur photographer and have talked to one of my friends who is a surgeon about taking a picture of an operation he will perform in the hospital. Will I need a release to publish the picture?

There have been many court decisions in which the use of a photograph of a person undergoing medical treatment was held an invasion of the right of privacy. Technically, the use of such pictures to illustrate articles on medicine should not constitute an invasion of privacy when the use of the picture does not violate one's sense of decency, and some courts have so ruled. Since people are more likely to be sensitive about such pictures it is really important to get consent, and the consent should be both broad and specific. It is also clear that the consent of a patient

222

to medical or surgical treatment is not tantamount to a consent to take pictures of him in treatment.

PAYMENT FOR REPRINT

I took a picture of a motel for a booklet put out by a local club. A few months later an advertising salesman for the local newspaper asked me for a print of this picture. I quoted him a price for it and he replied, "Why should I pay for a reprint? I will just cut the photograph out of the booklet and make another picture." Does he have a right to do this?

If the picture which you took was properly copyrighted, no one can reproduce your picture without violating the copyright laws. Someone could, however, take another picture of the same motel and use it without violating the copyright law.

CONSENT OR LACK THEREOF

I plan to sell some of my photographs to magazines as well as entering them in national contests. Some examples of these pictures are a full bench of people in Rockefeller Plaza; a picture of an Amish man in a Pennsylvania market; people lining the rail of a Manhattan sightseeing ferryboat; an old sea captain on the New England coast. The people in the pictures did not know I was photographing them at the time and I did not ask them for releases. Can my pictures be published even though I do not have the releases?

Model releases are generally required in cases where pictures are to be used for purposes of advertising or trade. If a picture is published by a photographic magazine as a contest winner or for other editorial purposes, and if the pictures do not hold a person up to ridicule or are not otherwise offensive, it is the opinion of the authors that consent of the subject should not be necessary. It is still best, of course, to have the consent.

THE OPTION IS YOURS

I took pictures of an accident and would like to know whether, if I sell them to some interested party or an insurance company, I have the right to sell the same pictures to anyone else.

Assuming that you are a freelance photographer and not in the employ of any publication, when you take pictures of the accident, you have the

223

absolute right to dispose of them under whatever terms or conditions you desire. When you wish to sell such pictures, you have the option to sell either all rights to the picture or one-time reproduction rights only or you might make a different arrangement. Before the selling of prints you should be sure to affix a notice of copyright on the prints, for in the situation you describe, you would not get the protection a photographer normally gets when he sells pictures to a publication. In the latter case he is protected by the copyright notice the publisher places in the magazine. Thus, if you protect yourself by appropriate copyright notice and by appropriate contract arrangement, you would have the right to sell as many prints as you may wish. On the other hand, if you sell all rights to the picture, you would have no right to resell the prints.

TO WHOM DOES A PORTRAIT BELONG?

I am a professional portrait photographer of children. Do I need a release from the parents in order to enter a photograph of their child in a contest run by a photographic magazine?

Where you are engaged to take pictures for a fee, the relationship between you and your customer is such that while you may retain the physical possession of the negatives, you cannot do anything with them without the consent of the customer. New York and some other states would permit you to exhibit the picture on the premises of your photographic studio as samples of your work, but if the customer objects, you would have to remove the picture. Thus, the consent of the customer must be obtained before entering his picture in a contest, and the child being a minor, you would have to obtain the consent of a parent. The situation would be different in some respects if you had taken the pictures gratuitously or if they happened to be candid shots.

CONSENT OF PROPERTY OWNER

If I take a picture of a store or other private property with the consent of the owner to use it in an ad, and then I sell the picture for that purpose, is the owner of the store or other private property that was photographed entitled to any part of the profit from the sale of the photograph?

Since you have permission of the owner of the property and the owner has made no agreement with you regarding the division of the profit from

the sale of the picture, you would not legally be obligated to give him any part of the profit. Having given his consent, the question is purely one of contract, and since the owner did not protect himself he would have no claim against you.

PHOTOS OF HOTEL GUESTS

I took photographs at a local summer resort for advertising purposes, but did not obtain releases from the persons in the photographs. They were guests in the hotel. The owners of the resort want to use the pictures and are willing to assume full responsibility. If anyone sues me, will I be covered by such an agreement?

This agreement would protect you providing the resort owner is financially sound. (In several states the agreement must be made in writing.) You must remember that you will continue to be liable to the people shown in the pictures. The resort owner, by assuming responsibility, agrees to reimburse you for any damages awarded against you; but if at that time the resort is out of business or otherwise insolvent, then the agreement to indemnify you, while legally good, would naturally be a worthless piece of paper.

LIABILITY ON WEDDING ASSIGNMENT

I am starting out as a candid wedding photographer. If the pictures I take at a wedding do not turn out well, can I be sued by the people who engaged me to take the pictures?

If you hold yourself out to be a professional photographer who is competent to take pictures of a wedding and you fall down on the job, then you can be sued and held liable unless you can show you were not at fault. When you hold yourself out as a professional, the law requires that you do a good and workmanlike job. If, on the other hand, you tell your customer that you are an amateur and that you will merely do your best to do a good job, then the situation would be different and, provided the court accepts your version of the arrangement, it would not hold you liable because the pictures did not turn out well.

READ THE CONTEST RULES

A few years ago I entered some of my pictures in a photography contest. I did not win a prize, and this year I asked the sponsor of the contest to return my pictures. I was told the prints and negatives had been destroyed six months after the contest closed in accordance with the rules announced for the contest. Why should they have the right to destroy my pictures?

The sponsor had a perfect right to dispose of the pictures after the period of time specified in the contest rules. The rules set forth the terms and conditions upon which pictures are submitted. You do not have to submit pictures if the rules are not to your liking. In our experience the publishers of photographic magazines always make some provision in their contest rules for the return of pictures if postage is supplied with the entry, but no one could be expected to keep mountains of pictures on hand year after year just because someone might subsequently ask for the return of his pictures. You might be interested to know that the United States Post Office Department has strict rules that must be observed by sponsors of contests who use the mails in connection with the contests.

WHEN IS THE PROCESSOR LIABLE?

I recently took some film to a local camera store for processing. Now I am told by the camera store that the processor lost my film. The pictures on the roll of film were taken at my son's birthday party, and although they aren't worth much to anyone else, they mean a lot to me. Can I sue?

You might sue, but even if you won your case on the ground of negligence, it would hardly be worth the trouble as a practical matter. Your problem is to establish damage, and this would be extremely difficult in your case. Nevertheless, if there were no other complications, you could receive nominal damages in an amount fixed by the judge or jury. However, you probably were given a receipt at the camera store which contained a limitation of liability to the cost of replacement of film. While the law is not too well settled on the effect of such receipts, there is at least one reported case in the lower court in New York holding that such receipt is a barrier to successful prosecution of your claim.

PHOTOS OF MODEL FOR PUBLICATION

I recently took some pictures of a model who posed in the nude. I did not get a release, but the model told me when I took the pictures that I could sell them to a magazine. The magazine to whom the pictures were sent wants a written release, but the model has moved out of my town and I cannot find her. Is the release necessary?

The magazine is right to insist on a written release. Although many states do not require the consent of a subject in writing, the publication of a nude study is fraught with danger. The publisher as well as the photographer may be sued for invasion of privacy or libel, and no one would want to base his defense on an oral consent. In a New York case, a model had posed in the nude for a photographer but orally forbade him to have the picture published in any manner so that her face would show. It was established at the trial that the model had posed in the nude previously with the same restriction. The court awarded her $1,500 in damages.

21
MARKETING YOUR PHOTOS

INDEPENDENT SHOOTING OR ASSIGNMENTS?

Suppose an amateur wants to make extra money with his camera. Is he better off taking pictures on his own in the hope of selling them or should he go after assignments?

He has little choice. Assignments are better than shooting purely on speculation, of course, but you seldom can get them just for the asking. Most amateurs who work their way into the professional field begin by shooting on their own, building up portfolios of pictures buyers might want. Sometimes the pictures sell. Again, the portfolios may aid in obtaining assignments.

COMPILING A PORTFOLIO

What sort of pictures should an amateur include in his portfolio?

The types of shots he believes he can take at a profit—pictures he knows how to shoot and knows at least some buyers want.

RECOMMENDED PRINT SIZE

What size black-and-white print should be used to make up a set of sample pictures?

They should be at least as large as the prospective buyer is accustomed to seeing. The largest probably would be 11 × 14. The most popular size is 8 × 10.

FIRST COMES SUBJECT MATTER

Is what you shoot as important as how you shoot it in taking pictures for sale?

Subject matter and technique are both important, of course, but subject matter comes first. If a buyer isn't interested in what you are shooting, the most brilliant technique won't save your pictures. Yet at least reasonably capable photographic craftsmanship is expected.

PRINT PROTECTION IN THE MAIL

How should I protect prints when sending them through the mail?

You can buy photo mailers at most camera supply stores. They provide an envelope plus two sheets of corrugated cardboard. If you have cardboard available, you can buy envelopes and make up your own at a somewhat lower cost. Some photographers make a point of pairing up one cardboard with corrugations running lengthwise with another that has them crosswise. This combination gives maximum strength.

PICTURES AND CAPTIONS

What sort of caption material should accompany a news picture?

The caption should answer the basic journalistic questions of who, what, when, where, and sometimes why and how. It should be brief and relate to items of significance shown in the picture.

OMIT THE TECH DATA

Should my pictures be accompanied by technical data on how they were taken?

This information isn't of the slightest interest, except when you are submitting photographs in picture contests or to camera magazines. Then you should indicate the camera, lens, film, lighting conditions, exposure and other information that might be of significance to a photographer.

ABOUT PRESS PASSES

Where can I get a press pass?

Press credentials are of value only when they are issued by a news-gathering agency that is recognized in the area where you want to use them. The way to get them is to obtain an assignment from a newspaper, magazine, television station, news service, or other source of this type. From time to time you may see printed press passes offered for sale, but they aren't worth the paper they are printed on.

MATCHING MARKETS AND PICTURES

Is it easy to sell a picture, once you get one that is really good?

It often is if you take that picture to the right market, but you can't sell snow scenes to a buyer who wants desert views, no matter how good they are. There are many types of markets. We think first of the publications we see every day, but they make up only one small segment of the whole picture market. There are thousands of other possibilities. They range from the people who want portraits and commercial pictures of the type provided by regular studios to laboratories requiring photographs that record information the eye can't see.

CAPTION FASTENING

How do you fasten captions to pictures you offer for sale?

Some photographers attach them to the backs of their prints with rubber cement or cellulose tape. Others type the captions on sheets of paper with an inch or so of extra space at the top, and fasten this area to the bottom of the back of the print in such a manner that the caption extends below the print and can be read without turning the picture over. This latter system is convenient for an editor, but makes pictures hard to stack and often results in the captions being torn off.

FIRST OR FOURTH CLASS?

Is it necessary to send prints and captions by first-class mail?

It isn't as far as postal regulations are concerned, although you may prefer to use first class for greater speed and more gentle handling. You can send prints and captions fourth class by using a sticker which labels the shipment as merchandise that can be opened for postal inspection if necessary. The captions are considered merchandise, along with the prints they describe, but you can't insert a letter in such a fourth-class shipment.

ABOUT RETURN POSTAGE

Do I have to enclose return postage to get my pictures back?

Most publications refuse to return unsolicited contributions that are not accompanied by return postage. It is always best to enclose it, unless you are mailing pictures made on assignment or specifically requested. The normal procedure is to return pictures in the same way they were sent. So enclose the amount of postage required to send the shipment.

. . . AND A RETURN ENVELOPE

What about a return envelope?

You will get rejects back more promptly if you enclose a self-addressed, stamped envelope with the pictures you submit. This makes it easy for the editor to mail them. Enclosing an addressed, gummed return label along with the postage will expedite return of your pictures, too.

ID STAMP

What's the best way of identifying my pictures?

Have a rubber stamp made. Use it to put your name and address on the backs of your prints in a neat, professional manner.

CONTRAST FOR PUBLICATION?

I have heard that contrasty pictures are preferred for publication. Is this true?

Not exactly. In terms of photographic print quality, buyers don't want harsh contrast of the "soot and whitewash" variety. They prefer full-scale prints with plenty of rich middle tones in between the ends of the scale. The type of contrast they want is subject contrast—the sort you get when you place a light subject against a dark background to make it stand out.

HOT NEWS—WHAT TO DO?

What should I do if I happen to be on hand when an important news event takes place and regular news photographers are not there?

If you happen to be taking pictures of a minor fire in your neighborhood, for example, and a whole building blows up to make the fire into a big news story, keep on taking pictures of the events that follow as long

231

as you have film. Don't go home and develop your negatives. Instead, call the office of your newspaper and ask for the picture editor. Tell him what you have and ask what your pictures are worth and how to handle them. If the event really is important, he will want you to bring in your undeveloped film at once. Don't delay in offering news pictures of this sort. They lose their value quickly.

WORTH A QUERY?

Does it pay to query an editor before submitting pictures?

It does when you have a choice of several possible buyers and particularly when the pictures are of short-term interest. Under these conditions the query will eliminate uninterested prospects, saving the time and cost of submitting the pictures themselves. You simply tell the editor what you have to offer. Keep your letter brief and to the point. Things to cover are the subject matter, what is going on, number and size of prints, availability of releases if required.

MULTIPLE QUERIES

Can I submit the same pictures to more than one buyer?

Indeed you can, and with photo payments as low as they are in many fields it is only by making more than one sale from a negative that the photographer can hope to come out ahead. However, it is not considered ethical to submit prints from the same (or similar) negatives to two publications in the same field at the same time. If prints have previously been sold or are being considered, an editor has a right to know about it. These factors sometimes may enhance the value of pictures, at other times may work against them.

PUBLICATION RIGHTS

Just what rights does a photographer give and which ones does he keep when he sells a picture to a publication?

That depends on the arrangement he has made. Most sales cover "one-time publication only," which means the buyer can publish the picture once and the photographer retains all other rights. At the other extreme, you may sell "all rights," which means just what it says.